Illustrated Dictionary of
ART TERMS

Illustrated Dictionary of

ART TERMS

A Handbook for the Artist and Art Lover

Kimberley Reynolds
with Richard Seddon

Peter Bedrick
New York

1

First American edition published in 1984 by
Peter Bedrick Books
125 East 23 Street
New York, N.Y. 10010

Published by agreement with Breslich and
Foss, London.

Library of Congress Cataloging in Publication Data

Reynolds, Kimberley.
 Illustrated dictionary of art terms.

 Originally published: London : Ebury, 1981.
 1. Art—Dictionaries. I. Seddon, Richard Harding,
1915– II. Title.
N33.R49 1984 703'.21 83-15739
ISBN 0-911745-31-9
ISBN 0-911745-32-7 (pbk.)

Manufactured in Great Britain
Distributed in the USA by Harper & Row
and in Canada by Book Center, Montreal

PREFACE

The terms encountered in discussions of works of art and in descriptions of the methods used to create them should provide a means of deepening our appreciation and assisting our understanding. Unfortunately, complex explanations of techniques, obscure labels and critical jargon abound in writing about art, and all too frequently present an impenetrable barrier to the non-specialist.

The purpose of this dictionary is to provide a simple guide to terms frequently encountered in books, magazine articles, catalogues and even television programmes on making and looking at works of art. In addition to the individual entries, we have also provided as many sizeable illustrations as possible. Verbal explanations are sometimes adequate on their own, but certain subjects such as styles or schools of painting can only be properly explained and remembered with the aid of visual examples.

The scope of the dictionary is biased towards the fine, rather than the decorative or applied arts. That is to say, this is principally a book for the person interested in painting and sculpture rather than metalwork, furniture or pottery. We have, however, included a number of terms for types of work that are frequently encountered in museums, such as enamels and terra cotta. We have omitted architectural terms unless they are directly relevant to painting or sculpture, as in the case of caryatid and kouros.

The way to use the dictionary does not require any explanation, but we hope that the reader will make use of the cross-references. These are indicated by SMALL CAPITAL LETTERS in the text and at the start of every caption. Since too many cross-references can be distracting, we have included them where they will illuminate a specific topic, but have omitted them where we believe the term to be generally understood. It would be ridiculous to refer the reader to Renaissance each time the term appears.

To assist additional research or merely general reading, we have concluded the book with a brief bibliography organized under different headings, from periods in art history to aesthetics and artists' materials. Obviously, the list only includes a minute number of the books available on each subject, but the ones that we have mentioned we know to be both reliable and helpful.

Lastly, we hope that this book will provide both explanation and enjoyment for anyone who has the enthusiasm to walk through the doors of their nearest art gallery or pick up a pencil and sheet of drawing paper.

K.R.
R.S.

effect will not be uniform; and if the ground is too absorbent it will soak up too much oil and leave the pigments insufficiently bound, thereby causing impermanence.

A.A.A.
Australian Academy of Art.

A.A.L.
Academy of Art and Literature.

Abbozzo
See LAYING-IN.

A.B.P.R.
Association of British Picture Restorers.

Absorbent Ground
A chalk ground which absorbs oil and is used in oil painting to achieve a matt effect and to speed up drying. There are two drawbacks to this type of ground: the matt

Abstract Art
A work of purely abstract art is one that is entirely independent of the natural world, although it may have had its origins in Nature. Such a work is considered as an object in its own right and has no distinguishable subject-matter. Its arrangement of forms and colours gives pleasure in much the same way that a piece of music gives pleasure. This is the distinctive feature of abstract art.

Like many labels in art history and aesthetics, 'abstract' is an awkward and inappropriate word. Pure forms of AESTHETIC

ABSTRACT ART. *The Frozen Sounds, Number 1 by Adolph Gottlieb. One in a series of imaginary landscapes executed by the artist in the 1950s. Gottlieb has simplified the 'landscape' into areas of earth and sky by sharply accenting the horizon line.*

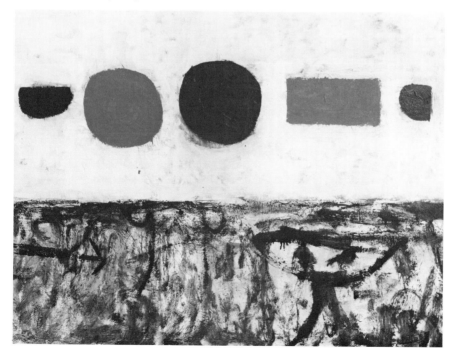

BEAUTY are not found in Nature and then abstracted. Instead, they are created by the artist and then imposed on Nature. The man-in-the-street who is upset by abstract art, attacks it because it interferes with, or changes Nature.

The natural world contains numerous incidental and inharmonious features on which artists tend to impose a degree of order and harmony when including them in works of art. If an artist makes only slight alterations to natural subject-matter, he produces a work which closely resembles the appearance of Nature. This is more or less realistic art. However, if an artist allows order and harmony to dominate rather than control natural forms, he produces what is commonly called an 'abstraction', although as we have seen it is, in fact, an imposition.

Abstract Expressionism

An aspect of ABSTRACT ART in which the

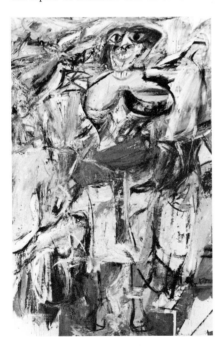

ABSTRACT EXPRESSIONISM. Woman and Bi-cycle *by Willem de Kooning. A typically tempestuous work by a leading member of the New York School.*

physical subject is abandoned for one which is purely emotional or intellectual. In short, the artist expresses a feeling or an idea solely by means of form, line or colour and without direct reference to subject-matter. This development of abstract art has been most thoroughly explored by American artists, particularly Willem de Kooning, Jackson Pollock, Hans Hofmann, Barnett Newman and Mark Rothko. In the words of Willem de Kooning, abstract expressionists adopt 'the Impressionist manner of looking at a scene, but leave out the scene'. See also ACTION PAINTING and AB-STRACT IMAGE PAINTING.

Abstract Image Painting

An aspect of ABSTRACT EXPRESSIONIST paint-ing in which emotional expression has been confined to form and colour alone, and in which the application of the paint or other medium is a secondary factor. It is distin-guished by this from ACTION PAINTING.

Academic Art

Usually a pejorative term for works of art, especially nineteenth-century paintings and sculptures, which follow the strict rules laid down by established academies.

Academy

The garden near Athens where Plato taught was called 'The Academy' and its name has been used ever since to describe many different types of institutions. It was not until the sixteenth century in Italy that artists began to form the sort of groups we recognize as academies today. At that time, patrons and well-known artists joined together to form establishments where Classical art, especially the human figure, could be studied, members were elected and membership became a status symbol. Art academies flourished in Italy and France in the seventeenth century, but did not reach England until the eighteenth century, when the Royal Academy was founded in 1768. Unfortunately, as academies grew in num-ber and prestige, their principles became dogmas, so that by the end of the nineteenth century many of them were highly com-mercial and conservative institutions which stifled all forms of artistic experiment.

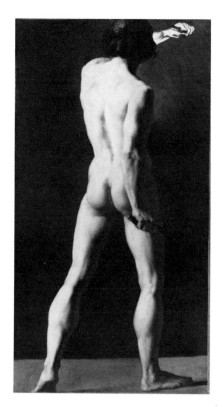

ACADEMY FIGURE. *An oil study attributed to Théodore Géricault.*

Academy Figure

Usually a drawn study of the human figure of which the proportions are about half life-size and whose pose is taken from classical sculpture. Such works are merely exercises in depicting the human form, sometimes restricted to specific muscles, and are not considered works of art by the artist.

Acanthus

Acanthus

A decorative motif based on the leaves of

the acanthus plant, also known as bear's claw or bear's breech. The most notable and widespread use of this motif is on the capitals of Corinthian columns in Greek, Roman and Renaissance architecture.

Accidental Colour

The image of a bright object will stay imprinted before the eyes if a spectator stares at it and then looks away. The colour of the image, however, will change to its complementary colour, for example red will change to green. In this context, it is called an accidental colour and forms part of the law of successive contrasts.

Accidental Light

Any form of light that is not daylight, for example moonlight, candlelight or firelight. Some painters have specialised in introducing accidental light (or accidentals) into their works, notably Joseph Wright of Derby, who often mingled two different kinds of accidental light in one painting.

Accidental Points

Vanishing points which do not fall on the main horizontal line of a painting or drawing. See PERSPECTIVE.

Achaean Art

Art of the Mycenean Bronze Age from *c.* 2000 B.C. to *c.* 1100 B.C. This culture was based around Mycenae and included peoples of eastern and southern Greece who called themselves Achaean, hence the name.

Acheiropoietos

A statue endowed with religious significance in the belief that it has been created without human aid.

Acrolithes

Ancient Greek statues composed of wooden bodies to which stone limbs and heads were attached.

Acrylic Paint

A synthetic paint based on acrylic polymer resin. When dry it is water-resistant, flexible, stable, non-fading and non-yellowing. Acrylic can be thinned with linseed oil, turpentine, proprietary media or water and

mixed with glazing media. It dries more quickly than oil paint, although it can be used for all oil painting techniques, and can be applied in transparent washes like water-colour. Above all, it has great powers of adhesion and remarkable durability. Despite these advantages, it is disliked by some artists because it dries too fast without retarders for subtle reworking of delicate tonal areas, damages bristle and hair brushes, and is only available in artificial, chemical equivalents of certain pigments.

Action Painting

Paint is dripped, splashed, thrown or otherwise applied with expressive gestures to the picture surface in this variety of ABSTRACT EXPRESSIONISM. Jackson Pollock,

ACTION PAINTING. Yellow Islands *by Jackson Pollock. By the time he completed this picture in 1952, Pollock was cultivating a greater element of chance by more gestural application.*

the artist most commonly associated with the term, abandoned all formal preliminary sketches and studies to work in this manner in order to 'express my feelings rather than illustrate them'. The term was coined by the American critic, Harold Rosenberg, in the early 1950s.

A.D.A.G.P.

Association pour la Diffusion d'Art Graphique et Plastique. A French organization which administers copyright.

Adherence

A term which describes how well a paint film sticks to a surface. Adherence is a quality much looked for in paints, for without it deterioration can be rapid. The principal factors which contribute to good adherence are the glueyness of the paint; the type of surface to which it is applied; its elasticity and the degree to which it is impermeable.

Advancing Colour

Colour which seems to come forward towards the observer when contrasted with

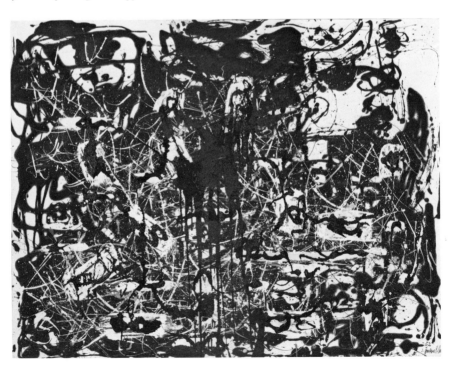

any colours already present in a picture. By this means, the artist is able to establish a sense of depth. In the simplest terms, warm colours (e.g., reds) come forward, while cold colours (e.g., blues) retreat.

Aerial Perspective

As the artist attempts to make his painting appear three-dimensional, he takes into account the way the atmosphere affects what he sees. The further away an object or scene is, the less detail and tonal contrast can be distinguished, and the bluer it appears. By repeating these effects on the canvas, he is able to create a sense of distance. Leonardo is said to have invented the term to distinguish depth established through tone and colour from that established form which is called linear perspective. Aerial perspective is also known as atmospheric or colour perspective.

Aerugo

Bright green rust which forms on bronze and other metals which contain copper after exposure to air or acid. The obsolete pigment Verdigris was made of this substance.

Aesthete

A person who claims a special sensitivity to beauty.

Aesthetic Movement

A FIN DE SIÈCLE English movement whose principal figures included Walter Pater, Oscar Wilde and Aubrey Beardsley. The movement's slogan was 'art for art's sake', implying that art was self-sufficient and required no social or religious justification. A logical extension of this philosophy gave rise to the belief that subject-matter was less important than purely aesthetic considerations. Therefore, as Wilde said, 'a well-painted turnip is better than a badly painted Madonna'. Owing to the vociferous nature of its chief adherents, the Aesthetic Movement provoked considerable controversy.

Aestheticism

The total commitment to the appreciation of art as an aesthetic rather than moral, social or any other kind of experience. See AESTHETIC MOVEMENT.

Aesthetics

A term deriving from the Greek *aisthetika*, or 'perceptibles', which is generally defined as the philosophy of taste and perceptible beauty. Although the concept of aesthetics was discussed by Shaftesbury and his contemporaries in England, the term itself was coined in Germany by Alexander Gottlieb Baumgarten in the mid-eighteenth century. Its application was originally restricted chiefly to the theory of taste. However, by the mid-nineteenth century its definition had expanded to encompass 'the Science of the Beautiful', and subsequently the term became associated with an affected dandyism which elevated the pursuit of sensations to a pitch of 'poetic passion' and which denied the importance of any motive but beauty in art. Today, however, the term aesthetics is used to refer not only to the fine arts but to all forms of beauty.

Affronté

Explains that the subject of a work of art is facing forward, towards the viewer, or as in Brancusi's work, *The Kiss*, that two subjects are face to face.

After . . .

Describes a work which is not original. The work may have been copied from the antique or from the style and subject of another, generally well-known, artist.

A.G.B.I.

Artists' General Benevolent Institution.

Agnus Dei

A symbolic representation which shows Christ as the Lamb of God, His head surrounded by a halo and carrying a cross and/or a flag. The subject of innumerable works of art, this image calls for the glorification of the Saviour (Lamb) through the redemption of the world.

Agreement

Proportional balance in a work of art.

Agrestic

Rough, unpolished metal, in sculpture.

A.I.A.
Academy of Irish Art; American Institute of Architecture.

A.I.C.A.
Association Internationale des Critiques d'Art.

A.I.G.A.
American Institute of Graphic Arts.

Airbrush
First developed and patented by the British artist Charles Burdick in 1893, the airbrush is a sophisticated spray gun used primarily by technical illustrators. A stream of air is compressed through the barrel of the gun and as it approaches the gun's mouth, the barrel widens so that the air expands, creating a partial vacuum. Paint, which is fed into the barrel from a reservoir, mixes with the air and is atomised. The result is an extremely smooth blend of tones and colours which is controlled *mechanically* by the gun rather than by the artist's hand. Two types of airbrush are manufactured, single and double action, and the difference between them lies in the way the air is controlled. In a single action brush the mixture is constant and the density of application can only be controlled by varying the distance between the nozzle and the surface of the work. In a double action brush there is an adjustable air and paint flow which makes it possible to control the mixture more accurately. When used by a professional, the airbrush can produce an effect as finished as a photograph and this quality makes it particularly suitable for commercial artists.

Albescent
Becoming white by degrees.

Alerion
Ornamental carving or heraldic device of a large bird, usually an eagle, with wings spread and without beak and feet.

Alhambraic
Adjective which describes decoration based on that of the Alhambra, the palace of the Moorish kings at Granada. The dominant features of the palace are glazed tiles and mosaics, the design of which are geometrical and brightly coloured, with details accented by gilding. Also known as Alhambresque.

Alizarin
See REDS.

Alkyd Paint
A new form of paint, derived from alkyd resin, introduced by Winsor & Newton Ltd. in 1970. It has similar properties to ACRYLIC PAINT but is faster drying and is primarily intended as a substitute for oil paint.

All'Antica
Used to describe works of art that imitate Greek or Roman works.

Alla Prima
A method of painting in which the paint, usually oil, is applied directly to the picture surface so that the finished appearance is produced in one application. Also known as Au Premier Coup.

Allegory
Subject-matter of a work of art which represents a wider moral or intellectual concept than the basic representation. This is normally accomplished by the use of symbols and often by classical allusions, particularly in Renaissance painting.

Altarpiece
A work of art, either painted or sculpted, which is positioned on, behind or above an altar and which is often made of hinged panels (see DIPTYCH, POLYPTYCH and TRIPTYCH). The subject is usually a well-known religious event, but may depict a sacred person or event specifically connected with the church in which it is located. Synonymous with REREDOS.

Alto-rilievo
The same as high RELIEF.

A.M.C.
Art Masters' Certificate.

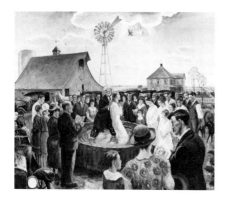

AMERICAN SCENE PAINTING. Baptism in Kansas *by John Steuart Curry. Curry popularized scenes from the daily life of Mid-Western America. This baptism by total immersion has the characteristic narrative element associated with the Regionalist aspect of American Scene Painting.*

American Scene Painting

A term used to describe the works of American artists active during the 1920s and 1930s who tried to achieve independence from European traditions and to adhere to the principles of NATURALISM, in defiance of contemporary tendencies towards ABSTRACTION. Sub-categories include Regionalism, a mid-Western movement led by artists such as Thomas Hart Benton and Grant Wood which presented local themes in a highly realistic manner, and SOCIAL REALISM, which developed in the works of Ben Shahn and Raphael Soyer and treated sociological issues such as poverty and racialism.

Amorino

The same as PUTTO.

Amphisbaena

A mythical monster, with a head at both ends of its body, which is found most frequently in classical sculpture.

Amphora

A two-handled Greek or Roman vessel, principally used for holding wine or oil, made of fired clay. Usually beautifully decorated, these containers often served to support important paintings.

A.M.T.C.

Art Masters' Teaching Certificate.

Amusement Art

A term used by writers in aesthetic philosophy to refer to art which aims to amuse or entertain, rather than have some symbolic or functional purpose, in order that emotion may be discharged in some make-believe or artificial situation—without affecting practical life.

A.N.A.

American National Academy or Associate of National Academy.

Anaglyph

An object which is sculpted in low relief or embossed. In photography, the term refers to a stereoscopic picture made of superimposed images printed in complementary colours.

Anaglyptography

An engraving which results in an embossed appearance, primarily used for representing coins or medals.

Analytical Cubism

See CUBISM.

Anamorphosis

A work painted or drawn in such a manner that from all but one vantage point it appears so distorted as to be unrecognizable. However, when viewed from the designated spot or through a curved mirror or other lens, it becomes immediately recognizable.

Anastatic Printing

A relief printing technique used for making copies of existing printed matter. The process involves exposing the subject to be copied to nitric acid and then pressing it on to a zinc plate. The acid bites into the plate where there has been no ink on the original, thus producing a relief plate which is inked and printed in the usual manner. See also RELIEF PROCESS.

Anatomy

The structure of the human body, prin-

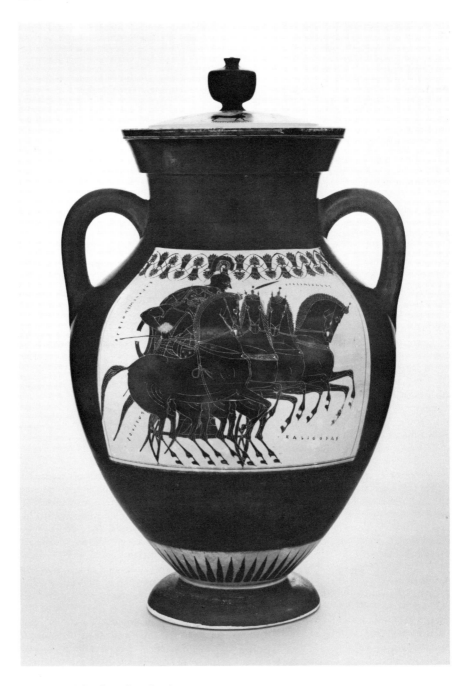

AMPHORA. *A Greek amphora from between 550 and 530 B.C. decorated with a painting of a charioteer.*

cipally the bones and muscles. A knowledge of anatomy is essential to the artist in conveying a natural appearance, balance and movement.

Anguine
Snake-like in form.

Animalise
To depict man in a manner that emphasizes his animal characteristics or makes particular parallels with specific animals. Often used humorously.

Animalism
The use of animal motifs for purely decorative puposes, as in illuminated manuscripts. Limbs may be elongated and intertwined to make an interlace, and the choice of animals is often drawn from the scriptures to represent allegorical vices and virtues.

Annular
Ring-like or composed of sections of rings. Such forms have appeared in designs through the ages.

Annunciation
A representation of the Archangel Gabriel visiting the Virgin Mary who is told that she will bear a son and name him Jesus. In addition to the symbol of purity and chastity generally associated with the Virgin (most commonly a lily), scenes of the Annunciation usually include a dove, representing the Holy Spirit, (in the form it took to descend to Christ at his baptism), descending from Heaven to the Virgin, and she is usually depicted reading from the scriptures or praying.

Anonimo
A term used in art history to mean any unknown Italian artist, but also frequently applied to two sixteenth-century writers on art, Anonimo Magliabechiano and Anonimo Morelliano.

Anti-Art
A term used to classify objects which intentionally or accidentally appear to reject all the traditional qualities of works of art, especially beauty. It was originally applied as a purely destructive and frivolous principle by the DADAISTS in order to mock conventional attitudes to works of art, Marcel Duchamp's READY-MADES providing a typical example.

Anticaglia
Fragments or remains of art objects of antiquity.

Anti-cerne
To leave a white line of bare canvas around some elements of a painting to divide areas of colour so as to set off different colours. This device was often employed by the FAUVIST painters.

Antique
Greek or Roman art up to the fifth century A.D. Synonymous with CLASSICAL. Antique works were greatly esteemed during the Renaissance at which time their study was incorporated in the curriculum of student artists, a practice which has continued in some institutions to the present day. The work has also become a general term for old pieces of furniture.

Antiquity
The CLASSICAL period of Greek and Roman history.

Applied Art
Originally used to describe decoration applied to practical, mechanically produced objects to make them more attractive. The concept was popularised in Britain at the time of the Industrial Revolution, but through the work of William Morris and the ARTS AND CRAFTS MOVEMENT the idea was changed to mean the application of artistic skills and tastes in the design of utilitarian and decorative objects.

Appliqué
Decoration made by cutting out designs from one piece of material, usually but not always cloth, and applying them to the surface of another.

Aqua-Fortis
An archaic name for nitric acid, the liquid

used by engravers to bite-in the designs on their metal plates.

Aquarelle
A French term for a painting composed entirely of transparent WATERCOLOUR washes, i.e. which no opaque medium is used. Prints or drawings coloured in this fashion may also be called aquarelles, and an artist who paints in this way is an aquarellist. In Britain watercolour pictures have traditionally been transparent and the term is little used.

Aquatint
An ETCHING technique so called because the finished print resembles a watercolour, and is a tonal rather than a linear work. An aquatint is made by covering a metal plate with special granular resin through which the acid filters to the metal plate. Sometimes, an artist will rub sand over the surface of a plate, which has been treated with an acid resistant ground in the normal way, to produce a grainy effect similar to that of the aquatint resin. To make the design on the plate, stopping-out varnish is painted over the resin, and the plate is immersed in acid. Tonal effects are achieved by repeated varnishing and immersing. It is usual for lines to be made on an aquatint by one of the usual etching processes before the tones are bitten-in.

A.R.A.
Associate of the ROYAL ACADEMY.

Arabesque
An interlacing, linear decoration, usually carved or painted on panels and composed of leaves, flowers, scrolls and, in Western art, animal and human forms.

A.R.C.A.
Associate of the Royal College of Art.

Archaic Art.
See GREEK ART.

Archaic Smile
The artificial smile on the faces of Greek statues of the pre-Classical or Archaic period. We know neither how it developed,

nor why. By the end of the 6th century B.C., it had been superseded by a more serious expression. See GREEK ART.

Architectonic
An architectural term which is used in art criticism to describe art which, like architecture, is constructed through the systematic combination of masses according to a predetermined plan, thereby imbuing the work with a sense of order and stability. In a philosophical context, architectonic means the breaking down, identifying and classifying of knowledge.

Argil
A whitish potter's clay.

Armature

Armature
A type of frame, often of metal wire, used by sculptors as a support for clay, wax, plaster and other modelling materials.

Armory Show
A famous exhibition, originally called the International Exhibition of Modern Art, organised by the Association of American Painters and Sculptors in 1913, which showed the American art world what was being accomplished in European (particularly French painting). It was a *succès de scandale* and included works by Paul Cézanne, Henri Matisse, Pablo Picasso, Marcel Duchamp, Wassily Kandinsky, Odilon Redon and Georges Braque. The Armory

Show is credited with immense influence in the development of twentieth-century American painting. Its name came from the 69th Regiment Armory in New York where the exhibition was held.

Arriccio

The first, smooth layer of plaster (applied over a rough layer) of a true or *buon* FRESCO, on which the cartoon is traced. Also known as *arricciato*.

Arris

A sharp ridge formed when two surfaces meet, a device commonly employed in sculpture.

Art Brut

The artist Jean Dubuffet invented this expression to describe the graffiti and crude pictures by mentally ill and small children which he collected and exhibited. Dubuffet's own work incorporates many images from this 'art in the raw'. His mistrust of the work of professional artists was set out in an essay for the catalogue of the first exhibition of Art Brut: *L'art brut préféré aux arts culturels*.

Art Deco

A style, which developed in reaction to ART NOUVEAU and was highly popular during the period 1910–35. Its name is an abbreviation of *L'Exposition Internationale des Arts Décoratifs et Industriels Modernes*, which was the first exhibition of Art Deco work, in Paris in 1925). Its principal characteristics are geometrical motifs and the use of industrial materials and images. Like Art Nouveau, Art Deco was primarily decorative, concentrating on architecture, textiles, wallpapers, the graphic arts and such utilitarian objects as clocks and lamps. Art Deco played an important role in popularising modern movements such as Cubism and Futurism by incorporating their images in its designs.

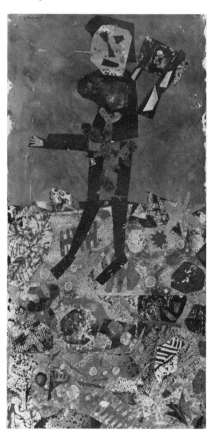

ART BRUT. *Man with a Hod by Jean Dubuffet. The artist used a wide variety of materials and techniques to capture the crude, direct imagery he found so vital in the work of children and the mentally disturbed.*

Artefact

Any work of art or craftsmanship, but most commonly used in the archaeological sense to mean those from prehistoric civilizations.

Art for art's sake

The catchphrase of the AESTHETIC MOVEMENT.

Artist's Donkey

A long stool which has an upright support for a drawing-board at one end, so that an artist can sit while he draws.

Art Informel, L'

The direction taken by ABSTRACT EXPRESSIONISM in Europe, closely allied to ACTION and GESTURAL painting in the United States. See also TACHISME.

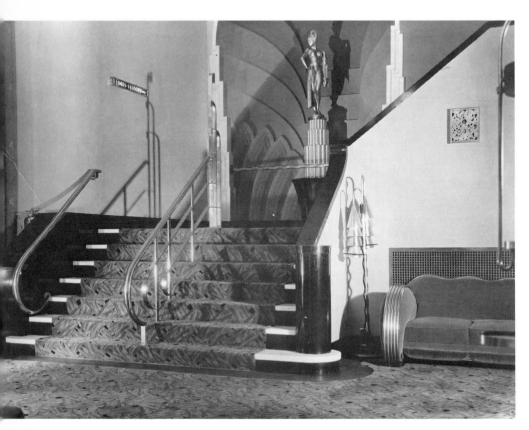

ART DECO *The foyer of the Earl Carroll Theatre, New York, designed and built by George Keister and J.J. Babolnay. The clean lines and geometrical shapes are typical of Art Deco.*

Artist's Proof

Prints added on to a LIMITED EDITION which are for the artist's own use or sale. Every artist's proof should be marked A/P and should not be numbered. In a large run, especially of prints not made by lithographic techniques, artist's proofs can acquire more value than the other prints in the run. Sometimes this is merely because the purchaser feels the print is more directly associated with the artist, but in a large run they may be of better quality as they will be pulled off before the plates have been worn down and so may appear fresher. Sometimes confused with TRIAL PROOF.

Art Mobilier

Works of art small enough to be moved.

Art Nouveau

A decorative style common in architecture, applied and graphic arts and fashion at the turn of the century. It grew out of William Morris's ARTS AND CRAFTS MOVEMENT, but not unaffected by the Decadents of the concurrent AESTHETIC MOVEMENT, Art Nouveau perpetuated Morris's ideal of a synthesis of all the arts (indeed, the symbolist writers inspired much of the imagery of Art Nouveau, particularly the exploration of the line), and the creation of an environment which integrated art and daily life, but the artists involved (including Gauguin, Redon, Bonnard, Vuillard, Munch and Toulouse-Lautrec) were caught up in the FIN DE SIÈCLE atmosphere, experimenting with mysticism, exalting in youth and all that was new.

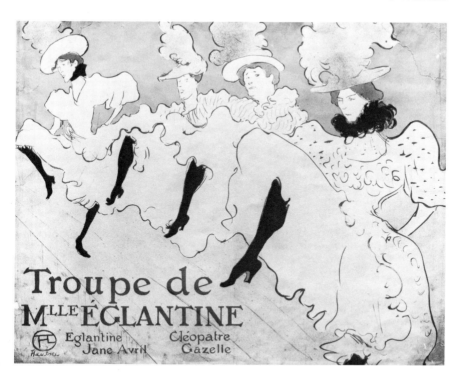

ART NOUVEAU. *A poster design for the 'Troupe de Mlle Eglantine' by Henri de Toulouse-Lautrec showing the sinuous decorative line associated with the Art Nouveau movement that swept Europe at the end of the nineteenth century.*

Although determined that their's was to be a new art, the Art Nouveau artists drew on the work of many previous artists and genres, including the Rococo, Gothic and Eastern arts. All of these sources were combined with a deep interest in nature, resulting in the incorporation of plant and water images specifically. The sinuous vine or tendril is the most commonly recognized Art Nouveau motif. The style was rapidly adopted throughout Europe and the United States. In Germany it was known as 'Jugendstil' after the Munich review *Die Jugend*, meaning 'youth'; the Italians called it 'Stile Liberty' after the London store whose fabrics were identified with the style, and before the name, Art Nouveau, was popularized by the English, the French called it the 'Style Modern'.

Art Therapy

Psychologists have come to recognize that through drawing, painting and other art activities, a person may be able to communicate ideas and fears which, perhaps because they are carefully protected in the subconscious, he would otherwise be unable to express. Art as a therapeutic resource may function in a variety of ways: providing information about the mental state of the patient for the therapist; provoking, perhaps through conversation and analysis, recognition of ideas the patient has expressed in the pictures, and/or allowing the patient to discharge emotions (a process known as catharsis) which might otherwise have been repressed or released in a destructive outburst. The physical act of applying paint can also help in this respect. See also ART BRUT.

Arts and Crafts Movement

'A work of utility might be a work of art, if we cared to make it so,' declared William Morris, the man whose vision combined the ideals of Carlyle, Pugin and Ruskin and who

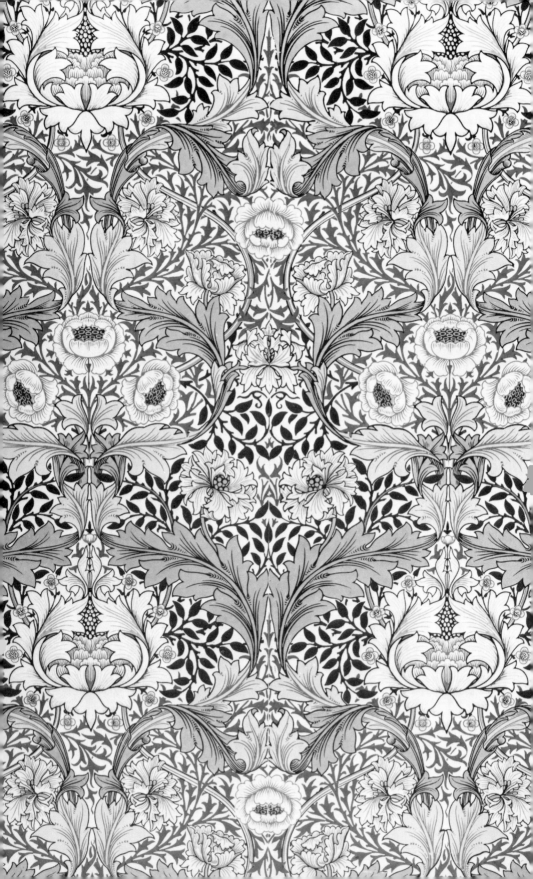

ARTS AND CRAFTS MOVEMENT. *Hand printed wallpaper by William Morris and Co.*

brought together the talents of Rossetti, Burne-Jones, Crane, Ford Madox Brown, Ashbee, Lethaby, Mackmurdo and others. Morris founded a movement which made British design pre-eminent for a while, and which can be dated from 1860, when he moved into the Red House and founded the firm of Morris and Co.

Morris and his associates saw industrialization as a threat to the essential quality of life, and though ultimately they had come to accept the machine age and to recognize the benefits which were possible through industrialization, they always believed that man, not machine or profit, was supremely important. Morris laboured for good conditions for workers and truthful designs, believing the two were connected as a man living in impoverished circumstances would, he felt, be unable to create things of beauty, or, as Ruskin put it: '. . . the circumstances with which you must surround your workmen are those simply of happy modern English life, because the designs you now have to ask for from your workmen are such as will make modern English life beautiful.'

The Arts and Crafts Movement resulted in a revival of the Guild system and centres of education, chiefly in design and the applied arts. Preparing the ground for ART NOUVEAU, the source of inspiration for its designs were natural forms; stylized plant motifs being central to its decorations. But decoration was not in itself a feature of the Arts and Crafts Movement, the artists were concerned with the material in which they were working and the purpose for which it was intended. Having familiarized themselves with both these aspects, the exploration of the decorative function of the medium was seen as a natural extension of their work.

Arts Council of Great Britain
A body founded in 1945 by King George VI with the aim of furthering the appreciation of, and education in, the fine arts. It is a government-funded organization which sponsors exhibitions and patronizes in-

dividual artists and art-organizations. Patronage usually takes the form of grants or purchases.

Artwork
Drawn or photographic material, often including type-matter, which has been designed for printing or other forms of commercial reproduction.

A.R.W.A.
Associate of the Royal West of England Academy.

Ascribed to . . .
Denotes that a work of art is of unknown origin but that experts believe it to be the work of a particular artist.

Ashcan School
See THE EIGHT.

Ashlar
Stone which has been squared up, and sometimes polished on one side; often used for facing buildings. The variety of masonry made of these stones is called ashlar masonry.

ASSEMBLAGE. *Instruction by Richard Stankiewicz. A sculpture made from scrap iron and steel.*

Assemblage
A work of art made by constructing or linking FOUND OBJECTS, rather than mounting them on a flat surface (in which case the work would be known as a COLLAGE).

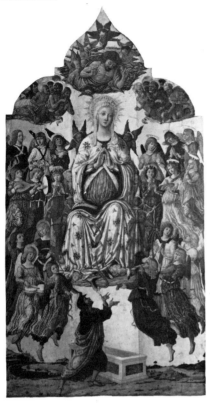

ASSUMPTION. The Assumption of the Virgin *(central panel from an altarpiece) by Matteo di Giovanni. Christ watches as angels raise the Virgin to Heaven. In the foreground, St. Thomas receives her girdle.*

Assumption

A representation of the transportation of the Virgin's soul to Heaven, three days after her death (see also DORMITION). Unlike Christ, she did not ascend of her own accord, but was carried to Heaven by angels. In addition, apostles and saints may be shown watching her journey.

Assyrian Art

The art of the Assyrian Empire, developed in Mesopotamia from *c.* 1500 B.C. to 612 B.C., when the capital at Nineveh was destroyed. The chief art form was the polychromed low-relief in stone, of which the subject-matter was restricted almost exclusively to scenes celebrating the king's prowess, particularly in battle and out hunting. These reliefs were conceived in narrative form, and must be read horizontally like cartoon strips. Although they depict the human figure stiffly, and nearly always in profile, animals are frequently portrayed with remarkable realism. Examples of free-standing Assyrian sculpture include human-headed lions and bulls which were positioned at city gateways to ward off evil spirits and to welcome the approaching monarch.

Asymmetrical

Describes a work that lacks balance between the volumes and proportions of its parts.

A.T.D.

Art Teachers' Diploma.

Atelier

A term derived from the French, but in general use, for an artist's studio or workshop.

Atelier Libre

A large studio which is made available to artists who pay a fee to go there to work. The fee includes the price of a model, but not tuition.

Atlantes

See CARYATID.

Atmospheric Perspective

See AERIAL PERSPECTIVE.

Attitude

The pose or posture of a model or other figure.

Attribute

Specifically, the symbol readily associated with a particular figure which enables the spectator to establish his or her identity in a work of art. Saints in Renaissance paintings are usually shown with one or more attributes, for example, St Jerome is accompanied by a lion and wears a cardinal's hat, St Peter holds a bunch of keys, and St George carries a lance and a shield marked with a red cross.

Attributed To . . .

States that the authorship of a work of art is in doubt, but that on documentary or stylistic grounds it can be assigned to a particular artist.

Attribution

The assignment of a work of art to a particular artist or school on the basis of documentary evidence and stylistic similarity to a work or works of known authorship.

Au Premier Coup

See ALLA PRIMA.

Aureole

The circle of light which surrounds the head or the body as a symbol of holiness, in representations of angels, saints and other sacred figures. When this circle appears around the head alone, it is a halo or nimbus, when around the whole body, it is known as a glory, MANDORLA or Vesica Piscis.

Aurigerous

Golden-coloured.

Auripetrum

A gold substitute made of tinfoil coated in saffron and varnished. This medium was much used in mediaeval mural paintings.

Auripigmentum

The original name for the yellow pigment orpiment.

Autograph

A work of art believed to be entirely by the hand of the artist to whom it is ascribed. See also ATTRIBUTION.

Auto-Lithograph

A lithographic print made by drawing directly on the stone or plate, i.e. without the use of photography.

Automatism

In psychology, this term means an action performed by the unconscious. The SURREALISTS adapted the concept to mean automatic drawing.

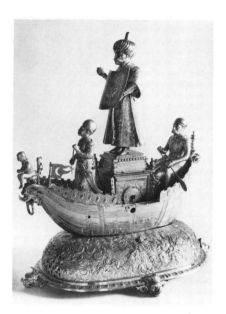

AUTOMATON. *Figure clock of a Turkish ship made in Augsburg at the end of the sixteenth century. When the hour strikes, the Turk standing on the ship raises his right arm. At the quarter hour, the ape sitting on the prow moves backwards and forwards and the standing oarsman's head turns.*

Automaton

An object with a hidden motor, clockwork mechanism or other source of power that allows it the appearance of spontaneous movement. Animal and human models, in particular, have always fascinated artists and their public. One of the most famous examples is the mechanical theatre at Hellbrunn Park near Salzburg which was made in the eighteenth century and has 113 moving figures.

Avant-garde

A term used about artists who are experimental, innovatory and otherwise ahead of the established art of the time.

A.W.G.

Art Workers' Guild.

A.W.S.

American Watercolour Society.

B

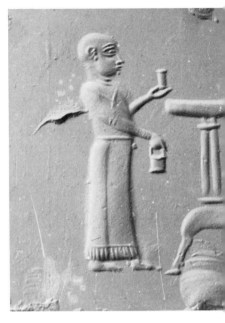

BABYLONIAN ART. (*Above*) *An impression from a Babylonian cylinder seal. A priest holding a bucket and a small drinking cup stands in front of an empty offering table and divine symbols on altar stands. The crescent refers to the moon god, Sin.*

B.A.A.T.
British Association of Art Therapists.

Babylonian Art
In the fertile valley between the Tigris and Euphrates rivers, known as Mesopotamia or Babylonia (after the capital city, Babylon), a civilization developed between 4,000 and 1,000 B.C. which was to influence and reflect the character of the surrounding area. Babylonia was rich in vital natural resources—food, water and climate—and so proved attractive to poorer but more aggressive nations. Each conquering nation left its impression on her art—indeed, artists were often treated like spoils of war and put into the conquerors' service. The first recorded invasion of Babylonia was by the Sumerians, and for at least a thousand years the two cultures are indistinguishable. By the middle of the second millennium B.C., Sumerian influences had died out, and Babylonian art began to be closely allied with that of nearby Assyria, with whom the Babylonians had to trade to obtain the stones, metals, woods and pigments necessary as materials for their artists and in which the region was barren.

Sculpture was perhaps the most important Babylonian art form. Freestanding sculpture was usually in the form of votive offerings for temples and appears in the form of highly stereotyped kneeling or standing figures, which became increasingly naturalistic through the centuries. Relief carvings generally related stories of victorious battles, royal or religious ceremonies, or hunting parties and were frequently painted in a variety of colours. Finally, gems, ivory and cylinder seals were carved with decorations and narratives with great intricacy and skill, particularly in the case of the seals on which the carving had to be so arranged that when the cylinder was rolled across soft clay the narrative unfolded without overlapping or distorting.

Few examples of Babylonian wall-painting survive owing to the perishable nature of the brick surfaces to which they were applied. However, it is known that TEMPERA wall painting was practised by the Babylonians as early as 3000 B.C., with figures representing similar scenes to relief sculpture and using the same stylistic conventions, in which limbs were depicted in profile and torsos from the front.

Bambocciata
A small painting of humble subject-matter, such as peasant scenes, popular in the Netherlands and Italy in the early seventeenth century. Named after Pieter van Laer, a leader of the SCHILDERSBENT, whose nickname was *Il Bamboccio* and who painted scenes of low-life in Rome.

Barbaric Art

The portable arts, principally comprising precious metalwork, of the nomadic barbarian peoples who filtered westwards into Europe from *c*. 150 B.C. to A.D. 500. They included the Visigoths (western Goths) who settled in Spain, the Ostrogoths (eastern Goths) in Italy, the Franks in Gaul, the Lombards in North Italy and the Anglo-Saxons in Britain.

Barbizon School

A group of French painters who congregated in the village of Barbizon in the Forest of Fontainebleau outside Paris, under the leadership of Théodore Rousseau. Members of the group included Charles-François Daubigny, Narcisse-Virgile Diaz and Constant Troyon and associated with them were Jean-Baptiste Camille Corot and Jean-François Millet. There was no Barbizon 'style', but all the artists were agreed on the need to treat landscape as a real and not a fanciful or romantic subject, a point of view strongly influenced by the work of John Constable. They were united in their opposition to the dicta of the established academies, and although they always pain-

BARBIZON SCHOOL. (*Below*) The Forest of Fontainebleau, Morning *by Théodore Rousseau, the leader of the school of painters based in the village of Barbizon in the Forest of Fontainebleau.*

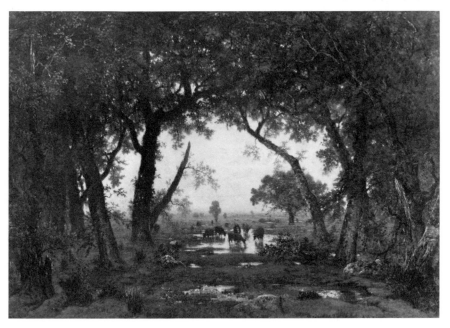

ted directly before the subject, they finished their work in the studio.

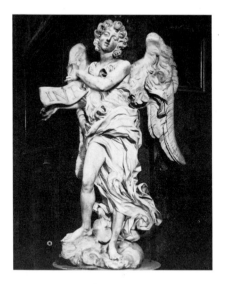

BAROQUE. BAROQUE. Angel *by Gianlorenzo Bernini.*

Baroque

A style which developed chiefly in Italy around 1580 and continued to influence artistic production in Western Europe for more than a century. Its naturalistic and classicizing tendencies have been interpreted as a reaction against the prevailing sixteenth-century Continental style, MANNERISM. Its original motivation, however, appears to have been the Counter-Reformation, by which the Roman Catholic Church (severely shaken by the appearance of Prot-estantism in the North) attempted to reassert its authority. Painters, sculptors and architects of the day, particularly in Italy, responded to this call by developing a theatrical and propagandistic style which attempted to capture the sympathy of the viewer through compelling effects of drama and grandeur. In this sense, Italian Baroque art, which was essentially religious, was incomplete without an audience. It frequently assumed the nature of a spectacle, combining painting, sculpture and architecture in a single work.

For convenience, the Italian Baroque is often divided into three phases. The Early Period (*c.* 1580–*c.* 1625) saw the appearance of Baroque principles in the work of painters such as Annibale Carracci and Domenichino, sculptors such as Francesco Mochi and architects such as Carlo Maderna. The Higher Baroque manner (*c.* 1625–*c.*1675) was confined almost exclusively to Rome, where it can be most clearly seen in the dynamic sculptures of Gianlorenzo Bernini and the audaciously innovative ecclesiastical architecture of Borromini and Rainaldi. The restless quality inherent in High Baroque art became the dominant characteristic of the Late Baroque phase (*c.* 1675–*c.* 1715). Indeed, examples such as Andrea Pozzo's S. Ignazio ceiling anticipated many aspects of the effusive ROCOCO style which followed.

Despite the fact that the Baroque style left its strongest mark on Italian art, it spread rapidly across Europe. However, outside Italy and Spain its principles were frequently applied with great success to purely secular works. Thus the sense of movement, the emphatic contrasts of light and dark, and the grandeur of the Baroque are also found in the art of Germany, Austria, France,

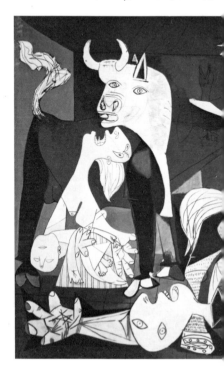

BATTLEPIECE. *Two different reactions to war. Top:* Niccolà Mauruzi da Tolentino at the Battle of San Romano *by Paolo Uccello. One of three paintings from the great hall of the Palazzo Medici-Ricciardi which were commissioned to celebrate Niccolà's glorious victory over* the Sienese at San Romano in 1432. Bottom: Guernica *by Pablo Picasso. An anguished and personal outburst against the bombing of the town of Guernica in 1937 during the Spanish Civil War.*

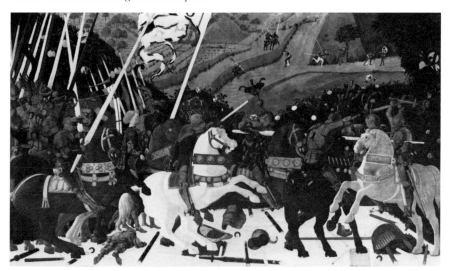

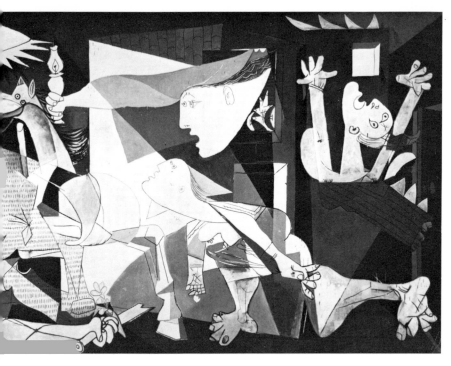

Scandinavia, the Netherlands and England and is typified by the works of artists such as Peter Paul Rubens and Diego Velazquez.

Bas-Relief
The same as LOW RELIEF.

BAT
The abbreviation for '*bon à tirer*', the French for 'good to pull'. Appears on one ORIGINAL PRINT in a LIMITED EDITION which is the print the artist or publisher has approved from the plate before the run is begun. Only one BAT print is made and it usually becomes the property of the printer or the editioning studio.

Batik
A RESIST technique for making designs on textile fabric. The areas not to be coloured are waxed and the fabric then immersed in dye. By using brushes, bamboo or a special copper crucible called a tjanting, it is possible to control the application of the wax and, with successive baths of different coloured dyes, to make intricate designs.

Battlepiece
Any scene of warfare, ranging from reliefs on ancient monuments to victory, for example Trajan's column in Rome, to protests against the iniquities of war, as in Pablo Picasso's *Guernica*.

Bauhaus, The
A famous school of architecture and design at Weimar in Germany founded by Walter Gropius in 1919. Among the many influential artists associated with the institution are Wassily Kandinsky, Paul Klee, Lyonel Feininger and László Moholy-Nagy. Influenced by William Morris's ideas and the ARTS AND CRAFTS MOVEMENT, Gropius combined ideals of craftsmanship and good design with mass production and the machine age. In 1925 the school moved to Dessau and subsequently to Berlin in 1932, where it was closed by the Nazis in 1933.

Beau Dieu, Le
A popular representation in Gothic art of Christ as a teacher.

Beauty
The random impact of experience on the five senses is ordered and related naturally by the human mind in the everyday process of perception. When this mental activity is devoted to an object in nature, not for practical purposes but as a form of contemplation, the mental impression can be enjoyable or disagreeable. If particularly enjoyable, then it can be said that the object possesses natural beauty, if it seems disagreeable, then it may be described as ugly. A work of art that produces an agreeable mental impression, however, is described as possessing aesthetic beauty. This is a result of the satisfaction the mind derives from contemplating any image that has been organized and ordered into a unified whole. This the artist achieves by the combination of such elements as shape, proportion, tint, key, tone and numerous other attributes of his technique. Aesthetic beauty, therefore, differs from natural beauty in that the object represented in a work of art need not be beautiful itself.

Beaux Arts, Les
See ÉCOLE DES BEAUX ARTS.

Before All Letters
In printmaking, a proof of the main subject of the print before any type-matter has been added. These prints are not common, which makes them more valuable to collectors than other types of proof. See also LIMITED EDITION.

Bentname
See SCHILDERSBENT.

Bentveughels
See SCHILDERSBENT.

Bevel
A tool used in stone and wood carving to off-set angles. Bevelled edges are often seen on MOUNTS and some manufacturers of mount-boards emphasize these edges with contrasting colours. See also FRAMING.

Bibelot
An artistic trinket.

Biedermeier

A style of German and Austrian art and architecture from *c.* 1815–50, characterized by sobriety, solidity and bourgeois values. The word derives from the name of a fictional character, Gottlieb Bierdermeier, who was the epitome of middle-class philistinism.

B.I.I.A.

British Institute of Industrial Art.

B.I.I.D.

British Institute of Interior Design.

Binder

The substance mixed with pigment to make paint adhere to a surface: oil for oil paints, gum arabic for watercolour, etc. Sometimes wrongly called binding.

Biomorphic Art

A branch of ABSTRACT ART which draws the inspiration for its shapes from living organisms. Biomorphic forms are found typically in the works of Yves Tanguy, Joan Miró, and Jean Arp.

Birdsmouth

A shape of wood moulding useful to picture-frame makers.

Biscuit

Porcelain or plain pottery which has not been glazed. Also known as bisque.

Bishop's Length

Portrait canvases in either whole (106 × 70ins) or half (56 × 44ins) sizes.

Bisque

See BISCUIT.

Bistre

A brown pigment made from soot which was in common use in the seventeenth century and used with both pens and brushes.

BIOMORPHIC. Human Concretion *by Jean Arp.*

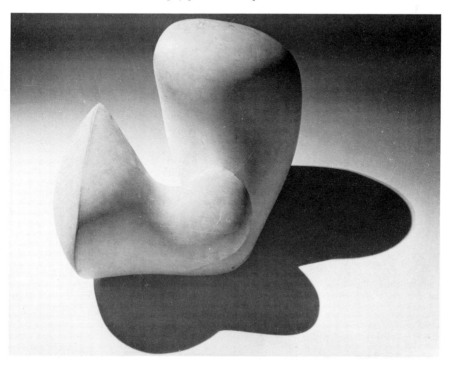

Biting-in

A term used in ETCHING for the exposure of metal plate to acid.

Bitumen

A deep-brown pigment (made of and sometimes called asphaltum) which was used extensively in oil painting until this century. We have learned from the disastrous effects on many canvases that bitumen never dries completely. It has caused cracking and blackening in numerous pictures, of which notable examples are found in the works of Joshua Reynolds and the American Luminist Movement.

Black

Black consists of a mixture of equal parts of pigments of the three primary colours, and the seeming paradox arises that in this regard at least, black is white and vice-versa.

BLACK–FIGURE VASE PAINTING. *Vase paintings are almost the only surviving examples of classical Greek painting. Here we see Achilles and Ajax (identifiable through the names written above each figure) playing a game. All the detail on their faces and armour has been created by scratching through the glaze to allow the natural colour of the clay to show through.*

The only difference being that when all three are absorbed we see black and when all are emitted we see white. It has to be remembered that in nature there are no colours—only wave lengths—and that what we see as colours are really mental reactions. Black and white, are not usually termed colours. The painter, however, is able to buy black 'colour' in paint form. Those commonly available from the artists' colourmen include: Black; Blue Black; Ivory Black; Lamp Black and Mars Black. See also COLOUR and COLOURED GREY.

Black-Figure Vase Painting

A method of applying designs on pottery used by the ancient Greeks. It entailed the application of black glaze directly on to natural clay rather than over a first coat of glaze; additional ornamentation was then cut into the black areas. The style emerged in Corinth *c.* 700 B.C. and was perfected by the Athenians during the sixth century B.C.

Blaue Reiter, Der

Der Blaue Reiter (meaning The Blue Rider) was a group of Munich-based Expressionist artists formed by Wassily Kandinsky and Franz Marc. Heinrich Campendonk, August Macke and, later, Paul Klee were also members of the loosely organized

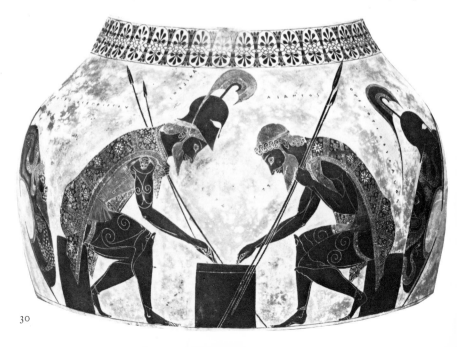

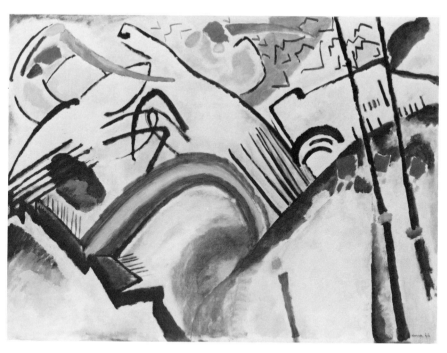

DER BLAUE REITER. Cossacks *by Wassily Kandinsky. Painted during 1910 and 1911, the dynamic arrangement of colour and line combined with simplification of figures show clearly Kandinsky's movement towards abstraction at the time of the formation of Der Blaue Reiter.*

association which was dispersed by the First World War. They held exhibitions in 1911, 1912 and 1913, and included works by a number of prominent guests, among whom were Pablo Picasso, Georges Braque, Kasimir Malevich, Maurice de Vlaminck, André Derain and Robert Delaunay. The group also published a year book called *Der Blaue Reiter Almanac*, which contains articles on their aims, artistic philosophies and on different aspects of contemporary art. Broadly, the aim of the group was to revive an interest in the spiritual values of art.

Blaue Vier

Literally, the Blue Four, a group formed by Alexej Jawlensky with Wassily Kandinsky, Paul Klee and Lyonel Feininger (hence the name), ostensibly in memory of DER BLAUE REITER but primarily to promote their works. Exhibitions were held in Germany (1922), Mexico and the U.S.A. (1924).

Bleed

(1) To allow a wash of watercolour or other thin medium to run into and combine with another area of colour. (2) To make ARTWORK, to be reproduced by printing, larger than the final page size so that, when the page is trimmed, there is no margin.

Bleeding Through

As oil paints age, they sink into the GROUND and become transparent; this process may result in any layers of paint below the surface showing or 'bleeding' through. See also PENTIMENTO.

Block Book

A variety of illustrated book, popular in fifteenth-century Europe, made of pages printed from wooden blocks on which both letters and illustrations were carved in relief.

Block Printing

A method of printing with carved blocks of

wood, metal or linoleum, in which separate blocks must be used for individual colours.

Bloom

An oil painting which has been improperly varnished or stored may develop a 'bloom' or film on the surface. This first appears as an opaque blue tinge, which turns white, yellow and eventually black as the condition (sometimes known as a 'chill') advances.

Blot Drawing

Leonardo da Vinci recorded an interest in the random shapes created by blobs of ink or paint, but the first artist to explore them in

BLOT DRAWING. (*Left*) *Detail from* Landscape with a Dark Hill *by Alexander Cozens. An ink blot reworked to make a landscape and illustrated in Cozens's book,* New Method of Assisting the Invention in Drawing Original Compositions of Landscape *(1785).*

BODEGON. (*Below*) Old Woman Cooking Eggs *by Diego Velazquez. Executed in 1618, when the artist was only nineteen years of age, this painting is one of a series of kitchen scenes in which the same two peasants and the same assortment of utensils appear.*

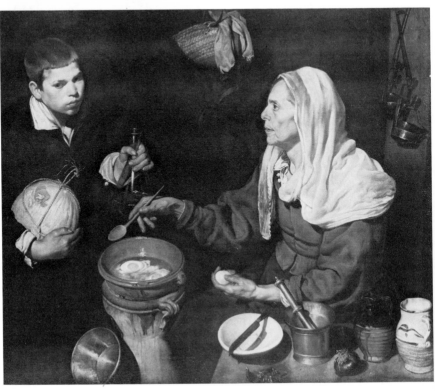

any great detail was the English water-colour artist, Alexander Cozens, in the 1770s and 1780s. Used in this century predominantly by the SURREALISTS, blot drawing has become closely linked with psychiatry.

Blue
One of the painter's three PRIMARY colours. Those blue paints commonly available from the artists' colourmen are: Antwerp Blue; Cerulean Blue; Cobalt Blue; Cobalt Blue Deep; Cobalt Turquoise; Coeruleum; French Ultramarine; Indigo; Manganese; Monestial Blue; New Blue; Permanent Blue; Phthalo Blue; Prussian Blue; Rowney Indanthrene Blue; Ultramarine and Winsor Blue.

Boast
To make the basic shape of a stone statue, before it is carved into its final form.

Bodegon
A kitchen scene in Spanish painting which has as its focus a still-life of food.

Body Art
See PERFORMANCE ART.

Body Colour
See GOUACHE.

Bohemian
1. Art produced in Bohemia during the late fourteenth century when, under the enthusiastic patronage of Charles IV, it was the artistic capital of Europe. 2. An adjective used to describe the life-styles of artists and poets with connotations of relaxed moral standards.

Bolus Ground
A ground for oil painting made of reddish-brown clay; now out of favour because of its tendency to retain moisture and so eventually to show through the paint. Also known as bole, this material can be used in the water-GILDING process.

Bone China
PORCELAIN made with bone ash to a formula developed in England in the last century by Josiah Spode, which gives a translucent, easily decorated material.

Bottega
The section of an old master's studio which was used by his students or apprentices.

Boucharde
A textured mallet used by sculptors to shape stone.

Bozzetto
See MAQUETTE.

B.P.D.
British Society for Poster Designers.

Braze
To solder together metal sections using a compound which has a very high melting point; a method useful in sculpture.

Broad Manner
The effect of combinations of thick lines in Italian Renaissance engravings, giving a bold effect. Thin lines, which gave a more delicate and tonally graded result, were known as the 'fine manner'.

Brown
The combination of all three PRIMARY COLOURS in unequal proportions, dominated by red. Brown paints readily available from the artists' colourmen are: Brown Madder; Brown Ochre; Brown Pink; Burnt Sienna; Burnt Umber; Madder Brown; Mars Brown; Raw Sienna; Raw Umber; Rowney Transparent Brown; Sepia and Vandyke Brown.

Brücke, Die
A group of German Expressionist painters formed in Dresden in 1905. The name means 'bridge' in German, and the group's intention was to make a bridge between the popular art of the day and the modern movement then developing. The leading members of Die Brücke were Ludwig Kirchner, Karl Schmidt-Rottluff, Emil Nolde, Max Pechstein and Otto Müller. These artists, none of whom were formally trained, worked in strong colours, pronounced outlines, and were influenced by

FAUVISM and POST-IMPRESSIONISM. Their work was particularly successful in the graphic arts. Die Brücke broke up in 1913, but was one of the most important art movements of its day and linked to the BLAUE REITER who developed a more abstract approach.

Brush Case

A cylindrical holder for storing or transporting paint brushes.

BRUSH DRAWING. Hands of an Apostle *by Albrecht Dürer. This brush drawing, which has been heightened with white, is one of a series of carefully executed individual studies from which the artist constructed his masterful altarpiece showing the Assumption of the Virgin. While only a copy of the altarpiece is now in existence, several of the studies have survived.*

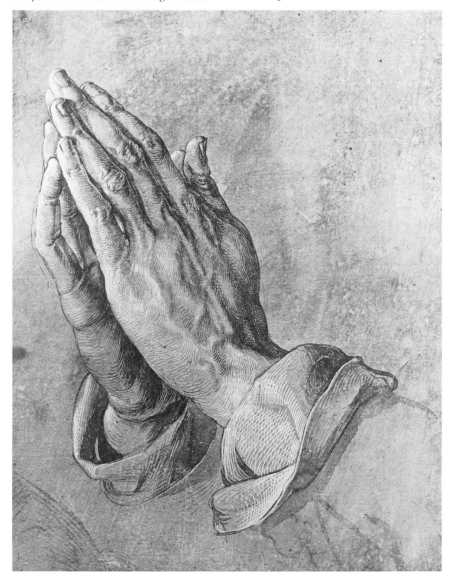

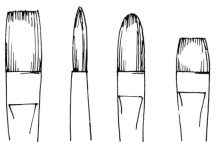

Flat, round, filbert and bright brushes for oil painting.

Brush Drawing

The application of ink with a finely pointed brush; this method gives an effect of great spontaneity and is particularly associated with CALLIGRAPHY and Chinese and Japanese art.

Brushes

The brush is the artist's principal tool for applying paints to a SUPPORT. The best shape and quality for every task has been determined over the centuries. Brushes for oil painting come in four main shapes: flat, round, filbert and bright, and most good-quality brushes are still hand-made. The shape is made, not by cutting the tips of the hairs, but by trimming from the root, bunching the hairs together and compressing them at the base in a quill or ferrule. Each hair's shape, strength and spring contributes to the finished shape and character of the brush. All the materials are carefully selected and graded to make appropriate brushes for different media and techniques. Most animal hairs have been put to use in the artist's brush at one time or another, but those which have proved most useful are:

Red sable: used in the best-quality brushes for both oil and watercolour painting. The finest sable is Kolinsky, though it is both rare and expensive.

Weasel hair: the most common substitute for sable.

Ox(Ear) hair: a coarse hair which does not point well and is used for work which requires little manipulation, such as lettering.

Squirrel hair: generally known as camel hair, it is too soft to offer much control, and

is used for applying broad watercolour washes.

Pig, Hog or Boar bristles: stiff, strong fibres principally used in oil painting.

Synthetic materials are being used with increasing success to simulate the qualities of each fibre. Brushes are sold according to shape, material and width; most ranges having approximately fourteen sizes from the smallest (000) to the largest (14). After use, a brush should be cleaned, repointed and left in an upright—that is, balanced on the wooden handle—position to dry.

Brushing Out

Using an AIRBRUSH to 'touch up' or remove unwanted material from a photograph or piece of ARTWORK.

Brushwork

Any manner a painter uses his brush to apply paint, for example long thick strokes, short stabs, or delicate swirls. A painter's brushwork is as distinctive as handwriting, a fact which is useful in ATTRIBUTION.

Buon Fresco

See FRESCO.

Burin

Burin

The most important engraving tool; made of a small, metal rod with a pointed, triangular head, which scoops out the wood or metal, resulting in a BURR.

Burnisher

A curved steel instrument used by engravers to polish or reduce edges on metal plates, as required, to give the desired result.

Burr

Burr
The metal ridge formed when an engraver uses a BURIN to make a cut on his block or plate. See DRY POINT and LINE ENGRAVING.

Bust
A portrait sculpture which shows only the upper part of the body; usually the head and shoulders.

B.W.S.
British Watercolour Society.

Byzantine Art
A term generally used to refer to the art and civilization of the Eastern Roman Empire, centred in Constantinople (formerly called Byzantium). The Byzantine period began in A.D. 330, when Constantinople became the eastern capital of the Empire, and continued until the mid-fifteenth century, when the city was conquered by the Turks.

Early Byzantine art was mainly religious, and in many cases gave public expression for the first time to Christian doctrines which had previously been suppressed. Examples from the early period are essentially CLASSICAL in character. However, this classicism had faded considerably by the sixth century, when the Byzantine style enjoyed its first 'Golden Age' under Justinian. The art of this period drew heavily upon eastern influences and was chiefly concerned with the glorification of the Empire. This tendency towards secularization was strengthened by the Iconoclastic Controversy (see ICONOCLAST) of the eighth and ninth centuries, which prohibited the depiction of the human figure in religious art. The subsequent phase, commonly referred to as the 'Macedonian Renaissance', was characterized by a renewed interest in the antique and an increasing vogue for Islamic motifs.

The Byzantine style manifested itself chiefly in mosaics, frescoes and relief sculpture. Its subject-matter was generally restricted to events from the history of Christianity, scenes from imperial life, and stylized motifs from nature. Byzantine architecture constituted a merging of HELLENISTIC and Oriental elements with the traditional classical forms as in the celebrated church of Sta. Sophia in Constantinople.

Cabinet Picture
See EASEL PICTURE.

Calcography
The art of drawing with chalks.

Calendered Paper
See PAPER.

Calligraphy
The art of fine handwriting. The term is sometimes extended to refer to the way an artist applies his medium, especially in watercolour painting. This derives from oriental art, in which there is little distinction between painting and handwriting techniques.

Camera Lucida
A copying instrument similar to the CAMERA OBSCURA but employing an adjustable prism like a telescope, to give an image which can be reduced to any size.

Camera Obscura
A box, tent or small room with a peephole through which an external object is reflected by a mirror on to a surface, where it can then be enlarged, reduced or copied. As an apparatus for drawing, it was probably first devised by Leon Battista Alberti, but the principle dates back to Aristotle. Camera obscura were much used by topographical artists in the eighteenth century.

Camden Town Group
The small group of artists dominated by Walter Sickert, Harold Gilman and Spencer Gore, who broke away from the N.E.A.C. in 1911. Greatly influenced by POST-IMPRESSIONISM, and especially the work of Vincent Van Gogh and Paul Gauguin, these artists spent the next three years portraying

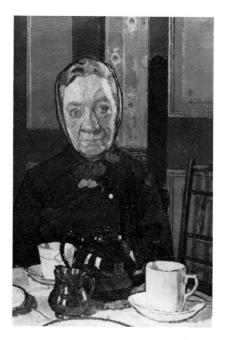

CAMDEN TOWN GROUP. Mrs. Mounter at Breakfast *by Harold Gilman. The tactile quality of the painted surface, the directness of representation and the heightened use of colour show the extent of Van Gogh's influence on Gilman during his time as a member of the Camden Town Group.*

CALLIGRAPHY. Good Works and Good Speeds *by Murase Taiitsu. The figure and table would have been drawn with the brush that was used for the characters.*

the part of London in which they lived, Camden Town. The other artists in the group were Lucien Pissarro, Augustus John, Henry Lamb and Charles Ginner.

Canopus
A type of ancient Egyptian, lidded vase which was carved in the shape of a deity and used to carry the remains (heart, lungs and other organs) of an embalmed body.

Canvas
The support which, since its adoption in the fifteenth century, has come to be the most popular with oil painters. Artist's canvas is made from a variety of heavy fabrics, the best being good-quality linen, followed by cotton, hemp and jute. All these materials must be STRETCHED over a frame and PRIMED before they are suitable for use; many artists prefer to buy 'pre-stretched' or prepared canvases from the artists' colourmen or specialist manufacturers, though if a canvas of a specific size or shape is required it will have to be made specially. As a working surface, canvas is very congenial to most painters, as it offers both good texture and

flexibility. Unfortunately, canvas is particularly susceptible to the attacks of age and atmosphere.

Canvas Board
CARDBOARD or PASTEBOARD to which a surface of PRIMED and SIZED canvas has been applied. An inexpensive and portable working surface, but one which is not recommended for works which are intended to endure as it tends to be made from inferior materials.

Canvas pins

Canvas Pins
Pins designed to keep wet canvases separate when carried together.

Canvas pliers

Canvas Pliers
Pliers designed to aid the stretching of canvas on a wooden stretcher.

Capriccio
Any fanciful painting or drawing. Most frequently used of eighteenth-century Italian paintings which combined views of buildings from different places in one composition. Such pictures were frequently bought by travellers on the GRAND TOUR and are encountered in the work of Giovanni Paolo Panini and Canaletto.

Caprice
A fanciful work of art. See also CAPRICCIO.

Caravaggisti
Seventeenth-century painters influenced by

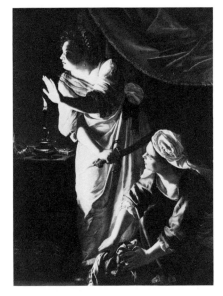

CARAVAGGISTI. Judith and her Maidservant with the Head of Holofernes *by Artemisia Gentilischi. The concentration on the contrast between light and dark effects was typical of the followers of Caravaggio.*

the use of chiaroscuro and dramatic realism in the work of Caravaggio.

Cardboard
A rigid surface made up of layers of paper pasted together. The top sheet is usually of better quality paper than those below, but it often deteriorates from the acidic action of the paper below.

Caricature
A portrait that offers an exaggerated, ludicrous and frequently satirical view of its subject. Probably first developed by the Carracci Circle in sixteenth-century Rome, caricature has been used by many notable artists, and some of the finest examples are to be found in the work of Gianlorenzo Bernini, William Hogarth, Goya and Honoré Daumier. Its most common function today is as social and political commentary in journalism.

Carolingian Art
The art produced during the eighth and

ninth centuries in Europe, beginning with the reign of Charlemagne and ending with that of Louis the Pious: a period sometimes known as the Carolingian Renaissance because of its enthusiastic interest in the culture of ancient Rome. Unlike the artists of the period we now call the RENAISSANCE, however, Carolingian artists tended to study and draw inspiration from the works of antiquity but not to copy them outright or consciously to model themselves on their knowledge of the ancient world.

Architecture, book illustration and je-welled metal-work are the principal surviv-ing forms of Carolingian art.

Carpet Page

A page of abstract design and holy ciphers adjoining the Evangelists portrait at the start of each of the Four Gospels in an illuminated manuscript of the Irish-Northumbrian school of the eighth and ninth centuries.

Cartellino

A realistically painted card, scroll or similar

device usually used to display a motto, or the artist's signature.

Cartoon

The popular meaning of this term is a humorous drawing, often with a caption in a newspaper or magazine. The true cartoon, however, has a long and distinguished history. It was an exact, full-size drawing for a painting, tapestry or fresco and is particularly encountered in the Re-naissance. It was normally transferred by one of the following methods: either by pricking the design with a needle or ROULETTE and rubbing powdered pigment through the holes to leave an outline of the design; or by rubbing the back of the cartoon with chalk and tracing the design; or by SQUAR-ING UP the cartoon and copying the design

CARTOON. Miraculous Draught of Fishes *by Raphael. One of a series of cartoons for tapestries which, if completed, would have been hung in the Sistine Chapel.*

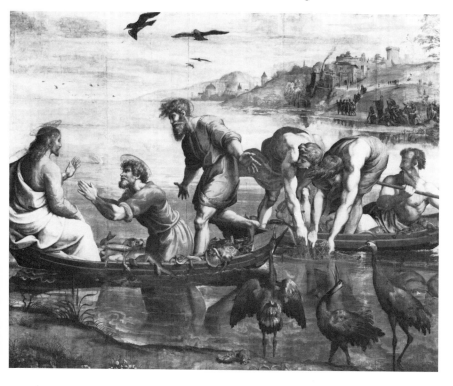

on to a surface prepared with a similarly-sized grid. Today artists tend to use cartoons for working out problems in specific sections of a work, and though they are usually full-size and may be quite detailed, they are rarely used as the exact basis for a work.

Cartouche

1. An ornament in the shape of a scroll used to hold an inscription. 2. A decorative frame for displaying an inscription. 3. An oval drawn around the name and title of a king in Egyptian inscriptions.

Cartridge Paper

See PAPER.

Caryatid

A statue, particularly associated with Greek architecture, of a woman used with others as pillars supporting buildings; the male counterparts are known at Atlantes.

Casein Paint

Pigments mixed with a casein BINDER, i.e., one made from milk proteins extracted from curd. Casein is an excellent adhesive on its own, but, when used as a binder, causes paint to be too brittle for use on canvas. This characteristic aside, casein paints have an agreeable consistency, are quick drying and their matt surface is durable enough to be left unprotected though, if a gloss finish is required, varnish can be applied in the usual way.

Casting

A process used by sculptors to duplicate work. A clay or wax model is coated with plaster to make a mould into which plaster or molten metal is poured. Casting is normally associated with hollow bronze sculpture. See also LOST-WAX.

Catacomb Art

The symbolical religious wall-paintings found in some early Christian burial chambers in Rome.

Catalogue

A basic list of works of art which provides information such as title, artist, medium, size and owner, gallery or collection of the works in an exhibition.

Catalogue Raisonné

A complete, annotated CATALOGUE of the works of a particular artist. It provides details, in particular, of the present condition, and PROVENANCE of each work.

Cave Art

The Stone Age paintings, drawings and carvings first identified in Altamira, Spain in 1879 and now known to have been executed in several suitable caves in the Pyrennees in Spain and France, the best-known being the paintings at Lascaux. Why the works were done is not known, although as they feature animals which would have been important for food and clothing, it is believed they may have had some magical significance. The works tended to be drawn or painted in charcoal or naturally coloured earths mixed with fat, and, despite some peculiarities of portrayal—combining frontal and profile views, for example—are recognizable animals and show vivid observation by skilled hunters.

Cavo-Rilievo

See INTAGLIO.

Celtic Art

The art produced in France and Britain between the fifth and first centuries B.C. Essentially decorative, it is considered superior to other BARBARIC ART as in its later forms it made use of motifs from classical Roman art. Most surviving examples are in the form of decorated weapons, musical instruments, wood carvings, pottery or jewellery.

Ceramics

All objects made of fired clay, including EARTHENWARE, PORCELAIN, STONEWARE and TERRA COTTA.

Cerography

The same as ENCAUSTIC PAINTING.

Ceroplastics

Wax modelling, often used for making casts from the human figure, especially death masks.

Cert. R.A.S.
Certificate of the Royal Academy Schools.

Cerulean
See BLUE.

Ceruse
A white, lead-based paint.

Chalcography
The art of engraving on copper.

Chalk
A soft limestone which can be used as a drawing material in its own right, employed as an INERT PIGMENT, or mixed with PIGMENTS and a gum BINDER to make pastels or other crayons.

Chamfer
To cut an even sloping or bevelled edge; used in framemaking.

Champlevé Enamel
An ancient method of decorating metal, usually copper, by drawing the design on the surface and hollowing out the areas to be coloured which are then filled with enamel powders. When fired, the metal forms an irregular outline, defining the design and separating areas of colour, rather like stained glass. The distinctive feature of champlevé is the irregularity of the metal outline dividing the areas of colour.

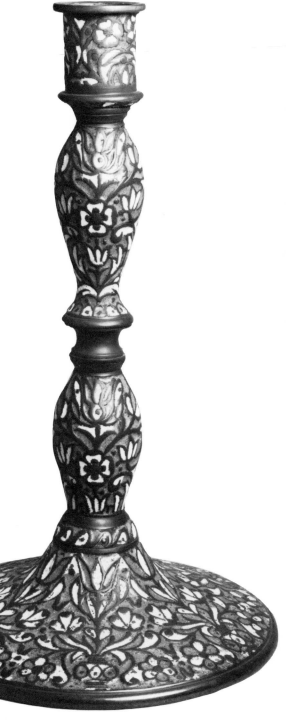

CHAMPLEVÉ ENAMEL. *One of a pair of English seventeenth-century candlesticks decorated with champlevé enamel in blue and white on a green ground. Note the irregularity and the thickness of the metal outlines.*

Charcoal

A soft drawing material made of charred wood, usually willow or vine twigs. Charcoal can be purchased in sticks of varying widths and degrees of hardness, also in wooden or paper wrappings to keep the fingers clean while drawing.

Chasing

A method of decorating metal objects with INTAGLIO designs or simply indentations. The designs are produced by hammering from the front rather than by punching from behind. See also REPOUSSÉ.

Chiaroscuro

In Italian, *chiaro* literally means light and *oscuro* means dark. Chiaroscuro, therefore, is the use of light and shade in a drawing or painting, particularly works in which the light and dark contrasts are very pronounced.

Chinese White

See WHITE.

Chinoiserie

European style in the arts and crafts which freely adapted motifs and techniques from Chinese art. The style first gained prominence in the sixteenth and seventeenth centuries, as a result of the expansion of trade with the Orient through the East India Companies, and its initial impact was on the decorative arts. However, during the eighteenth century Chinese motifs were taken up by several prominent painters, including Jean-Antoine Watteau and François Boucher, and subsequently became associated with the ROCOCO manner. In England the style was liberally applied to garden and furniture design, and it remained an important influence on English architecture as late as the early nineteenth century.

Chipboard

The poorest grade of CARDBOARD, made from recycled or waste paper. The heavier grades, used in furniture making, are made from wood chippings.

Chroma

A joint term for the hue and saturation but not the brightness or tone of colour. See also COLOUR.

C.I.A.D.

Central Institute for Art and Design.

C.I.C.

Certificate in Industrial Ceramics.

C.I.H.A.

Comité Internationale de l'Histoire de l'Art.

Cinnabar

See RED.

Cinquecento

The sixteenth century especially in Italian culture.

Cipher

In works of art, interlaced letters or initials, often a monogram.

Cire Perdue

See LOST WAX.

Citrine

See YELLOW.

Clair-Obscure

The French for CHIAROSCURO.

Classic

Modelled on Greek and Roman antiquity, the culture of which was held in such esteem in Renaissance Italy that anything CLASSICAL was considered a worthy model. Today, the term is used colloquially to refer to an object that is a worthy model.

Classical

Belonging to Greek and Roman antiquity.

Classicism

Adhering to the styles and principles of Greek and Roman antiquity.

Claude Glass

A device used to reduce and simplify views of landscapes. By reflecting the scene through a dark, convex lens, the Claude glass reduces colours to tones alone, and in the process, definition is lost. Claude Lor-

CLASSICISM. Laocoön *by Baccio Bandinelli. A Renaissance copy of the original Hellenistic statue, showing the strangulation of the Trojan Priest, Laocoön, and his sons by two serpents. Bandinelli's faithful reproduction of the original piece is a typical example of the intense interest that Renaissance artists and patrons displayed for classical art.*

rain is said to have employed such an instrument, hence the name. See also DIMINISHING GLASS.

Cloisonné Enamel

A method of decorating metal, and occasionally porcelain, in which the areas of colour are separated by the addition of

CLOISONNÉ ENAMEL. *A French nineteenth century coffee pot decorated with cloisonné enamel. Note the evenness of the metal bands and the delicacy of the floral motif immediately below the lid.*

flattened wire or metal strips. The areas between the metal are filled with ENAMEL powders and fired. The distinctive feature of cloissonné is the evenness of the metal dividing the areas of colour.

Cloisonnisme

A style of painting primarily developed by Emile Bernard; whose *Yellow Christ* of 1886 was the first major work executed in this manner. Paul Gauguin painted a more famous work of the same title and in the same style in 1889. The broad areas of colour, frequently divided by grey bands, in the paintings in this style have a resemblance to cloisonné enamel, hence the name.

Closed Form

A sculptural term describing the form of works, such as Constantin Brancusi's *The Kiss* or Greek CHORAE, which reflect the solid mass of the original block and does not make use of surrounding space.

Cobalt

See BLUE.

Cognoscenti

Those who have special knowledge of any subject, but particularly the arts. See also CONNOISSEUR.

C.O.I.D.

Council of Industrial Design.

Cold Colour

Any of the colours in the range from blue to green which, when applied to a surface and contrasted with other colours, appears to retreat, giving an impression of depth. See WARM COLOURS and AERIAL PERSPECTIVE.

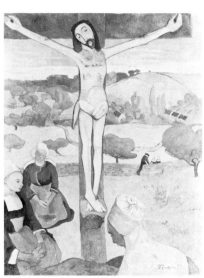

CLOISONNISME. Yellow Christ *by Paul Gauguin. Note the artist's use of areas of flat, unblended colour and pronounced dark outlines.*

Coll.

Abbreviation for 'Collection of'. See PRO-
VENANCE.

Collage

Commonly used to mean a picture which is
made of bits of paper, fabric or any other
material stuck to a surface. In French the
word literally means 'glueing' or 'sticking',
and was first introduced by Pablo Picasso
and Georges Braque in 1912 during their
phase of synthetic CUBISM.

Collograph

A print made from a block which, instead of
being cut in the usual ways, is composed of a
variety of materials superimposed on one
another.

COLLAGE. Bottle of Vieux Marc, Glass,
Guitar and Newspaper *by Pablo Picasso. The
flat planes of Cubist painting have been replaced
by cut-out paper. The use of newspapers and
lettering brings into question the distinction
between illusion and reality.*

Collotype

A reproduction which, though made by a
photomechanical printing process, is not
broken up by a HALF-TONE screen. Also the
process itself.

Colour

A full explanation of the scientific back-
ground to perception of colour would
require text and illustrations beyond our
present format. The following, therefore, is
restricted to a definition of the characteris-
tics of colour which are of interest to the
painter.

Since the IMPRESSIONISTS and NEO-
IMPRESSIONISTS began to study and employ
scientific colour theories in the last century,
an understanding of how we perceive
colour has played an increasingly important
role for many painters. Newton provided
the basis for much of our present knowledge
when he discovered that ordinary daylight
(white light), when passed through a prism,
was divided into seven distinct colours: red,
orange, yellow, green, blue, indigo and
violet. Artificial light behaves differently;

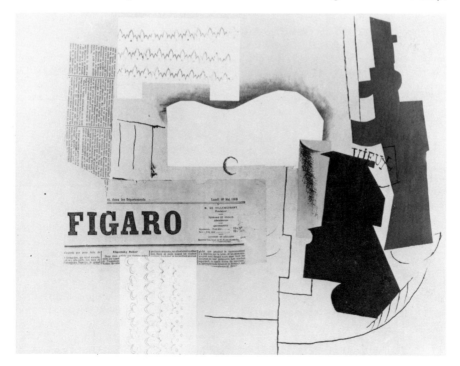

ordinary electric bulbs giving a yellowish tinge to what they illuminate because of a lack of blue, and fluorescent bulbs a bluish tinge because of an insufficiency of orange.

Each spectral colour, then, is a fragment of light and has its own wavelength to which the colour-sensitive part (the cones) of the eye responds. The cones are complemented in the eye by the rods, which are also light-sensitive, but only perceive light/dark contrasts without any colour. It is for this reason that when light is reduced—as evening falls or if the eyes are partially closed—that colour contrasts are diminished and we get a more tonal impression of the scene before us. The cones are believed to be sensitive to three colours: red, green and violet, and from these they mix all the colours we see and send the appropriate message to the brain. In the same way, any other colour can be made by mixing three coloured beams of light (in this case red, green and violet) and theoretically, the painter can mix any other colour using his three PRIMARY COLOURS: red, yellow and blue. If it were possible to obtain perfectly pure pigments, he would not only be able to mix all the colours he required using his primaries, but would also be able to make BLACK and WHITE. Pigments, however, are never pure, consequently any mixture which contains more than two colours becomes increasingly dull and muddy. Colour manufacturers provide pigments of an extensive range of colours so that complicated mixing can be avoided.

Coloured lights are referred to as transmitted colour, whilst the colour of an object, and therefore the painter's concern, is known as reflected colour. This is light which is reflected from a surface which has absorbed all the other colours of the spectrum, for example, a red surface will absorb every other colour except red, which it will reflect.

Every colour has three characteristics: HUE, TONE and INTENSITY, and its own COMPLEMENTARY COLOUR. The complementaries and the division of colour into warm (advancing) and cold (retreating) groups can be clearly seen on the accompanying colour wheel, as can the basic process of mixing colours from the three primaries.

Colour Chart
A chart which sets out samples of all the colours in a given range, organized in order of HUE and SATURATION.

Colour-Field Painting
A branch of MINIMAL ART which combines ONE-IMAGE ART with the use of large, flat areas of colours which are tonally very close. Its most famous exponent is Barnett Newman.

Coloured Grey
A grey produced by mixing equal amounts of all the PRIMARY COLOURS. See also BLACK.

Colour Perspective
See AERIAL PERSPECTIVE.

Colourist
An artist who uses colour with great skill and delineates form more by the conjunction of colours than by his use of line.

Colourman
A manufacturer and supplier of artists' materials, particularly paints.

Colour wheel

Colour Wheel

A circular diagram which shows how colours are mixed from the three primaries, and which can be used to explain warm and cool relationships and COMPLEMENTARY COLOURS as well as the constituents of SECONDARY and TERTIARY colours. See also COLOUR.

Commercial Art

The distinction between fine and commercial art becomes increasingly obscure. Essentially, though, commercial art covers advertising, TECHNICAL ILLUSTRATION, ILLUSTRATION, GRAPHICS and the APPLIED ARTS; that is, works which are commissioned and usually reproduced or marketed for the consumer. Fine art, on the other hand, is concerned with unique works or at least engraved works confined to a limited number of reproductions, and works which, while they may have been commissioned, are ultimately subject only to the artist's imagination, interpretation and execution.

Complementary Colour

For the painter there are three PRIMARY COLOURS: red, yellow and blue. A complementary of one of these primary colours is the combination of the other two, for example, the complementary of red is green (i.e. yellow + blue). When juxtaposed, complementary colours intensify each other. See also COLOUR and IMPRESSIONISM.

Composition

The organization of form in a work of art, particularly a picture. It is a general term which refers principally to the relation of masses, lines and colours across the flat, two dimensional surface of the picture.

Computer Art

Works of art made with the aid of a computer. The notion of computer art is not wholly developed, but one point is extremely clear: the computer is only a tool and is itself incapable of generating an idea. The inspiration for its 'artistic' output must be the artist's, who presents it to the computer in the form of a program. The computer's value lies in the rapidity with which it can explore all the possibilities of the program, and the viewing screen which makes it possible for the artist to see the various forms his idea could take without printing them out line-by-line.

Conceptual Art

Art as a concept or idea, rather than as a material object or objects. Any material record is merely an indication of the artist's mental image of his work, and of the way he arrived at it. Communication of the concept may take the form of a HAPPENING.

Concrete Art

All non-figurative painting not dependent on abstraction from a subject, but purely concerned with the construction of a composition from geometrical shapes, for example CONSTRUCTIVISM and SUPREMATISM.

CONNOISSEUR. Connoisseurs of Prints *by John Sloan. A humorous view of two garrulous connoisseurs at an exhibition.*

Connoisseur

A person who combines fine aesthetic judgement and sensitive appreciation with specialist knowledge of works of art and other aspects of taste.

Connoisseurship

An art-historical method of ATTRIBUTION developed by the Italian critic Giovanni Morelli in the 1880s. Morelli advocated the systematic examination of the way individual artists depict minor details, such as

the mouth or the ears, and claimed that such study would place attribution on a scientific basis.

Conservation

Strictly speaking, the term covers the preservation of healthy and sound works of art. In practice, it includes the repair of damaged objects as well (a function which is termed restoration), since the skills and knowledge required are identical. The conservator combines the artist's, art historian's and scientist's disciplines in looking after works of art. He may, for example, have to formulate colours to match those on a centuries-old support—particularly difficult when pigments are no longer available, remove layers of blackened varnish without disturbing the paint below them, transfer an entire painting to a new support, or copy and replace missing ornaments on a decorated frame. Moreover, he knows that even his careful efforts will inevitably alter the work and perhaps remove or obscure information which is valued by the historian (if, for example, a work is remounted, the original back will no longer be accessible for study). For these reasons the conservator spends much time and energy on the correct storage and display of work in an attempt to slow down the process of deterioration. He also makes use of photography to record various stages in a restoration process so that as much information as possible is preserved about a work's condition before restoration. It is largely through the efforts of conservators, working with artists' colourmen and other suppliers, that pure, stable and inert materials are now available. Any artist

CONSERVATION. *An oil painting of Lake Nemi by Richard Wilson during conservation. The top photograph shows the removal of the dirty varnish in the sky almost complete, with only two rectangular patches still to be 'cleaned'. The bottom photograph was taken under a powerful, angled light in order to see the condition of the picture surface. It shows, in particular, the pressure of part of the stretcher against the canvas.*

who sells his work or wants it to endure has a responsibility to ensure that his materials are of acceptable quality and are properly applied. The catalogues and additional literature provided by the artists' colourmen are readily available for this purpose.

Constructivism

A post-revolutionary Russian movement, founded in 1917 by the brothers Antoine Pevsner and Naum Pevsner (known as Gabo). They built on the initial experiments of Vladimir Tatlin, but broke with his conventional notions of sculpture as solid material and static mass. They felt sculpture as an expression of the modern age, should explore time. By making their work KINETIC and by experiments with light, they tried to make the spectator consider what lay beyond the three dimensions in which art had been presented. 'Modern' materials, such as glass, plastics and metals, and sophisticated engineering techniques were an integral part of Constructivism. The principles of the movement were set out in a document called the *Realistic Manifesto*, written by the Pevsners in 1920.

Conté

A French brand of chalk, stick or crayon available in sanguine (i.e. red), sepia and soft, medium or hard grades of black.

Continuous Representation

The appearance of several scenes from the same narrative in one picture, often arranged as a series of small scenes grouped around a larger one.

Contrapposto

A pose in figure sculpture which shows the human body twisted so that the torso faces a different direction to the hips and legs, and so that the weight of the body is placed on one leg. It was a development of the classical period of Greek art and much admired by Renaissance artists. Verrocchio's statue of David shows a typical contrapposto pose.

Conversation-Piece

A painting which shows a group of people, usually relations or close friends, in con-

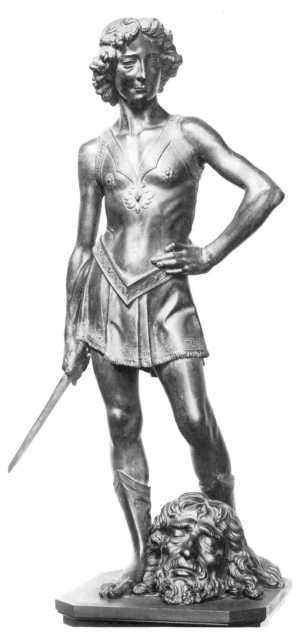

CONTRAPPOSTO. David *by Andrea del Verrocchio. A pose developed by classical sculptors and much admired and copied by Renaissance artists.*

versation in a relaxed home environment. In keeping with the informal atmosphere of the work, these paintings, which were especially popular in Britain in the eighteenth century, are generally fairly small.

Copper Plate Engraving
1. An INTAGLIO ENGRAVING process in which lines are incised into copper plate using a BURIN. 2. A print made from such a plate.

Coptic Art
The art of the native Christian population of Egypt, which founded its own church in 451 after the Council of Chalcedon and was most vital between the sixth and seventh centuries. The Copts were drawn from the working class, and theirs is a FOLK ART which was almost entirely independent of the more sophisticated, official culture of Alexandria. ENCAUSTIC wall-painting, woven textiles, manuscript illumination, ceramics and stone and ivory carving were the principal art forms. These combined classical ROMAN and BYZANTINE influences with pharaoic motifs, all expressed in the flat and colourful manner characteristic of primitive art. The Copts supplied the Roman armies with textiles, clothes and ceramic wares in addition to conducting a lively export trade of their own. Through these means their art was widely disseminated, thus preserving and transmitting HELLENISTIC ideas which had been superseded in major Roman centres by Byzantine art. Coptic influences have been identified in the art of many European countries such as Ireland, Italy and Germany, and particularly in works from monasteries. The Arab invasions of Egypt in 641, which established Islam as the official religion, began the decline of Coptic art and religion. They survived, however, until the Turkish conquests of 1516, when their distinctive character was swamped by other Mediterranean Christian influences.

Copy
A duplicate of a work of art. Before the invention of colour photography, artists would frequently produce copies of paintings for different clients, though these copies would be carried out by assistants in the artist's studio. The copying of great works

COPTIC ART. *A relief sculpture showing* Leda and the Swan.

of art was traditionally part of an art student's curriculum, particularly in the ACADEMIES, and it helped the students acquire an understanding of the techniques and brushwork of former masters.

Coroplastics
Sculpture and decoration in TERRA COTTA.

Cosmati Work
A type of decorative work in which marble was inlaid with coloured stone and mosaics, produced in Rome from the twelfth to the fourteenth century. It is named after the Cosmas family who first worked in this manner.

Coulisse
A compositional device by which elements such as arches, rocks or trees are placed at the sides of a painting to direct the eye to the centre.

Counter-Proof
A proof made by placing a fresh piece of paper on top of a print which has just come off the press and is therefore still wet, and running both through the press again. The result is a reverse of the print made from the plate, and so shows the image on the plate itself.

C.P.S.
Contemporary Portrait Society.

Crackle
See CRACKLIN and CRAQUELURE.

Cracklin
The cracking of the glaze on ceramic. Potters frequently fire ceramics under conditions which they know will produce cracklin to achieve an attractive effect. However, when a piece of glazed pottery is not correctly prepared, cracklin can appear inadvertently. Also known as crackle and crazing.

Craquelure
The network of cracks which sometimes appears on paint and varnish of an oil painting as the paint ages and settles. Also known as crackle.

Crayon
Commonly used as a general term for the many proprietary brands of wax-based drawing sticks used by children, but technically any drawing material in stick form can be classified as a crayon; this includes PASTELS, CHARCOAL and CHALKS.

Crazing
See CRACKLIN.

Croceate
Saffron-coloured YELLOW.

Cross-hatching
Using patterns of parallel, criss-crossing lines to create tones on drawings and engravings. See also HATCHING.

Cubism
A movement which originally constituted a reaction to IMPRESSIONISM and which followed Paul Cézanne's lead in his search for geometric forms in nature. Its chief concern was the representation of form, and to this end it sacrificed the actual appearance of an object to a rendering of its overall structure and position in space. In practice, this generally entailed the superimposing of several views of the same object on a single canvas or sheet of paper. Although Cubism is considered a form of REALISM, it wilfully rejects the principles of perspective, and, in its concentration on form, relegates colour to a position of secondary importance. The term 'cubism' allegedly derives from art critic Louis Vauxcelles's 1908 description of the angular volumes in George Braque's paintings as 'cubes'.

Although Pablo Picasso and Braque, the chief exponents of Cubism, did not meet until 1907, both had been working in an essentially Cubist manner for some time. Indeed, it was in 1907 that Picasso completed his *Les Demoiselles d'Avignon*, which heralded the emergence of Cubism as an identifiable artistic style. This work, like so many subsequent examples of Cubism, fused an enthusiasm for primitive (especially African) art with a tendency to reduce the subject to its simplest geometric form.

Cubism is frequently confused with abstraction and the avoidance of subject-matter. In fact, the very opposite is the case. Picasso and Braque, in particular, deliberately set out to depict objects, but represented what was known about their appearance instead of what could be seen from one point of view. This early phase of Cubism, from 1907 to approximately 1912, was devoted to the analysis of the forms of objects, and has therefore been called analytical Cubism. In about 1912, Picasso, Braque and especially Juan Gris, began the use of COLLAGE, in which fragments of newspapers, railway tickets and other materials were incorporated in the composition to serve as 'emblems' of the objects they represent. This practice, which became known as synthetic cubism, remained vital until about 1915.

Cubist-Realism
The same as PRECISIONISM.

Curvilinear
Composed of curving lines.

Cyan
See BLUE.

Cycladic Art
The art of the early Neolithic settlers in the central islands of the Aegean (including Ceos, Delos, Melos, Naxos and Paros) called the Cyclades, which, through Crete to the south and Asia Minor to the east were in touch with the older cultures of the Mediterannean. They were a Chalcolithic culture (prior to the classical Bronze Age) flourishing from *c*. 2,500–2,000 B.C.

As a highly creative civilization, their marble statuettes, carved stone vases with drilled holes for thongs to suspend them, water mirrors, palettes and fine pottery, are of great skill and beauty. The accurate working and fine forms were perhaps achieved by abrasion with emery that may have been exported from its source, Naxos, to ancient Egypt as early as *c*. 4,000 B.C. Though not so elaborate as the art works of Crete, the Cycladic arts show formal qualities highly fashionable in modern art, and are almost universally esteemed. They influenced, with Crete, the early HELLADIC culture and in the late phase were themselves dominated by the influences of Crete and the Greek mainland, the latter finally predominating.

D.A.
Diploma of Edinburgh College of Art; Doctor of Arts.

Dabber
A roll of material used to spread ink over a block or plate for printing, or to apply the GROUND to an etching plate.

Dada
Zurich 1916 saw the formation of what was to become an international movement among avant-garde artists: Dada. Artists including Marcel Duchamp, Jean Arp, Francis Picabia and Max Ernst, expressed their outrage at the course the world was taking during and immediately after the First World War in the creation of works of ANTI-ART and absurd events. Typical of these were Duchamp's READY-MADES, a lecture in which thirty-eight speakers held forth at the same time, and the famous addition of a moustache to a reproduction of the *Mona Lisa*. This type of protest was not limited to the visual arts but found expression in the literature and poetry of the day. Indeed, one of the founding members, the poet Tristan Tzara, is often credited with naming the group by stabbing a penknife in a dictionary at random—'dada' means 'hobby horse' in French.

Dance of Death
A common theme in mediaeval art showing one or more figures representing death leading a grotesque procession or dance in which characters from all walks of life are depicted. The intention was to remind the viewer that all men are made equal at death and that none can escape it. Also known as *Danse Macabre*.

DANUBE SCHOOL. Landscape with a Footbridge *by Albrecht Altdorfer. One of the first paintings in post-classical European art to be devoted exclusively to landscape.*

Danube School
A general term for the painters associated with the developments in landscape painting in the region around the Danube in the early sixteenth-century. The most important of these developments were the introduction of figures as an integral part of the landscape and the reduction of detail in favour of atmosphere. The artists most often credited with initiating these changes are Albrecht Altdorfer, Lucas Cranach and Wolf Huber.

Dead Colour
Any colour used for underpainting or LAYING-IN the design for an oil painting on canvas to be carried out in the traditional method rather than ALLA PRIMA. The colour is usually a dull brown, grey or green, and the underpainting includes the indication of tonal values.

Decadent Art
See AESTHETIC MOVEMENT.

Decalcomania
A SURREALIST technique, devised by Oskar

Dominguez but particularly associated with Max Ernst, akin to BLOT DRAWING, whereby the artist applies a smear or blob of paint or ink to a paper surface which he then folds, or transfers by pressing another piece of paper on to it. The resulting impression is used as the starting point, or source of inspiration, for the subsequent work of art.

Deckle Edge
The ragged edge found on hand-made papers and nowadays sometimes simulated on machine-made papers.

Décollage
The removal, frequently by tearing, of sections of collages, billboards or other surfaces built up in layers. The images so revealed intrude on the surface subject matter and so dislocate its meaning or significance.

Decorative Art
The same as APPLIED ART, but also including objects which are purely ornamental.

Découpage
The act of cutting out paper designs and applying them to a surface to make an all-over COLLAGE; or an object which has been covered in this way.

Deësis
A representation of a group containing Christ, the Virgin Mary and John the Baptist, either in a single picture or in a series of adjoining panels.

Del., Delin
An abbreviation used in printmaking for the Latin, *'delineavit'*: 'he drew it'. It is preceded by the name of the artist who created the original drawing from which the plate was made.

Depth
1. The degree of SATURATION of a colour. 2. The degree of recession in a picture.

Design
Nowadays synonymous with composition, but also used within the APPLIED ARTS to mean the overall conception, including the production and intended use, of an object.

Design Council
A British body founded in 1944 to work for improved standards of design in industry.

Designer's Colours
Best quality GOUACHE paints, often used in commercial art for presentation purposes and not necessarily permanent.

Des. R.C.A.
Designer of the Royal College of Art.

De Stijl
A group of Dutch painters, architects, sculptors and writers which, under the leadership of Theo van Doesburg and through the pages of a journal of the same name, attempted to 'make modern man receptive to what is new in the visual arts'. Founded in 1917, De Stijl was totally committed to abstraction in all areas of modern art and design. The artists felt that by using only primary colours and black and white, and straight lines and right angles, they could create a pure and universal art. The founding members included the painters Piet Mondrian, Bart van der Leck and Vilmos Huszar; the architects Oud, Van't Hoff and Wils, and the sculptor Georges Vantongerloo.

Device
A motto or emblem; may be used as an artist's signature or a printer's trademark.

D.F.A.
Diploma of Fine Art.

D.I.A.
Design and Industries Association.

Diaper
A background pattern made up of small repeated motifs, usually geometric or floral, and often found in mediaeval manuscript illumination.

Diminishing Glass
A lens used for viewing an object to be reduced and transferred to a painting or drawing, or, when used by commercial

artists, to show the size a piece of ARTWORK will be when it is reproduced.

Diorama

A scene painted in a combination of opaque and transparent media and lit in such a manner that, when viewed through a peephole, a three-dimensional effect is given. Often the lighting can be adjusted to create different atmospheric effects. The term also refers to the light-box in which such a scene is viewed, which was invented by L. J. M. Daguerre in 1822, and can be extended to include the building in which dioramic views are exhibited.

Dip.A.D.

Diploma in Art and Design.

Dipper

Dipper

A container for OILS and MEDIUMS which clips to the side of the palette.

DE STIJL. Composition with Grey, Red, Yellow and Blue *by Piet Mondrian. One of seven related canvases executed between 1919 and 1921, all using the three primary colours, black and shades of grey on a linear grid.*

Diptych

A painting or relief carving on two hinged panels, usually an ALTARPIECE.

Direct Painting

The same as ALLA PRIMA.

Disegno

A term from the Italian for both drawing and design in the sense of composition. The latter meaning includes that used in Mannerist Italy *c.* 1540–1600, referring to the ideal vision or *disegno interno* the artist had of his work before beginning it.

Distemper

An inexpensive but impermanent painting technique in which powdered colours are mixed with glue or size and diluted with water. It is used for scene painting and interior decorating, rather than studio work which is intended to endure. Also the painting mixture used for this technique.

This term is not in use in the U.S.A., where Calcimine and Scenic colours are equivalents.

Divisionism

The term Georges Seurat and other NEO-IMPRESSIONIST painters used for POINTILLISM and OPTICAL MIXTURE.

Donor

The person responsible for commissioning a work of art, usually a painting, and giving it to a church or other religious institution. Such a gift was usually presented in fulfillment of a vow, as thanksgiving for divine protection from some natural catastrophe, or in the hope of divine favour at a later date. The Virgin Mary (who was believed to have great powers of intercession) or a local patron saint most often formed the subjects of these works, and from the Renaissance onwards the donor, and sometimes his family, were included in the belief that they would attract special favour by close association with a religious figure. In these cases, it was obviously important for the donor to be recognisable and as a result representations of donors provide some of the earliest examples of genuine portraits in post-classical European art.

DIPTYCH. (*Above*) *A fourteenth-century carved ivory diptych from either France or Germany showing scenes from the Passion.*

DONOR. (*Right*) The Virgin and Child with Saints and Donor *in the style of Simon Marmion. The donor kneeling before the Virgin is believed to be Charles the Bold, King of France.*

not laid out as a corpse. In addition, the apostles are usually shown gathered around her body, for she was said to have prayed to see them before joining her son in Heaven.

Dotted print

An engraving made by punching holes in a metal plate. The process was most widely used during the fifteenth and sixteenth centuries and was often combined with other engraving techniques, with the dotted areas making up background textures. Also known as *manière criblée*.

Dragging

1. The technique of applying thick oil paint over a recently painted area so that the top layer is uneven and allows the paint to show through in patches. 2. In the INTAGLIO printmaking process, leaving a film of ink on the surface of the plate, resulting in a less stark contrast between the printed lines and the background.

Dragon's Blood

A transparent red resin once used to colour varnishes and as a pigment in mediaeval manuscript illumination and Greek and Roman painting. Its impermanent nature led to its replacement, but the resin is sometimes used as a RESIST in printmaking.

Dormition

A scene of the death of the Virgin Mary, based on the belief contained in some Christian literature (notably the thirteenth-century publication, *The Golden Legend*) that she did not actually die, but fell into a deep sleep for the three days before her ASSUMPTION. For this reason, she is frequently depicted reclining on a couch and

Drapery-man

From the Renaissance until the nineteenth century, the painting of drapery, especially in the background of portraits, was an important and specialized art form. By the eighteenth century, an established portrait artist would invariably have a studio assistant who only painted background drapery.

Draughtsman

A person who specializes in drawing; often used of those who produce technical or mechanical drawings used by architects and designers.

Drawing-board

Typically, a completely smooth, squared up piece of wood about $\frac{3}{4}''$ thick to which an artist can attach his paper when drawing. It may have certain refinements, such as a raised edge or edges.

Drawing Stand or Table

A large, standing drawing-board adjustable to any angle, usually with built-in measuring tools, grids and light.

Drier

See SICCATIVE.

Drolerie

A humorous picture, often showing animals behaving as humans. See also GROTESQUE.

Dry-brush

A technique used with watercolours, acrylics and inks, in which a brush which is only just moist is charged with pigment and rubbed along its side across the paper to leave an uneven area of colour. The paper or paint below shows through to provide a broken or mottled effect.

Drying Oils

See OILS.

Dry Mounting

See MOUNT.

Drypoint

An INTAGLIO engraving process in which the design is scratched into a copper plate with a steel needle or diamond point, held like a pen. The depth of the line depends on the force applied. The BURR created as the line is made is usually allowed to remain to give a soft, fuzzy effect to the resultant print. Owing to the fragility of the burr, drypoint plates tend to wear out very quickly, though they can be steel-faced by electrolysis.

Duck

Textile used for CANVAS.

Duecento

The thirteenth century, especially in Italian culture. Also known as the dugento.

Dynamic

A term frequently encountered in art criticism where it is often used to convey a vague impression of excitement or power. Properly, however, the word refers to forms which imply movement to the human eye as a result of their arrangement. At the simplest, vertical and horizontal lines are static, diagonal lines, curvilinear and interlacing are dynamic.

E.A.C. Des.
East Anglian Certificate in Design.

Early Christian Art
The term most frequently used to describe Christian-inspired art produced between *c.* A.D. 300 and 700, distinct from BYZANTINE ART. Although it borrowed heavily from the style of the pagan classical tradition, Early Christian art developed a new and complex iconography of its own. The elaborately carved stone sarcophagi and ivories of the fourth and fifth centuries allowed Early Christian artists to give sculptural expression to the history and doctrines of their faith. It was, however, in the realm of two-dimensional art—catacomb paintings, mosaics and manuscript illuminations—that these artists were able to give fullest visual expression to their beliefs. In all Early Christian art, the message was more important than the work of art itself. Thus, though vigorous and compelling, a great deal of this work is inferior to its classical predecessors.

Earth Art
An experimental art form popular in the 1960s in which the artist manipulated the natural environment, ostensibly to make a significant statement. By its very nature, earth art cannot be exhibited in galleries, although it is often photographed in stages and the photographs later displayed. Artists who have worked in this manner include Claes Oldenburg, Michael Heizer and Robert Smithson.

Earth Colours
Pigments which exist naturally in the earth in the form of clays, rocks or earths, for example the ochres and umbers.

Earthenware
Pottery fired at a low temperature (about 700° centigrade or less) which remains porous until GLAZED. This is the most common form of ceramic ware, found in all ages. See also STONEWARE.

Easel
A stand used by the artist to hold his panel or canvas. Easels have been adapted over the centuries to suit the various needs of the artist. The resulting standard models are:
Studio easel: permanent piece of furniture in an artist's studio, a studio easel may be mounted on wheels so that it can be moved within the room. It is a heavy, extremely stable easel, popular with portrait painters. The section which holds the SUPPORT can be adjusted slightly to avoid disturbing reflection.
Radial easel: lighter and more portable than the studio easel, the radial easel has three legs which can be folded together for storage. The section used to hold the SUPPORT can be adjusted from upright to flat to suit the needs of both oil and watercolour painters.
Sketching easel: lighter version of the radial easel used for working out of doors. The three legs usually telescope into themselves as well as fold together to increase portability. Some come with separate spikes which attach to the feet for use on soft ground.
Table/desk easel: small, legless structure which is erected on a table or suitable working surface.

Easel Picture
Any small painting executed at an easel; usually intended to be framed, although it may be displayed on the easel. Also called a cabinet picture.

Ecce Homo
A representation of Christ, popular during the Renaissance, at the moment he was presented to the Jews by Pontius Pilate before the Crucifixion. He is usually shown wearing the tattered robes, crown of thorns and marks of flagellation which symbolize

Studio, radial, sketching and table/desk easels.

the trials he suffered at the hands of the soldiers before being shown to the people. 'Ecce homo' are the words used by Pilate to announce Christ's presence to the crowd: 'Behold the Man!'

ECCE HOMO. *Ecce Homo by Antonio Allegri da Correggio. Pilate is in the background, gesturing towards the scourged Christ, who wears the Crown of Thorns.*

Eclectic

A term used in art history and criticism to describe the process whereby an artist borrows ideas and features from a variety of respected sources and combines them in his own work. Conscious borrowing of this sort (which should not be confused with the visual influences experienced regularly by all artists) is rarely successful. The term is often associated with the Carracci family (active in the sixteenth and seventeenth centuries) in Bologna, who were believed to practise eclecticism as a working doctrine, though most scholars now believe that this connection is inaccurate.

École des Beaux Arts

The French ACADEMY established in 1648 and reaching its peak under the Protectorate of Jean Baptiste Colbert who, together with the institute's President, Charles Lebrun reorganized the academy in 1663 and, in 1680, published a set of rules which was intended to cover every aspect of painting. While Colbert and Lebrun succeeded in achieving a recognized standard for associates of the École des Beaux-Arts, these rules, together with the rigid classical studies (for example, drawing and sculpting from antique models followed by studies from nature, with all work being related to basic theories of geometry, perspective and anatomy) imposed on students of the academy, gave rise first to the schism be-

tween the RUBÉNISTES and POUSSINISTES and eventually to a rebellion of artists, led by Jacques-Louis David, during the French Revolution. In 1793 the institution was closed, and in 1816 reconstituted under the title Académie des Beaux-Arts, as part of the Institut National de France.

Écorché

A drawing or model which shows a human or animal body without its skin : 'écorché' is French for 'flayed'. The purpose of such studies was to familiarize the artist with the musculature of the body, as opposed to the skeleton. See also ANATOMY.

Edition

All the IMPRESSIONS made from a single set of printing plates and issued at the same time.

Egg Tempera

The original type of TEMPERA, for which the BINDER is egg yolk. It first appeared in Europe at the end of the twelfth century and swiftly became the most important medium for panel painting until it began to be superseded by oil paint in the fifteenth century.

ÉCORCHÉ. Study of a horse *by George Stubbs showing the animal's different muscles.*

EGYPTIAN ART. Ti, *Master of the Horses of King Horemheb (1334–1306* B.C.*).*

Egyptian Art

The art of ancient Egypt, in its most characteristic form, spans almost three millennia, stretching from c. 3,000 B.C. to c. 300 B.C. or slightly later. Egyptian art was essentially pragmatic, developed and nurtured principally to assist in the glorification of the king and to implement his passage into the next world. Stylistically, it was a static form, changing little throughout its 3,000-year history and aiming chiefly at completeness rather than pictorial realism. Thus, for example, the human figure was depicted in painting almost without exception in an anatomically impossible pose—head and legs in profile, shoulders parallel to the picture plane—in order to accentuate as many of man's physical attributes as possible in a single image.

The reliefs and wall paintings decorating Egyptian royal tombs in pyramids and underground chambers most often chronicled the activities of the king, his family and subjects, although some of the most successful examples presented stylized, though acutely observed, views of the natural world. Free-standing sculpture tended, stylistically, to be even more rigid and formulaic than reliefs and paintings. In the realm of the applied arts, more freedom was allowed, resulting in exquisitely wrought gold jewellery and masterfully constructed wooden furniture.

Eight, The

An influential and innovative American group of eight artists: Arthur B. Davies; Maurice Prendergast; Ernest Lawson; Robert Henri (the unofficial leader); George Luks; William J. Glackens; John Sloan and Everett Shinn (later, George Wesley Bellows became an associate). Officially formed in 1907, the group had been drifting together since the 1880s. At a time when America was torn between economic extremes—great fortunes were amassed while massive immigration led to great poverty in the cities—this handful of artists rebelled equally against the sentimental products of the popular American painters and the rigid academic tradition imported from Europe. They determined to portray realistically the city life around

them and the unrelieved accuracy of their paintings of New York slums led to the nickname the 'Ashcan School'. Their style was undoubtedly influenced by the high proportion of members who earned their living illustrating newspaper articles. The Eight was a compassionate and nationalistic group, Henri and Sloan in particular were active in their efforts to improve art

THE EIGHT. Cliff Dwellers *by George Wesley Bellows. The Eight acquired the nickname of the Ashcan School as a result of their paintings of slums scenes such as the one depicted here.*

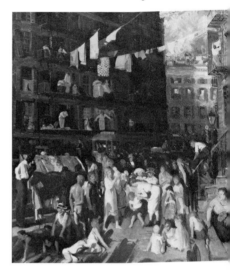

education. The Eight held only one exhibition as a group, at the Macbeth gallery in New York in 1908. In 1913 they organized the famous ARMORY SHOW.

Einzelkunst
A term applicable to Palaeolithic and primitive art from the German meaning 'art of the single thing' which refers to the depiction of persons, animals and objects in the same picture, but not spacially or compositionally related to one another. The cave animals of Altamira, for example, are shown at different angles and often overlapping, whereas conversely, the paintings of the Kalahari bushmen, show groups of animals with men in pursuit which are spatially related.

Elevation
An ISOMETRIC DRAWING which usually shows a particular side of a building (e.g. front), but sometimes shows a view of a building from one vantage point (e.g. north).

Embossing
A method of raising a design in RELIEF on metal, leather, paper, textiles and other surfaces through the use of dies or punches.

EMPAQUETAGE. (*Below*) Packaged Public Building *by Christo. A photographic collage for a project for a wrapped building.*

Empaquetage
A development of NEW REALISM, in which objects are wholly or partially wrapped. The Bulgarian artist Christo, who works in America, has effectively claimed this means of expression for his own. The items he has wrapped include buildings, people and whole sections of a landscape as for his *Running Fence* (1978). Empaquetage is not a permanent art form and relies on photographic records to preserve and disseminate its effect.

Empathy
In empathy you do not share the feelings of someone or something else (which is 'sympathy'); you imbue them fancifully with your own. This confusion causes much misuse of the word 'empathy' in modern usage.

Emulsion
A painting MEDIUM, containing materials which will not mix (i.e. oil and water, or water and resin), unless combined by the addition of an emulsifying agent. Emulsifying agents can be 'natural' (e.g. egg-yolk, milk of figs), 'artificial' (e.g. gums and varnishes) or 'saponified' (e.g. fatty oil, wax). TEMPERA is an example of an emulsion.

Enamel
1. A decorative coating predominately composed of glass (available in paste or powder form) which is fused to a metal or ceramic surface by baking in a KILN. 2. The process of applying the above substance. 3. A paint which has a high VARNISH or oil content and so dries to a brilliant gloss.

En Camaieu
A painting in a single colour. See also GRISAILLE.

Encaustic Painting
An ancient technique, in which pigments are mixed with molten wax and painted on to a surface to which they are fused by the application of heat. The encaustic method was used for Greek mural painting and for Egyptian mummy portraits; today it is more commonly an EASEL PAINTING technique. The important characteristic of

encaustic painting is that once heat is applied, all signs of application disappear, leaving an even surface which can be polished to a low sheen.

Engraving

1. The process of cutting a design into a block or plate which is to be used to make a printed IMPRESSION. The various methods by which the design may be cut are described under the specific headings: AQUATINT, DRYPOINT, ETCHING, INTAGLIO, LINE ENGRAVING, MEZZOTINT, RELIEF PRINT, WOODCUT, WOOD ENGRAVING. 2. A print made from an engraved plate.

Environmental Art

Large-scale works of art or architecture which create a total environment through which the 'viewer' must pass.

Equestrian Statue

A free-standing monumental portrait popular in ancient Rome and revived during the Renaissance which shows the subject riding on a horse. The horse itself is usually part of the portrait, highlighting particular characteristics such as strength, virility or nobility.

Eraser

Used for removing marks made by drawing MEDIA, normally made of rubber or plastic and a small amount of pumice or other abrasive material. Artists often find the non-abrasive, 'kneaded rubber' (also known as a 'putty' or 'plastic rubber') eraser particularly useful as it can be shaped to a fine point and used to lift out pencil, chalk or charcoal marks without smudging. COMMERCIAL ARTISTS and artists who work on a large scale may use an eraser which is set into an electrically powered base, or an AIR BRUSH which sprays an abrasive material on to the working surface.

Etching

An ENGRAVING method for which the design is cut or bitten into the metal plate through controlled immersion in acid. The process is simple to describe, but requires a high degree of skill. A metal plate is covered in a GROUND which acts as a RESIST to the acid.

Using a special steel needle, the artist then draws his design into the ground as if he were using a pen or pencil. When the plate is exposed to the acid, the areas where the ground has been removed through drawing will be eaten away to make the design on the metal. The artist can control how deeply the design is cut in specific areas by applying a STOPPING OUT MEDIUM at any stage in the process. When satisfied with the design, the artist will clean and ink the plate to make his first STATE. See also AQUATINT and MEZZOTINT. A print made by this process is also called an etching.

Etruscan Art

The art of the unidentified immigrants who settled in the part of Italy now known as Tuscany during the late eighth century B.C. and survived there as an independent culture until the third century B.C. Etruscan art combined elements from the art of the native population of the region, Minoan, Mycenean, Egyptian and, most prominently, Greek influences. Most surviving examples are in the form of monumental sculptures, particularly on the lids of SARCOPHAGI, and are made of terra cotta, bronze or local stone (but not marble), as well as wall-paintings, pottery and metalwork. The most important wall-paintings are to be found in the tombs at Tarquinii, where as well as religious and mythological subjects, there are scenes of hunting, fishing, athletic contests and other aspects of daily life. Even those scholars who consider Etruscan art to be essentially Greek, value these murals as rare examples of archaic painting. By the end of the third century B.C., HELLENISTIC influences appeared in Etruscan art and the region fell under the political and finally the cultural domination of Rome.

Euston Road Group

William Coldstream, Victor Pasmore and Lawrence Gowing led this short-lived British group formed in 1939 after the closure of the School of Drawing and Painting in London's Euston Road. The group offered an alternative to abstraction, being concerned with the realistic portrayal of townscapes and interiors, in particular.

ETRUSCAN ART. *This bronze mirror from about 350 B.C. is a typical Etruscan design. The incised decoration shows the* Toilet of Aphrodite.

Exc., Excud., Excudit

Latin notations which appear on ORIGINAL PRINTS which will be preceded by the name of the printer or publisher of the EDITION.

Expressionism

Specifically, that movement in modern art in which artists are concerned with communicating their emotional responses to subjects or ideas rather than representing how things actually look. The devices most commonly used to project emotions are distortion of recognized shapes and forms and strong, 'wrong', colours: that is those which do not correspond to reality. Van Gogh and the Fauves are usually considered early Expressionists. German movements such as DIE BRÜCKE and DER BLAUE REITER explored this type of art very thoroughly.

Ex Voto

A work of art made as an offering to a god or gods.

Eye-level

The sensed line which runs across a painting, level with the artist's eye, and allows the viewer to understand where the artist was in relation to his subject. See PERSPECTIVE.

EXPRESSIONISM. (*Below*) Portrait of a Man *by Erich Heckel. The elongation of face and hands combined with the heavy, dark accents on the facial structure produce a feeling of isolation and melancholy.*

F., Fec., Fecit

Latin notations for 'he made', follows the artist's name on a painting or sculpture, or on an ORIGINAL PRINT to distinguish the artist from the engraver, printmaker and/or publisher.

Fabriano

See PAPER.

Facsimile

An exact COPY.

Facture

The workmanship, quality or manner in which a material or medium is manipulated; applicable not only to the crafts, but to painting, sculpture and media such as ENAMEL and MOSAIC.

Faience

Tin-glazed and decorated earthenware exhibiting a high opaque glaze, so called after the Italian town of Faenza, which was famous for such pottery during the Renaissance. There are several varieties of such ware, notably Majolica in Italy, Delftware in Holland, and English Delftware in Britain.

Fake

A copy of an existing work of art or a work done in careful imitation of a well-known artist's style. Distinguished from a COPY or studio version because the intention is to deceive. See also ATTRIBUTION, FORGERY and PROVENANCE.

Fat over lean

A rule of thumb for painters in oil. As an oil painting is built up in layers, it is essential that each layer has more oil then the one below it so that as the paint dries, the top layers are flexible enough to accommodate shrinkage and settling without cracking.

Fauvism

A loose association of artists who were centred around the figure of Henri Matisse and officially named as a group at the Salon d'Automne in 1905 by the critic Louis Vauxcelles. Vauxcelles, spying a child's bust done in the Italianate manner, remarked 'Well, Donatello among the wild beasts'. The French for 'wild beasts' is *'fauves'* and the name caught on immediately. As a recognized movement, Fauvism lasted only two years, its three principal exponents, Matisse, André Derain and Maurice Vlaminck, going their separate ways in 1907. The Fauves were linked by friendship and mutual appreciation rather than by formal manifestoes, and also included Albert Marquet, Georges Rouault, Raoul Dufy and Georges Braque among others. The characteristics their work shared during this period were the use of pure, brilliant colours combined with simple handling which often resulted in rough brushstrokes and thick outlines. Interested in the colour theories which inspired the Impressionists. The Fauves consciously strove to 'liberate' colour, causing their divisionist experiments to be markedly more bold than their predecessors'. Perhaps the most original aspect of Fauvism was the belief that lights and shadows were equally luminous, which resulted in works which contrasted hues rather than tones. Fauvist paintings are essentially two-dimensional, concerned with working across the picture surface rather than with applying systems of perspective to achieve depth and recession.

F.B.A.

Federation of British Artists; Fellow of the British Academy.

F.C.A.

Federation of Canadian Artists.

FAUVISM. (*Top*) Joy of Life *by Henri Matisse.*

FÊTE CHAMPÊTRE. (*Bottom*) Concert Champêtre *by Giorgione.*

Ferroconcrete

Concrete into which steel bars are inserted to provide extra strength; used in sculpture.

Fête Champêtre

The portrayal of gentlemen and their ladies at ease in pastoral surroundings. This theme was an aspect of the pastoral element in Renaissance humanism and derived partly from Latin poetry, particularly the work of Virgil, and partly from courtly mediaeval art. The subject is found in paintings from Giorgione's *Concert Champêtre* in the sixteenth century to Édouard Manet's *Dejeuner sur l'Herbe* in the nineteenth century. It is, however, particularly associated with French ROCOCO painting, above all the works of Jean-Baptiste-Joseph Pater, Nicolas Lancret and Jean-Antoine Watteau, and is frequently called a *fête galante*.

Fête Galante

See FÊTE CHAMPÊTRE.

F.I.A.L.

Fellow of the International Institute of Arts and Letters.

Field Art

Another name for EARTH ART.

Figurative

Realistically representing nature.

Figure

Any representation of the human form, usually a STUDY which does not attempt to be a portrait.

Fin de siècle

Literally 'the end of the century', a phrase often used to describe the peculiarly jaded and sophisticated attitudes and characteristics prevalent in art and literature at the end of the nineteenth century. Especially used in connection with the AESTHETIC MOVEMENT, ART NOUVEAU and the Vienna SECESSION.

Fine Art

Essentially a distinction between 'art', 'craft' and 'APPLIED ART'. The modern notion of 'fine art' can be traced back to the Renaissance when there was a strong movement, led by Leonardo da Vinci, to demonstrate that the painter in particular was practising an intellectual and not a manual skill. Included under this heading are drawing; music; painting; poetry; printmaking; sculpture; and other forms of art which do not fulfil a practical function.

Fine Manner

See BROAD MANNER.

Finish

1. Describes the actual surface of an object, e.g. rough, smooth, glossy. 2. In art criticism, refers to the attention to detail in a work of art, in the sense that a carefully painted, detailed picture is often referred to as highly finished.

Firing

Heating clay objects or ENAMELS in a KILN to harden them and to fuse the enamel or glaze to its base.

F.I.S.A.

International Federation of Works of Art.

Fixative

A transparent liquid which is sprayed on work executed in a medium which can be damaged by contact (such as charcoal or pastel) to protect it.

Fl., Floreat

Latin notations for 'flourished'. Used in catalogues and books to indicate the period in which an artist was known to be working, when the actual dates of birth and death are unknown. Dates used in this way are normally those of the first and last documentary references to the artist.

Flat

1. The same as MATT. 2. Two-dimensional.

Folk Art

Art produced by artists or craftsmen who have had no formal training and which belongs to a closed cultural tradition. Common media are wood carving, needlework, weaving, textile dyeing and pottery. Primitive art is often in the folk tradition. See also NAIVE ART.

Fontainebleau, Schools of

Italian, French and Flemish painters engaged by the French monarchs Francis I and Henry IV to decorate the Palace of Fontainebleau in the mid- and late sixteenth century. Since there was no tradition of mural painting in France and in keeping with his wish to revitalize French art, Francis I imported Italian artists, of whom the most important were Giovanni Battista Rosso, Primaticcio and Niccolo dell' Abbate. These masters together with French and Flemish assistants evolved an ornate and elegant form of MANNERISM that influenced French painting of the period and which comprises the First School of Fontainebleau. The Second School consists of the artists working under the patronage of Henry IV at the end of the same century and is of little importance.

Follower of . . .

A title bestowed on any unknown artist who has executed a work in the style of a known artist, for example, Follower of Michelangelo. The term does not necessarily imply that the follower was a pupil of the named artist.

Fore-Edge Painting

The out-moded practice of making watercolour paintings on the long edges of the pages of a book, often in such a way that the image is only visible when the pages are fanned.

Foreshortening

The application of the principles of PERSPECTIVE to a specific aspect of a drawn or painted figure or object to make it appear three-dimensional. More particularly, foreshortening helps the reproduction of the appearance of objects as we perceive them

FORESHORTENING. Dead Christ *by Andrea Mantegna. If a photograph was taken from the same viewpoint, the feet would obscure the head and torso.*

and not as they are objectively, for example when photographed. Foreshortening is best understood by the study of photographs, because the camera does not have the ability to distort relationships the way the brain does. Consequently, protruding objects in the foreground, for example an out-stretched hand, appear grossly large.

Forgery

The deliberate creation of an imitation for the purpose of gain; either financial or prestigious. The forger must match wits with CONNOISSEURS and scientists. He tries, therefore, to match not only the style of an artist, but also the materials and techniques appropriate to the period. Because an artist's major work is often documented in correspondence, reviews, purchase records and the like, the forger will often invent works (and when possible, documentation) and then present them as unknown or early examples of the master's work. Occasionally, when gaps are known to exist in collections, he will create a work(s) to the believed specifications of the missing painting(s). Other methods of deception include the forgery of well-known signatures on paintings by lesser artists and the production of FACSIMILES.

Form

A word often confused with 'shape'. Properly, the form of an object is the combination of all the characteristics that establish its identity. Form not only includes shape, but also aspects such as size, texture, colour, tone, and movement. An artist may select certain aspects of the form for depiction, though often he attempts to express all aspects of form appropriate to visual perception and the medium. By doing so he conveys aspects of form which cannot be specifically delineated such as the movement or the emotions of the subject.

Formalism

In the Formalist approach to nature, based on distrust and uncertainty, Man withdraws into his own art and does not explore the challenging variety and chaotic individuality of natural forms. Instead he expresses a stable and reassuring simplification in formal terms, as in primitive patterns of African and American Indian decoration or the Geometric period of Classical GREEK ART. The contrasting mode is NATURALISM, as in Cretan (MINOAN) and Renaissance art, in which Man embraced the rich variety of Nature. A blend of the two produced IDEAL Form, which is often taken for Naturalism, but which is restrained and controlled by geometrical structure and limited variety.

Found Object

An object, also known as *objet trouvé*, which comes to an artist's attention by chance, and to which he ascribes aesthetic merit or some other significance. Found objects can be natural forms such as driftwood or rocks, or man-made items (Marcel Duchamp in particular is known for utilizing what he termed 'READY-MADE' items such as the famous urinal which he entitled *Fountain* and exhibited in 1917). The found object is part of SURREALIST theory, which holds that any object can be a work of art and exhibited as such; also, that chance and intuition are essential elements in the creation of the modern, supernatural world after which the group strived. If an object is not used exactly as it was 'discovered', it is considered an object 'composed', 'interpreted' or 'assisted'.

Foxing

The appearance of spots of brown mould on paper. The condition is caused by damp.

Fractur

A type of art, which originated with the German population in the state of Pennsylvania, derived from old-fashioned German Gothic calligraphy and used in the first instance to illuminate official records and documents (births, deaths, marriages, etc.) but later abstracted to make stylized patterns. Also called *Fraktur*.

Fragment

1. A surviving piece of a broken sculpture or ornament preserved for innate qualities as much as to document the existence of the whole work. 2. Deliberately made 'incomplete' work of art intended to provoke ideas

FRAGMENT. (*Above*) The Cottenham Relief.
A Greek marble fragment from about 510 B.C.

FRAME AND FRAMING. (*Right*) *Finishing off an elaborate carved frame.*

and emotions. See also NON-FINITO.

Frame and Framing

A frame is a border surrounding a picture which both enhances and protects it. The construction of a frame which will set off a picture but not distract from it is an art in itself. Apart from the joinery skills required to cut, glue and pin four, perfectly MITRED, corners from lengths of MOULDING, the framer must be able to select or fashion a moulding which is of an appropriate width, shape, tone and texture to suit the picture. This may involve carving, staining, gilding or otherwise decorating the frame; often in an extraordinary manner. However, no matter how beautifully decorated a frame may be, if it takes attention away from the work it surrounds, it is the wrong frame for the work.

Every picture benefits from having a

frame designed especially for it, though the cost of custom framing is often too high to make this possible. Even a frame made from standard moulding or assembled from a kit can be adapted to be more compatible with the picture it surrounds. There are no hard-and-fast rules of thumb which can be applied to every framing problem, though

71

generally oil paintings are not glazed, while watercolours, drawings, prints and other works of art on paper require a glass covering to protect them from air and dust. Oil paintings and those done in similar media are more likely to benefit from large, elaborate frames than are more delicate works, though the latter are usually surrounded by a MOUNT which may be tinted or otherwise decorated.

F.R.C.A.
Fellow of the Royal College of Art.

Freestone
Fine-grained and easily worked sandstone or limestone, widely used in mediaeval sculpture and carved embellishment.

Fresco
Wall painting in which pigments are mixed with water and applied to lime plaster which is still wet. The plaster serves both as the GROUND and the BINDER for the medium. In addition, it provides the lights and highlights for the finished work, being the only source of white. True, or *buon fresco*, involves preparing the wall with several layers of plaster, beginning with a rough *arriccio* on to which the design is first traced (see CARTOON) and ending with smooth *intonaco* which is only applied in small sections so that the artist can be certain that his paints will be going on wet plaster. This sort of fresco painting is very skilled as the artist must work very quickly and is virtually unable to make corrections. A less difficult, and less permanent, form of wall painting in which a water-based paint is applied to dry plaster is known as *fresco secco*.

Fresco Secco
See FRESCO.

Frieze
In classical architecture, the middle section of the part of a building (called the entablature) that rests on the columns. The frieze is frequently decorated with RELIEF designs and figures.

Frontality
The presentation, common in the art of early civilizations and in some primitive societies, of all the elements in a drawn or sculpted work of art as if viewed from the front, with no notion of perspective.

Frottage
The principle of frottage derives from the ancient means of taking an impression from a raised or textured surface by covering it with a sheet of paper and rubbing the paper with a soft drawing material such as charcoal. The SURREALISTS used this technique to provide textural effects on paper that were intended to stimulate the imagination and assist the emergence of unconscious images. The frottages were often incorporated in COLLAGES or elaborated into drawings or paintings and are particularly common in the works of Max Ernst.

F.R.S.A.
Fellow of the Royal Society of Arts.

F.T.D.A.
Fellow of the Theatrical Designers and Craftsmen's Association.

Fugitive
Used of pigments which have a tendency to fade, especially when exposed to daylight.

Functionalism
A concept in AESTHETICS, particularly related to architecture and design, based on the belief that anything that is well designed for its purpose is beautiful; that beauty cannot be achieved without efficiency.

Futurism
The original 'Foundation Manifesto of Futurism', written by Filippo Tommaso Marinetti in 1909 and published in the Parisian newspaper, *Le Figaro*, demanded 'Courage, audacity and revolution ... aggressive action'. It also called for the annihilation of the past (especially as preserved in museums and galleries), and glorified war ('the world's only hygiene'), energy and speed. Marinetti believed that the art of the past was too influential on the thinking of contemporary artists and that a new art form for the modern age had to be developed. By 1910 there was a Painter's

FRESCO. *The interior of the Arena Chapel, Padua, painted in fresco by Giotto. The walls and ceiling of the building are lined with Biblical scenes, including the Life and Passion of Christ.*

Manifesto, written by the original core of the Futurist painters: Umberto Boccioni (who in 1912 also published his own Futurist manifesto on sculpture), Carlo Carrà, Luigi Russolo, Giacomo Balla and Gino Severini; Futurism was soon to encompass all the arts.

Prior to the First World War, the group was innovative and had some success in the major European capitals, their most famous exhibition being held at the Galerie Bernheim-Jeune in Paris in 1912. After the war, Futurist painting went into a decline and eventually the entire movement fell under the control of the Fascists.

The most important concept to emerge from Futurist painting was simultaneity. An expression of the group's energy worship, simultaneity was used to show motion by depicting multiple images of moving objects in different positions (rather like the individual frames of an animated cartoon). The concept also involved movement which had taken place previously but in the same place and that which was occurring outside the painter's field of vision but which he nevertheless perceived to be part of his subject (the crowd on the street below the balcony on which his model was posed, for example). One final but important characteristic of Futurism was its rejection of the spectator; Futurist paintings were so composed as to draw the viewer immediately into the centre of the activity on the canvas.

Gag Art
An infrequently used name for POP ART.

Gallery Picture
A large painting. Normally one in which the figures are life-size or larger and which must therefore be hung in spacious surroundings.

Galvanized Metal
Metal which has had a protective coating applied by electrolysis to prevent it from rusting; often used by sculptors.

Galvanoplastic Copy
The use of electrolysis to make reproductions of plastic works of art and engravings by coating them with a thin layer of metal.

Gamboge
See YELLOW.

Garzone
An artist's young apprentice.

Gel Medium
See MEDIUM.

Genre
1. Painting which portrays scenes from daily life, usually having a narrative quality and often making a moral point. This type of subject-matter was first used by Dutch seventeenth-century artists, such as Jan Steen, Jan Vermeer and Pieter de Hooch. 2. The word can also be used to refer to a particular category of subject-matter, for example, landscape, marine, or sporting.

Geometric Art
See GREEK ART.

Geranium Lake
See RED.

Gesso
A GROUND made of gypsum or chalk mixed with water or glue to provide a dense, brilliantly white absorbent surface for TEMPERA and some types of OIL PAINTING. The SUPPORT is usually a panel and is prepared with several coats of gesso before painting begins. The first, coarse undercoat is called *gesso grosso*; the final, fine surface coat is known as *gesso sottile*.

Gestalt
The German term for 'form, figure, fashion, configuration, manner and shape'. It is used in the psychology of perception and AESTHETICS to refer to the phenomenon that the total effect of an object may seem greater than the sum of its constituent parts. The mind selects and integrates a mass of sensation into an image, which is then identified and classified by the rational faculty. The integration of the selected

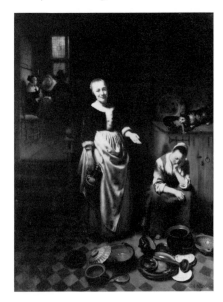

GENRE. A Sleeping Maid and her Servant *by Nicolaes Maes. A Dutch painting of the mid-seventeenth century when such scenes of domestic life first became popular in European art. Note the cat stealing a chicken on the right.*

sensations into a coherent image is the gestalt process. Gestalt was first studied in Germany by Koffka, Wertheimer and Kohler in the 1930s and in England by Ward and Stout, who stated that 'initial apprehension of a whole and proceeding to the analysis of its elements' facilitates understanding better than 'acquiring many separate elements and attempting a synthesis'.

Gestural Painting
A style of painting in which the paint is applied with expansive gestures so that the BRUSHWORK conveys emotion. See also ACTION PAINTING.

G.I.
Royal Glasgow Institute of Fine Arts.

Gilder's Cushion
A small pad which is used by gilders. It attaches to the thumb of one hand and has sides which exclude draughts so the gold leaf which rests on the pad is not disturbed.

GILDING. *Applying gold leaf to a picture frame.*

Gilding
Covering a surface with gold leaf. The two most common methods are mordant gilding in which the leaf can be applied to any ground but cannot be burnished, and water gilding for which the ground is only GESSO or a mixture of clay and iron oxide called bole. Once set, the leaf can be burnished to a high shine on this ground. See MORDANT.

Gisant
A sculptured, reclining effigy on a tomb that is a portrait of the deceased. In late Gothic art, the subject is often shown as a decaying corpse or skeleton.

Glasgow School
A group of Scottish painters who gathered in Glasgow from 1850 to 1918 with aims similar to those of the original N.E.A.C. Led by William Yorke Macgregor, other members included John Lavery, David Cameron, James Paterson, and E. A. Walton.

Glazing
1. The process of applying a thin layer of oil paint over opaque, dry layers to modify the tone, produce highlights and a sense of transparency. Generally, a dark colour is applied over a lighter one. It is a technique which was commonly used by the OLD MASTERS and which cannot be employed in ALLA PRIMA painting. Rigorous restoration of a picture can remove the glaze. 2. In pottery, the transparent glassy coating made from silicates and fired in a kiln which both decorates and protects the clay surface. 3. The process of covering a picture with glass to protect it.

G.L.C.
Guild of Lettering Craftsmen.

Glory
See AUREOLE.

Glyphograph
An engraved drawing made from a copy of a letterpress plate; the copy is obtained by using electrolysis to make a metal cast of the original plate.

Glyptic
A work of art which is made exclusively by carving, cutting or incising i.e., one which is not moulded or modelled. Also called a glyphic.

Glyptics
The art of cutting designs on stone, especially gems and semi-precious stones. Also known as glyptography.

G.M.C.
Guild of Memorial Craftsmen.

Golden Painting

A technique of mediaeval origin in which dilute oil paints are applied to a GESSOED panel which has been covered with gold LEAF and burnished. It is most commonly found in religious paintings.

Golden Section

A proportion, also known as the Golden Mean, which has been employed by artists in the composition of paintings for centuries. The proportion is the result of the division of a line so that the shorter section is to the longer as the longer is to the whole. This works out to a ratio of .618 to 1, or approximately 5 to 8. There is no known reason why this ratio should be superior to any other, yet it is one which is regularly found in nature, from the number of leaves on a plant's stem to the graduated widths of the curves which make up a shell's spiral.

The name Golden Section was first used in the nineteenth century, but the proportion itself dates back to the work of the Greek mathematician, Euclid. In the early fifteenth century the Italian mathematician, Luca Pacioli, wrote a book on the subject called *Divina Proportione*, which was illustrated by Leonardo da Vinci. This influential work led to the widespread use of the Golden Section by many Renaissance and later artists.

Gold Size

The adhesive surface used in GILDING. See also BOLUS GROUND.

Gothic Art

A style of art and architecture which was consolidated in Île-de-France in the middle of the twelfth century, and was widely adopted throughout Europe over the following three centuries. During the RENAISSANCE, the Italian humanists denounced the Gothic style, for they considered its practitioners had rejected their classical heritage in favour of the 'barbaric' tastes of the Gothic tribes which had sacked Rome in the fifth century. Renaissance propaganda declared that Gothic artists and craftsmen were incapable of imitating nature and that their work was static and superficial—a notion which persisted until the nineteenth century

and was so prevalent during the seventeenth and eighteenth centuries that to describe something as 'gothick' was to condemn it as being against all the established principles of art. Contemporary opinion holds that the Gothic style, typified by church art and architecture, was characterized by lightness and grace.

In architecture this was achieved through the use of verticals—pointed arches, ribbed vaults and spires—and the division of solid walls with vast windows, arches and ornate, lacey, decoration. Indeed, the detail and naturalism of much of the decorative carving alone disproves Renaissance opinion.

The emphasis on windows necessarily reduced the possibilities for painting within Gothic buildings, but provided great opportunities for artists to explore light and colour in STAINED GLASS. The frequent inclusion in Gothic abbey churches and cathedrals of porches decorated with rows of statues inspired artists to make fully rounded sculptures for the first time since the fall of Rome. The statues which decorated early porches, such as that of Chartres Cathedral (*c.* 1140), are more or less structural in appearance, but by the thirteenth century, Gothic sculpture had reached its maturity. Figures became completely ornamental, and high relief sculpted and carved figures began to be made for the interiors of buildings. Related to this new concept of a sculpture that was increasingly distinct from architecture, was the emergence of a more interpretative and emotional style of carving, of which the sculptural group known as the PIETÀ was perhaps the most typical example.

It is usual to divide the Gothic period into three phases: Early (mid-twelfth to thirteenth century); High (thirteenth to fourteenth century) and Late or Flamboyant Gothic (fifteenth century). High Gothic art is noted for the naturalistic developments in sculpture described above, and for the renewed interest in painting made possible by the increasing use of wooden ALTARPIECES. Gothic painting is rich and colourful, often employing a gold leaf ground (see GOLDEN PAINTING) and, particularly in the field of ILLUMINATED MANUSCRIPTS, displays close observation of nature, many examples

demonstrating serious botanical study. By the fifteenth century, the Gothic style had been adopted throughout Europe, constituting what was later to be identified as an international style. (See INTERNATIONAL GOTHIC.) Its stress on observation from nature and the realistic depiction of the human form prepared the way for the Renaissance.

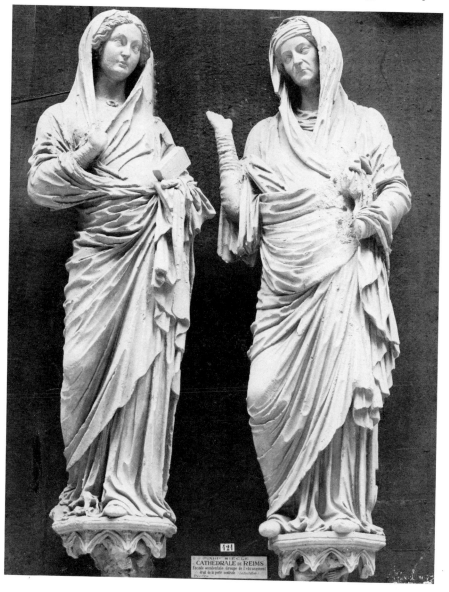

GOTHIC. *Thirteenth-century figures from Rheims Cathedral representing The Visitation of the Virgin Mary (left) to her cousin, Elizabeth, the future mother of John the Baptist.*

Gouache

Watercolour made opaque by the addition of white pigments and sometimes with a glue BINDER. It is also known as body colour. Unlike transparent watercolour, gouache does not allow whiteness of the paper to show through the paint. It should also be noted that it lightens considerably in drying.

Gouge

A chisel used for woodcarving, the end of which may be either V or U-shaped.

Graffito

See SGRAFFITO.

GRAND MANNER. The Battle of Thor with the Serpent of Midgard *by Henry Fuseli. This picture was Fuseli's diploma picture for membership of the Royal Academy and illustrates the fashion towards the end of the eighteenth century for paintings of heroic events.*

Grand Manner

HISTORY PAINTING which takes for its subject heroic characters or events.

Grand Tour

A journey through the major European countries, notably France, the Netherlands and Italy, that was intended to provide the finishing touch to an English gentleman's education. The custom was particularly fashionable in the late seventeenth and throughout the eighteenth century, though it was also popular amongst Americans at the end of the nineteenth century. Many large private collections in England were originally founded on paintings and other works of art amassed by wealthy young travellers as they proceeded round Europe, and these collections, in their turn, influenced many English artists.

Graphic Art

A term which is in the process of transition and is divided between the FINE and COMMERCIAL ARTS. The full expression is usually used to mean ORIGINAL PRINTS and the processes involved in their making. The shortened form 'graphics' is most commonly used to mean COMMERCIAL ART, TECHNICAL or MECHANICAL DRAWING and the equipment and processes they involve. The words are often used interchangeably.

Graver

The same as BURIN.

Gravure

An INTAGLIO commercial printing process which uses plates or cylinders covered in cells of varying depths (and which therefore hold varying amounts of ink) to obtain its light/dark contrast. This process is more specifically known as photogravure.

Greek Art

Undoubtedly the most important influence on the course of Western art, Greek art was largely known through literature and copies of statues until the eighteenth century, when major excavations brought examples to the notice of collectors and artists. Unfortunately the ravages of time and successive invasions have destroyed much of a prolific artistic output, and almost all examples of Greek art that survive are in fragmentary form. This is particularly true of painting, which is only known to us from

the examples that appear on pottery.

Greek art is usually divided into five periods, as follows: Geometric from 1100–700 B.C.; Orientalizing from 700–600 B.C.; Archaic from 600–480 B.C.; Classical from 480–323 B.C.; and Hellenistic from 323–27 B.C. Each has its own values and characteristics which are briefly outlined below, but essentially the history of Greek art is one of a development from rigid, stylized conventions typical of the art of Egypt, Babylonia and other Near Eastern nations, to a naturalistic, though idealized, representation of the human figure.

The art of the Geometric period is known to us only through the decoration on vases and other ceramic wares, and a few small clay and bronze figurines. Its vase painting is not significantly different from that of Minoan and other Aegean cultures of the same period, though towards the end of this phase, human and animal forms began to appear in otherwise purely abstract designs.

The Orientalizing period forms a transitional stage between the Geometric and Archaic, and is so called because it demonstrates the Eastern influence of the great trading nations of the ancient world: Egypt, Babylonia, Syria and Phoenicia. The motifs and conventions of the art of these nations were strongly related and their rigid forms, usually combining frontal and profile views of the human figure, made a marked impression on Greek art of the time. By far the most significant developments occurred in vase painting and they include the enlargement of designs, dominant use of bold outlines, increasing concentration on the human figure, and the incorporation of narratives, of which typical examples are battle scenes and athletic contests.

In the Archaic period the art of vase painting reached its peak and all evidence suggests that wall- and panel-painting reached a similar level of quality. The narrative trend of the Orientalizing phase continued to grow, with an increasingly

GREEK ART. *One of the most famous pieces of Greek sculpture, the Venus de Milo dates from the Hellenistic period and provided an ideal of female beauty in Western art for centuries.*

79

naturalistic representation of the human form in scenes taken from mythology and daily life. Anatomical observation grew more accurate in painting and the first free-standing sculptures in stone and terra cotta were fashioned, known as KOUROI and KORE. In relief carving and pediment sculpture, attempts to achieve pictorial effects appear, including modelling and the indication of depth by perspective. The Archaic period was brought to a close with the sack of Athens by a Persian army in 480 B.C.

The Classical period that followed became the model for the arts of all subsequent antique cultures and the basis of Western art for two millennia. It was an age of sculpture in which the notion of the idealized human form was most fully articulated, both in the statues themselves and in treatises on the subject. Throughout the period a variety of supple, elegant poses developed hand in hand with a rather austere naturalism and increasing range of expression in facial features. For the first time, the names of a number of sculptors became known, notably Polyclitus, Praxiteles, Lysippus and Phidias the sculptor of many great works on the Parthenon. Relief carving attained a level of great complexity and variety during the period, with crowded compositions presenting illusions of depth and space in scenes of daily life, and especially in scenes of processions and battles on friezes.

During the Hellenistic period the interests that dominated Classical sculpture were expanded and explored under the impact of a host of cosmopolitan influences. Certain sculptors created variations on Classical themes, as in the celebrated work called the *Venus de Milo*, but for the most part a more realistic and individual representation evolved. This was characterized by detailed study of anatomy, the development of truly free-standing works that could be viewed from all angles and, most notably, the use of dramatic poses and the expression of a far wider range of emotions. Relief carving also followed these trends, and likewise shared a wider subject-matter, including such subjects as children and character types for the first time.

Green

A SECONDARY COLOUR comprised of blue and yellow. Green paints commonly available from the artists' colourmen include: Alizarin Green; Bright Green; Cadmium Green; Chrome Green; Cinnabar Green; Cobalt Green; Emerald Green; Hooker's Green; Monestial Green; Olive Green; Opaque Oxide of Chromium; Pale Olive Green; Permanent Green Deep; Permanent Green Light; Phthalo Green; Prussian Green, Rowney Emerald; Rowney Olive; Sap Green; Terre Verte; Viridian; Winsor Emerald; Winsor Fast Green and Winsor Green.

Grey

A TONE between black and white. Grey paints commonly available from the artists' colourmen include: Charcoal Grey; Davy's Grey and Payne's Grey.

Grisaille

A MONOCHROME painting executed entirely in shades of gray. A grisaille may be done as a finished painting or as an UNDERPAINTING. See also EN CAMAIEU.

Grotesque

An ornament or decorative design which combines human and animal characteristics. They take their names from the grottoes in which they were discovered during the late Renaissance. See also DROLERIE.

Ground

1. A bare support is not suitable for painting. To protect the support from dampness and atmospheric pollution and make a suitable surface on which to paint, a first coat of paint or other preparation such as GESSO is applied; this is the ground. The ground gives the desired qualities of whiteness, smoothness and absorbency. There are four types of grounds commonly used: oil, gesso, emulsion and acrylic. 2. In etching, the acid-resisting wax or varnish which is spread over the surface of the metal plate before the design is made. An etching ground must be tough enough to resist the MORDANT, soft enough to take the needle marks without chipping and dark enough to show the design. 3. In ceramics, a clay

surface which is to be decorated by painting.

G.S.A.
Glasgow School of Art.

Guilds
Mediaeval associations which were originally formed to train and protect their members. Most painters had to be members of guilds and could only develop through the guild heirarchy: the apex of which was the MASTER. By the fifteenth century, guilds had become notoriously restrictive and artists like Leonardo da Vinci and Michelangelo rebelled against them. ACADEMIES were established to take the place of the guilds.

Gum Arabic
The BINDER used in watercolours, made from the gum of the Acacia tree, and traditionally associated with Arabia.

HALO. Seven Saints *by Fra Filippo Lippi. Each of the saints portrayed (John the Baptist is in the centre, flanked from left to right by SS. Francis, Lawrence, Cosmas, Damian, Anthony Abbot and Peter Martyr) is crowned with a halo to signify his sacred status.*

Hachure
Same as HATCHING.

Hair Pencil
A very fine camel-hair brush.

Half-length
An almost obsolete term for a size of portrait canvas which measured 50 × 40 ins.

Half-tone
1. Any tone or shade which is between the lightest and darkest extremes of its range. 2. A printed image obtained by photographing a subject through a screen which breaks up the image into small dots. The dots are closer together or further apart according to the dark and light 'continuous' tones of the subject. The eye then combines the dots to reconstruct a complete, tonal image.

Halo
See AUREOLE.

Handling
The way an artist applies and manipulates his MEDIUM.

Hand-made Papers

Commonly used by artists for fine drawings and finished watercolours done for exhibition. They are made by mixing pulverised rags with glue-size solution and floating the dilute mixture on to fine wire mesh held in a frame. The liquid drains away and the sized residue settles as a thin sheet which, when dried, constitutes the paper; bearing a watermark, if thicker, shaped wires have been incorporated in the mesh.

Happening

An event in which an artist stages an idea in front of an audience, who may participate. Unlike a theatrical performance, a happening is neither repeated nor rehearsed. The term originated with the art form's chief exponent, Allan Kaprow, and happenings occurred regularly in New York in the late 1950s and throughout the 1960s.

Hardboard

A stiff material used as a painting support, the quality of which ranges from cheap and unstable laminated CARDBOARD to compressed wood fibres.

Hard-Edge Painting

A manner of painting, characterised by sharp, clearly defined outlines, and associated with MINIMAL ART. Its reliance on

HAPPENING. Self Burial (Television Interference Project) by Keith Arnatt.

HARD-EDGE PAINTING. Hyena Stomp *by Frank Stella. Stella has taken care to make each stripe in his painting as uniform and sharply defined as possible.*

control was a reaction to ACTION PAINTING and other forms of ABSTRACT EX-PRESSIONISM, in which the artist was seen to be separated from his medium. Prominent artists working in this style include El-lsworth Kelly and Kenneth Noland.

Hard Paste
The material, made of feldspar, kaolin and flint, from which true PORCELAIN is made. The formula originated in China and was imitated by Europeans with a porcelain made from a SOFT PASTE base.

Hatching
The use of parallel lines to provide tone and shadow in a work of art, the medium of which does not allow blending e.g., etching, engraving and drawing. Tones are made by varying the density of the lines. See also CROSS-HATCHING.

H. Dip.
Higher Diploma in Art and Design.

Helladic
The art and culture of the pre-HELLENIC or Bronze Age) period of mainland Greece; c. 2600–c. 1100 B.C. Late Helladic is also called Mycenean.

Hellenic
The art and culture of Greece and its territories from c. 1100–323 B.C. See GREEK ART.

Hellenistic
The art of Greece and areas under Greek influence and between the reigns of Alexander the Great and Augustus from c. 323–c. 27 B.C. See GREEK ART.

Herm
A type of columnar Greek statue, believed originally to have depicted the God Hermes, showing a bearded head on a tapering column, usually with a prominent phallus. These statues are believed to have served as boundary markers and milestones. Also known as a Term.

Hermeneutic
Refers to the technique of understanding cultures, including art, based on becoming like-minded, regardless of distance in time. Mediaeval hermeneutics centred on interpretation of the Bible, but later, the study became general. It is the basis of modern art history and criticism, which can no longer simply classify but must interpret, explain and judge.

Heroic
1. In art criticism, subject-matter of the highest order. 2. A statue which is larger than life-size by two or three feet.

Hieratic
A term which describes the stylized conventions of religious figures usually in Egyptian or Byzantine art. Such works are normally distinguished by their emphatic FRONTALITY.

History Painting
Painting consisting of subject-matter drawn from classical history, poetry, religion, and, since the eighteenth century, contemporary events. During the Renaissance, Leon Battista Alberti proposed that the painting of an *istoria* was the highest form of art and that it raised painting to the status of the liberal arts or fine arts. Within the various categories of painting, history painting was

HUDSON RIVER SCHOOL. View of the Cats-kills, Early Autumn *by Thomas Cole. An idyllic view of American landscape with the Catskill mountains in the background.*

generally considered the most important by academies from the sixteenth to the end of the nineteenth century.

H.N.D.
Higher National Diploma.

Hog's Bristle Brush
See BRUSHES.

Holograph
A three-dimensional image constructed of light made by illuminating a special photo-graphic image, known as a hologram, with coherent light from a laser.

Horizon Line
A PERSPECTIVE term used to describe the horizontal line which can be drawn across a picture from the centre of vision which is at the artist's EYE-LEVEL.

Hors Commerce
An artist may extract a print(s) from a LIMITED EDITION for use in portfolios, exhibitions or for other means of gaining public exposure. These are marked HC, are not sold and are not considered part of the edition.

Hortus Conclusus
Paintings of the Madonna and Child in a closed garden with roses, other garden plants and sometimes female Saints and a fountain.

Hot Colours
Same as WARM COLOURS.

Hot Wax Painting
See ENCAUSTIC PAINTING.

H.R.A.
Honorary Royal Academician.

H.S.A.
Hampstead Society of Artists.

Hudson River School
Generally considered the first native art movement in the United States, although all its artists had had some training in Europe, this group of landscape painters worked in New York State, New England and even travelled to the wilderness in the far West. Their united interest was the

American landscape, and they portrayed it realistically in all its aspects, from small, intimate scenes along familiar rivers to panoramic views of distant mountains. They often idealized their subjects, sometimes tinting their palettes with reds and purples to give scenes a 'rosy glow'. The Hudson River School lasted from *c.* 1825–70 and included the artists Thomas Cole, Thomas Doughty, Asher Durand, Sanford Robinson Gifford and John Trumball among others. The second generation of Hudson River painters became known as the Luminists (see LUMINISM).

Hue
The most basic attribute of a COLOUR, e.g. redness or yellowness.

I.A.A.
International Association of Art.

I.A.L.
International Institute of Arts and Letters.

I.B.D.
Institute of British Decorators and Interior Designers.

I.B.I.A.
Institute of British Industrial Art.

I.C.A.
Institute of Contemporary Art.

I.C.O. Gra. D.A.
International Council of Graphic Design.

I.E.L.A.
Irish Exhibition of Living Arts.

I.F.A.
Incorporated Faculty of Arts.

Icon
A sacred image, particularly of the Byzantine, Russian or Greek Orthodox Churches, representing Christ, the Virgin or a saint. By and large, icons are paintings or mosaics, though they may occasionally be carved in low-relief. They first appeared as Christian cult images at the end of the fifth century, and were immediately established as objects of popular devotion. After weathering the savage storm of iconoclasm in the eighth century, the cult of image worship became established in the Eastern Church. The production of icons, in fact, continued uninterrupted in Russia into the twentieth century.

Iconoclast

The Iconoclasts were a cult of the Byzantine Church in the eighth and early ninth centuries who associated sacred images with idolatry and were responsible for the destruction of icons on a massive scale. Supported by the Byzantine Emperors Leo III and his son Constantine V, their campaign was so successful that few icons from before the middle of the ninth century survive today.

Iconography

An art-historical term for the study of subject-matter, particularly images and symbols, in figurative works of art. Such study may concentrate on the development of a particular theme or themes in the work of one or several artists.

Iconology

A term used by the art historian, Erwin Panofsky, to distinguish between ICONOGRAPHY and his own more general approach to the study of meaning in the visual arts.

Iconostasis

A screen found in Byzantine, Greek and Russian Orthodox churches which separates the sanctuary from the nave and on which icons are displayed.

I.C.S.I.D.

International Council of Societies of Industrial Design.

Ideal

Ideal, idealization and idealize are used loosely in reference to works of art which improve or perfect the appearance of nature. The term derives from Plato's *Theory of Ideas*, in which the Greek philosopher proposed the concept that beneath perceived objects lie timeless and changeless forms, of which we perceive only imperfect variations. Without these ideal forms, the world would be a chaos of meaningless sensations, language would be impossible and art and science would lack their universal importance. The interpretation of this doctrine by the Neo-Platonist philosopher Plotinus led to the conclusion that a work of art can reflect the essence of an ideal form, and this attitude had a widespread influence on Renaissance art. It is succinctly summarized in a statement of Michelangelo's that, 'All the reasonings of geometry and arithmetic and all the proofs of perspective are of no use to a man without the eye.' The artist's eye for 'ideal' truth could be best developed by study of Classical sculpture, which Renaissance artists believed embodied 'ideal' beauty'

Idealization has taken many forms in the history of art, not all closely related to the doctrine of Plato, by any means. It is most often used, without philosophical justification, in the sense that to idealize is to improve on or to perfect the appearance of nature.

Illuminated Manuscripts

Hand-written books, decorated with paintings and ornaments and found in many periods before the advent of printing. The earliest illuminated manuscripts are EGYPTIAN and the form is found in Late Antique, BYZANTINE, Hiberno-Saxon and CAROLINGIAN art. It is, however, particularly associated with the ROMANESQUE and GOTHIC periods. The manuscripts were written on parchment or vellum and the most common books illuminated in the Middle Ages were Gospels, Psalters and Books of Hours.

Illumination

The embellishment of written, and later printed, text with gold, occasionally silver and other colours. The term is today applied to the decoration of early manuscripts in general, for which see ILLUMINATED MANUSCRIPTS. The old French term was '*enlumine*', meaning 'brighten', and strictly speaking, therefore, 'illumination' applies to the use of gold and silver. Decoration with red ink, for example, is not illumination but rubrication.

Illusionism

The representation of an object so that its naturalistic appearance deceives the spectator's eye and it *seems* real, although the spectator *knows* that the object is only depicted.

Illusionism has been common in painting

ILLUMINATED MANUSCRIPTS. *A fragment from the late thirteenth-century Flemish manuscript called the Beaupre Antiphoner. The initial letter 'O' shows the* Betrayal of Christ.

and decoration since Antiquity, when the Greek artist Zeuxis was famous for his TROMPE L'OEIL paintings of grapes which appeared so realistic that even the birds were said to be deceived by them. Illusionism became part of the technical vocabulary of architecture and theatrical design.

Illustration

A drawing, painting or printed work of art which accompanies a written text which may be of a literary or a commercial nature. A good illustration will not only be decorative, but will emphasize and interpret the text.

ILLUSTRATION. Madonna Lilies *by Walter Crane. The artist has emphasized the 'stately', 'pale', 'proud' and 'pure' qualities indicated in the poem.*

Illustration Board
See PAPER.

Imagen de Vestir
Crudely carved images representing holy figures found in some Spanish and Italian churches. Only the head, hands and feet of these carvings are finished in detail.

Imago Pietatis
A representation of Christ standing in the tomb, with the emphasis on the suffering of the Redemption. He is sometimes accompanied by the Virgin, Saints and Angels. This image was particularly popular in late mediaeval church art. See also PIETÀ.

Imp.
An abbreviation of the Latin word '*impressit*', meaning 'he has printed it', which appears on a print preceded by the name of the printer, or sometimes the name of the engraver.

Impasto
Strictly speaking, this term describes the thickness of oil or similar paint applied to a support, although it commonly includes the process of application. The marks of the brush, palette knife or other implements are frequently visible, and enhance the textural richness of the work.

Imperial
See PAPER.

Impression
1. Any print made from a carved or engraved block, plate or stone. A good impression is one for which the strength of ink, pressure and control of the paper combine evenly to make a clear and faithful copy of the original. 2. An entire EDITION.

Impressionism
A movement, which originated in France in the 1870s and whose artists attempted primarily to achieve a high degree of naturalism through the exact analysis of tone and colour and through the meticulous

depiction of light on the surface of objects. The Impressionists departed from the traditional use of continuous, blended brushstrokes, and instead applied bright, high-key colours in disconnected strokes which were to be combined by the eye. Although Impressionist pictures were generally painted out-of-doors, allowing for a fleeting, circumstantial record of a scene, even those produced in the studio attempted to avoid any suggestion of contrivance. Auguste Renoir and Edgar Degas became particularly adept at conveying effects of spontaneity in their studio-produced

IMPASTO. (*Left*) The Beach at Scheveningen *by Vincent van Gogh. The top left-hand corner of the sky, the waves of the sea and the brushstrokes incised into the foreground show how thickly Van Gogh applied his paint.*

IMPRESSIONISM. (*Below*) Bathers at La Grenouillère *by Claude Monet. This early example of an Impressionist painting displays characteristically fragmented brushstrokes and an overriding concern with the effect of light.*

pictures, chiefly by relying heavily on sketches taken directly from nature.

Like most major stylistic movements, Impressionism constituted a reaction to the past, specifically to the Academic style of the early and mid-nineteenth century. But it also resulted from contemporary researches in the field of colour physics, and innovations in colour theory, such as the discovery that an object casts a shadow tinged with its COMPLEMENTARY COLOUR.

Public hostility to Impressionism was considerable, and the first Impressionist exhibition, held in Paris in 1874, was both a critical and commercial failure. However, the chief artists of the movement, including Claude Monet, Camille Pissarro, and Alfred Sisley, as well as several of those less firmly committed to its precepts such as Renoir, Degas and Paul Cézanne, are among the most influential figures in the course of modern art.

Imprimatura

A transparent, coloured tint or glaze which is laid over a preliminary sketch or drawing to make a coloured GROUND. See also VEIL.

In., Inv., Invenit., Inventor

Abbreviations and different word forms of the Latin meaning 'to design, to create' and found after an artist's name on a print. It indicates that the artist produced the original work but did not make the block or plate from which the print is made.

Inc., Incid., Incidit, Incisor

Abbreviations and different forms of the Latin meaning 'to cut' and found after the name of the engraver of a print, when the engraver is not the artist of the original work.

Indian Ink

Pure black INK used for drawing and sometimes used to accent watercolours.

Indigo

See BLUE.

Industrial Design

A branch of APPLIED ART which specializes in mass-produced, machine-made articles.

Occasionally called Industrial art.

Inert Pigments

White or almost white pigments which can be used to extend or modify other pigments because they are chemically stable (and so will not react in combination with others), and colourless or nearly colourless when ground in oil. Chalk, clay and gypsum are common examples of inert pigments.

Informal Art

See, ART INFORMEL, L'.

Ingres Paper

See PAPER.

Ink

Two types of ink are regularly used by artists: thin solutions known as drawing inks, which can be applied with either a brush or pen, and the thicker pastes used for printmaking. Drawing inks resemble ordinary writing ink in consistency, but they are specially formulated to be less FUGITIVE and more waterproof to meet the artist's requirements. They can be thinned with water before use, and a WASH of one colour can be placed over another without affecting the original stain. Nowadays drawing inks are manufactured in a variety of colours, but most are ultimately fugitive and are not recommended for works of art which are intended to endure. They are, however, popular with commercial artists for the sharp, dense appearance of a freshly drawn or painted image made with drawing inks reproduces well. The range of black inks generally known as INDIAN INK is an exception, being virtually permanent. These are made of pure carbon pigment (usually lampblack) and may be purchased in liquid form (that is in a suspension which includes a preservative) or in solid cakes or sticks. In its dry state, black drawing ink may be called Chinese or Japanese (also known as Sumi) ink. The solid pigment is mixed with water or other liquid to rehydrate it to usable form. These transparent black inks have been in use in the East since approximately 2,500 B.C.

Printmaking inks are thick pastes made of pigment bound in a drying oil, and re-

semble oil paint in nature and consistency. They are sticky, come in a range of colours and are usually applied to the printing surface with rollers so that they cover it thinly and evenly.

Intaglio

1. A design in sculpture, jewellery or carving which is cut below the surface, as opposed to RELIEF work in which the design stands out. Also known as cavo-rilievo. 2. In printmaking, the etching or engraving of a design into a metal plate so that the design is below the plate's surface. Ink is then spread over the plate but wiped off the surface so that it remains only in the incised design. Paper, which may be dampened, is then firmly pressed against the plate and forced into the design, from which it receives the ink image.

Intensity

A term that describes the power, brightness and strength of a PIGMENT or COLOUR.

International Gothic

A style of painting identified with the last phase of Gothic art, dating from the late fourteenth to the early fifteenth century. The concept of such an international style in Europe at this time was first described by the French art historian Louis Cournajod in 1892. He distinguished several characteristics which hold good to this day, most notably an attempt to reflect the elegance and sophistication of court life through secular subject-matter, the use of elongated figures, an emphasis on costume, and a new, more delicate use of colour. A delight in naturalistic detail might be added to this list with advantage.

International Gothic is usually suggested to have originated in France in the mid-thirteenth century, though with a debt to the naturalism of Flemish art of the time, and to have spread principally to Italy, Germany, England and Spain. Notable exponents of the style include the Limbourg brothers in Burgundy, Gentile da Fabriano in Italy and the Master of the Wilton Diptych in England. It should be noted that contemporary art historians have recently started to question the very idea of such an all-embracing style, and it is rapidly falling from use in the field of Italian painting in particular.

Intimism

Post-Impressionist *genre* paintings, especially those of Pierre Bonnard and Edouard Vuillard, which show detailed interiors, gardens and domestic scenes.

Intonaco

See FRESCO.

I.S.

International Society of Sculptors, Painters and Gravers.

Isocephaly

A compositional characteristic of classical Greek, or Hellenic art in which the heads of all the figures are on the same level, whether standing, seated or mounted. The most famous example is on the frieze of the Parthenon in Athens.

Isometric Drawing

TECHNICAL DRAWING which does not use PERSPECTIVE, but keeps the scale of height, width and depth constant throughout so that engineers and builders can see actual and not distorted relationships. Shape and depth is provided to a certain extent through the use of lines that vary in thickness and tone.

Italianate

A term used for the style of any work of art that recalls the classicism of the Italian Renaissance.

Ivory Board

See PAPER.

Japan
1. A type of clear varnish mixed with oil paint. It is quick-drying and produces a glossy effect. 2. A type of quick-drying matt paint used for sign painting.

JAPONAISERIE. The New Necklace *by William McGregor Paxton. The screen, the figurine and the kimono jacket worn by the seated girl show how fashionable Japanese objects became in the second half of the nineteenth century in both Europe and America.*

Japanning
The term for a number of different European imitations of Oriental LACQUER, found on furniture and objets d'art from the mid-seventeenth century onwards.

Japonaiserie
Refers to both the Japanese goods that flooded into Europe from the 1850s onwards, and the works created by Western craftsmen in imitation of them. Much valued by the 'decadent' or Parnassian poets and painters, Japanese fans, woodblock prints, porcelain, textiles, furniture and lacquer succeeded the eighteenth century fashion for CHINOISERIE after the re-opening of Japanese trade routes in 1858. They enjoyed a much publicized vogue until the turn of the century. Although highly prized today, Hokusai prints were being used as packing material for porcelain when James Whistler first encountered them in the 1870s. See also UKIYO-E.

Japonisme
The influence of JAPONAISERIE upon the work of the IMPRESSIONIST and POST-IMPRESSIONIST painters. See UKIYO-E.

Journeyman
From the French 'journée' meaning a full day, a journeyman was a skilled worker, who had completed his apprenticeship, but was not yet a Master of his GUILD. He was therefore employed by the day to work under Master artists or craftsmen in the mediaeval studios.

Judas Hair
Brilliant red hair in paintings, so called because of the reputed colour of St Jude's (rather than Judas Iscariot's) hair.

Jugendstil
See ART NOUVEAU.

Junk Sculpture
A form of sculpture in which the debris of modern society is used. See ASSEMBLAGE, READY-MADES and FOUND OBJECTS.

K

Kaolin
Fine white clay for making PORCELAIN.

Key
The predominant range of colour VALUES and TONES in a painting. A painting is said to be in a high key if the predominant range is of light, bright colours, and in a low key if it is at the dark end of the scale.

KINETIC ART. Kinetic Sculpture (Standing Wave) *by Naum Gabo. A vibrating metal filament gives this sculpture a delicacy that could only be provided by movement.*

KICKWHEEL. *The potter controls the speed of the kickwheel by the rapidity with which he pushes against the foot bar.*

Kickwheel
A POTTER'S WHEEL operated by a treadle, bar or pedal at its base.

Kidney
A steel or rubber tool used for shaping and smoothing clay surfaces in CERAMICS.

Kiln
An oven or furnace used for firing CERAMICS and fusing ENAMELS.

Kinetic Art
A general term for works of art, particularly sculptures, which contain mobile elements. See also AUTOMATON, MOBILE.

Kit-Cat
A size of canvas (36 × 28ins) previously used for portraits. It took its name from a series of portraits showing the torsos and hands of the members of the eighteenth-century Kit-cat club: a Whig group which met in Shire Lane, the premises of one Christopher Cat, a pastry-cook. The series was executed by Sir Godfrey Kneller, and thirty-nine of the original forty-two pictures can be seen in the National Portrait Gallery, London. Each member donated his portrait to the club.

Kitsch
Low quality, frequently mass-produced artefacts, usually of sentimental appeal. Plastic Madonnas and models of the Eiffel Tower fall into this category.

Kitchen Sink Realism
The painting of a group of British SOCIAL REALIST artists, working during the 1950s and 1960s, whose principal preoccupation

93

was the depiction of banal domestic scenes of working class life. The most important members of the group were John Bratby, Derrick Greaves, Edward Middleditch and Jack Smith.

KITCHEN SINK REALISM. Mother Bathing Child *by Jack Smith. This painting of 1953 echoes the interest in working class life that emerged in British writing and painting in the early 1950s.*

Kneaded Rubber
See ERASERS.

Kolinsky
The Siberian mink, or marten, whose hair is used for the best 'red sable' brushes.

Kore
The female counterpart of KOUROS.

Kouros
A Greek statue of a young man from the ARCHAIC period. Highly stylized, and usually characterized by the ARCHAIC SMILE, it seems by reason of its rigidity, to be confined by the rock from which it is carved.

Lacquer
1. A VARNISH made of RESINS or shellacs dissolved in turpentine or alcohol, but not recommended for use on paintings because of its tendency to turn yellow. 2. A resin obtained from the trees of the variety *Rhus vernicifera* which grow exclusively in the Far East; and its modern synthetic equivalents which can be coloured and used to decorate objects or massed together and carved. These two art forms are traditionally associated with Japan.

Landscape Painting
A painting in which natural scenery is the principal subject, although figures, animals, buildings, and other objects may be incorporated in the composition. In Western Art, paintings of exclusively landscape subjects fell from favour at the end of the classical period and only re-emerged in the sixteenth century. Landscape was of course often depicted in the background of paintings, and in the works of some artists, such as Giovanni Bellini, Giorgione and Leonardo da Vinci, it became an increasingly conspicuous element. It was in the work of the DANUBE SCHOOL that landscape first came to be treated as an independent *genre*.

The seventeenth century saw the emergence of two strands of landscape art: the pastoral or ideal tradition of Claude Lorrain and Nicolas Poussin; and the naturalism of Dutch artists such as Albert Cuyp, Jacob van Ruisdael and Meindert Hobbema. Eighteenth-century artists drew equally on these schools, with the conventions of Claude's work establishing a type of picturesque beauty exemplified by the works of Richard Wilson and the young J. M. W. Turner, in England. The straightforward, naturalistic approach found in seventeenth-century Dutch art, however, came to

dominate the nineteenth century. The works of John Constable, in particular, provided a new focus for landscape as an unadorned subject, and his influence is particularly apparent on the BARBIZON SCHOOL in France. From the 1870s onwards, the century was dominated by the IM-PRESSIONISTS who brought the painting of pure landscape to its logical conclusion in works that examined the light and form of landscape with minimal concern for subject-matter. In the twentieth century, the confusion of styles and movements has disguised any notable themes in the history of the *genre*. It remains, though, the subject *par excellence* of the amateur and an enduring source of inspiration for any artist.

Lay-Figure

A jointed, wooden model of the human figure. Originally life-size, they were draped with clothes and accessories by portraitists, so that much of the painstaking and detailed work could be carried out in the absence of the sitter. Today full-size lay-figures are virtually unobtainable and artists make do with small MANIKINS, sometimes covered by fabric which is varnished to hold it in position.

Lay-in

To paint or draw the complete design for a work of art in a DEAD COLOUR on the actual painting surface prior to the application of colour. Also known as underpainting.

Layout

In COMMERCIAL ART and DESIGN, a detailed guide showing how material is to appear once it is printed. The layout artist instructs the printer regarding size of type-matter and illustrations and where and how special effects such as tints or borders are to be placed.

L.C.A.D.

London Certificate in Art and Design.

LIFE DRAWING. *Study for 'Le Bain Turc' by Jean Auguste Dominique Ingres. The drawings on this sheet of paper would have been made in front of a model.*

Leaf

Thin sheets of metal, especially gold, used for GILDING.

Lean Colour

Oil paints with a low oil content used for building up layers in the traditional method. See FAT OVER LEAN.

Life Drawing

Drawing the human figure from a living model.

Light Box

An instrument which has a translucent surface lit from below with a regulated light source which illuminates the entire surface evenly, used by commercial artists for checking transparencies and colour proofs for accuracy.

Limited Edition

An EDITION of a specific number of prints, in which the IMPRESSIONS bear numbers indicating the sequence in which they were produced and the total number of prints in the edition. 3/25, for example, signifies the third print in an edition of twenty-five. The block or plate is always destroyed or marked after printing a limited edition.

Limner

An old-fashioned word for an artist, particularly a portrait or figure painter. It is sometimes used to mean a painter of miniatures.

Linear

A painting or sculpture described as 'linear' is a work in which the artist has made his forms distinct by emphasizing their outlines, thus restricting where the eye is directed and interaction between elements in the work. See also PAINTERLY.

Line and Wash

The use of pen-drawing and watercolour washes to fashion a picture. Usually the penwork (using waterproof ink) is completed first and watercolour washes added to provide colour.

LINE AND WASH. *From* The Tour of Dr. Syntax in Search of the Picturesque *by Thomas Rowlandson. This watercolour would have been drawn in ink initially and then the washes of paint would have been added by the artist. The inscription at the bottom reads, 'Dr Syntax unable to pull up at the Lands end is fearful of being carried to the Worlds end.'*

Linear Perspective

PERSPECTIVE in which a three-dimensional effect is achieved solely by the use of line. The accurate disposition of lines achieves an illusion of distance by following the principles of perspective.

Line Drawing

A drawing in which lines alone produce the forms and in which HATCHING and CROSS HATCHING provide shading and modelling.

Line Engraving

The basic INTAGLIO engraving technique in which a BURIN is used to cut a design into a metal plate. The BURR which develops as the plate is cut is removed so that each line is sharply defined.

Linocut

A RELIEF print made from a LINOLEUM BLOCK.

Linoleum Block

Linoleum on a hardwood block that provides a printing surface in the manner of a WOODCUT. Since linoleum is a softer material than wood, it facilitates the carving of the image.

LINEAR PERSPECTIVE. *Detail from* The Annunciation with St. Emidius *by Carlo Crivelli. A sense of recession is achieved in this painting by the angles of the lines and the smallness of the figures and buildings in the background. The detail and the contrast between tones would be blurred, as they are in reality, if the artist had made use of* AERIAL PERSPECTIVE.

Linseed

The seed of the Flax plant from which a drying oil is pressed, which after refinement is suitable for mixing with PIGMENTS as 'linseed oil'. The stem of the plant also provides filaments that are made into flax canvas widely used for oil painting.

Linseed Oil

See OILS.

Literary Art

Works of art which illustrate a text or in which composition is entirely subordinate to a narrative.

Lithography

1. A printmaking process which operates on the principle that oil and water will not mix. A greasy crayon is used to draw the design on the surface of a porous stone (usually limestone); the stone is then thoroughly wetted and an oil-based ink rolled across its surface. Where the greasy design has repelled the water, the ink will adhere. The stone is then pressed on to paper; multiple impressions are easily made by repeating the wetting and inking stages. 2. A photomechanical process based on the above technique: a photographic image is developed on a special light-sensitive surface; the image forming the greasy surface necessary to the technique. The plate, which may be wrapped around a cylinder, is passed over water and then inked, but instead of printing on to paper, the plate makes its impression on a rubber 'blanket' which in turn transfers the design on to paper, which is why this process is known as 'offset' lithography.

Living Sculpture

See PERFORMANCE ART.

Loaded Brush

A paint brush which is holding the greatest possible quantity of paint.

Local Colour

The actual colour of an object or area. The effects of light, shadow and reflection from nearby objects usually reduce the percentage of local colour substantially and it is

observation of these changes which adds subtlety and realism to paintings. A naive artist, for example, paints predominately in local colours, and when he attempts to represent the effects of light or dark, it is usually through the addition of white or black pigments. An artist with some knowledge of colour, however, will be aware that the shadow of an object contains some of its COMPLEMENTARY colour and will modify his shadow accordingly.

London Group

A group of artists formed in 1913 and principally composed of artists from the defunct CAMDEN TOWN GROUP, defectors from the VORTICISTS, and additional like-minded artists who shared their ideas. The initial concern of the London Group was to integrate some of the principles found in POST-IMPRESSIONIST painting into British art, which was still notoriously academic. Walter Sickert and Roger Fry were two of the most influential members within this group, which also included Augustus John, Matthew Smith, C. R. W. Nevinson, Paul Nash, Jacob Epstein and the group's two official leaders, Spencer Gore and Harold Gilman.

Lost Wax

A method of CASTING which relies on melting away a thin layer of wax which has either been applied to the outside of a plaster cast and surrounded with a heat-resistant moulding material, or to the inside of a hollow mould which is then filled with sand. By pouring molten metal into the space where the wax is, the metal replaces the wax and, once cool, provides a hollow replica of the original sculpture.

Low Relief

A sculpture which has been carved from a flat surface, but in which the design is not deeply cut so that the image is raised only slightly from the background. Also known as a bas-relief.

Luminism

A recently coined name for the work of nineteenth-century American painters such as John F. Kensett, Fitz Hugh Lane, Worthington Wittredge, Sanford Robinson Gifford and Martin Johnson Meade, who carried on the traditions of the HUDSON RIVER SCHOOL. Their landscapes are infused with light and show overriding concern with the depiction of atmospheric effects. Unfortunately, to achieve their brilliant effects, the Luminists employed a number of recently introduced pigments which proved to be unstable and many of their works are permanently disfigured.

Lunette

A semi-circular painting surface, often the decorated area over a window or door.

LUNETTE. *A lunette showing a* Pietà *above the altarpiece of* The Virgin and Child with St. Anne and other Saints *by Francesco Francia. Note how the wings of the angels follow the shape of the painted border.*

Madder Lake
See RED

Magenta
A deep PURPLE. One of the three PRIMARY COLOURS of modern printing processes.

Magic Realism
Related to SURREALISM, and to the META-PHYSICAL ART of Giorgio di Chirico, magic realism is painting in which the individual elements are depicted with extraordinary attention to realistic detail. These elements, however, are placed in incongruous settings or are transfigured by juxtaposition with strange, often distorted figures. The impact of the painting depends upon the exactness of portrayal of individual elements, and affords much the same impression as a vivid and outlandish dream.

Mahlstick
A thin cane with a spherical head, often covered with leather, which the painter uses as a support for his arm during particularly long or detailed work. Also known as a maulstick.

Mainstream
A term used to define the unbroken strand of tradition in art. A 'mainstream' painter is thought to occupy a natural and logical position as the successor of one painter or school and the predecessor of the next.

Maiolica or Majolica
See FAIENCE.

Malachite
See GREEN.

Malerische
See PAINTERLY.

Mallet

Mallet
A sculptor's mallet is shaped like an emblematic thistle, having a conical, tapering head. It is carved from one block of hardwood, and different weights are used ($\frac{3}{4}$–$2\frac{1}{4}$lbs) according to the delicacy of the work.

Mandorla
From the Italian word meaning 'almond', a mandorla is an almond-shaped AUREOLE, which completely encircles a divine figure, usually Christ or the Virgin Mary. Also known as Vesica Piscis.

Manganese
See BLACK, BLUE and GREEN.

Manikin

Manière Criblée
See DOTTED PRINT.

Manikin
A small LAY-FIGURE with rudimentary joints.

Mannerism
A style in Italian art between *c.* 1530 and *c.* 1590 generally regarded as an interlude between the High Renaissance and the Baroque. It was characterised by elongated forms, vivid often harsh colours and frequently dramatic subject-matter. The principal artists associated with the style include El Greco, Jacopo Tintoretto, Parmigianino, Jacopo Pontormo, Agnolo Bronzino and Giorgio Vasari.

Maquette
A small clay or wax model which serves as a three-dimensional SKETCH for a sculptor, and is often presented to a patron for approval or entered in competitions for a prize or a scholarship. Also known as a bozzetto.

MAQUETTE. *A detailed study in terra cotta for a bust of Cardinal Emilio Zacchia by Alessandro Algardi.*

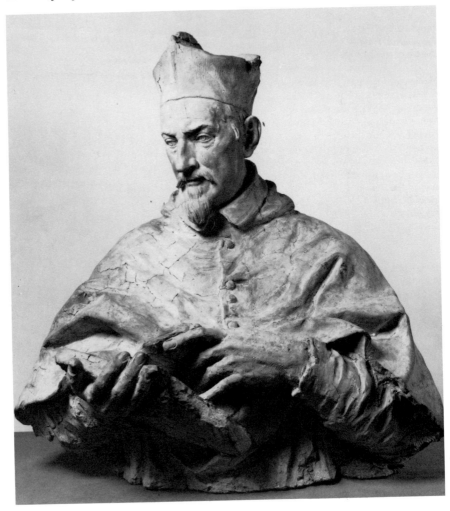

Marble

A hard, veined form of crystalline calcium carbonate formed in a variety of colours. It can be finely cut and attains a high polish and is therefore highly regarded by sculptors and architects. It is not, however, the most durable of stones. The most famous marble comes from the Carrara quarries in Tuscany.

Marbling

The decoration of paper with dyes which float in a soft gum solution. These are dispersed and flowing patterns produced by the disturbance of the surface with a comb. The paper surface is then laid upon the fluid, and picks up its variegated swirls and blotches. Marbling was much favoured for endpapers and book-edges in the eighteenth and nineteenth centuries.

Marine Painting

Any painting of the sea, but usually distinguished from SEASCAPES in that marine paintings often contain a narrative element. Famous battles, rescues and storms at sea have been depicted since classical antiquity, but only with the advent of the Dutch republic in the seventeenth century did marine painting really come into its own. Notable amongst the Dutch marine painters were Hendrik Cornelius Vroom, Cornelius Claesz, Jan Porcellis and, most

MARINE PAINTING. A Dutch Man-of-War and other Vessels in a Breeze *by Willem van der Velde the Younger.*

notably Willem van de Velde the Younger. As Britain took over the mastery of the waves, so too did her marine painters succeed the Dutch. Peter Monamy led the way, to be followed by Charles Brooking and, in the nineteenth century Jacques Philippe de Loutherbourg, J. M. W. Turner, and Clarkson Stanfield among others produced excellent marine pieces.

Marouflage

To glue a painted canvas to a wall or panel.

Mask

1. A mould of the face and/or head. 2. To act as a RESIST.

Masking Fluid

A liquid RESIST which is applied to those areas of work which are to be protected when applying watercolours or tempera in broad WASHES, or when working with an AIRBRUSH.

Masking Tape

A sticky tape which is useful to the artist in that it can be added as a support to a RESIST or as a guide in order to obtain a straight edge. It can easily be peeled away without damaging the surface.

Mass

A broad, cohesive area in a work of art that forms a significant element in the composition.

Master of . . .

A title bestowed upon an unidentified artist to whom particular works are ATTRIBUTED because of similarities of style. It is usually followed by the title of his best known work, the name of his patron or the region in which he is believed to have worked, as in 'Master of St Cecilia', 'Master of the Brunswick Monogram' or 'Master of Flémalle'.

Masterpiece

Today this term is used of an artist's best work or, if not referring to a specific artist, of any work of an exceptionally high standard. Originally, a masterpiece was that work which the artist submitted to his GUILD

to demonstrate his mastery. This was an important application, for only by becoming a master could an artist set up a studio and take on pupils.

Mastic
1. A resin, soluble in alcohol or turpentine. A turpentine solution was widely used as a picture varnish in the eighteenth and nineteenth centuries. 2. A resinous cement or grout used for setting mosaics.

Matt, Mat or Matte
Dull, lustreless, without sheen. A matt surface may be a consequence of the material (e.g. water-based paints) or, as with oil paints, a consequence of ageing and settling. Artists can deliberately produce a matt surface by the introduction of a matt MEDIUM or the application of a matt VARNISH. A matt effect is also frequently achieved by ruffling the surface so that it no longer reflects light efficiently. On a wooden or metal surface, this process is known as matting.

M. Des
Master of Design.

Mechanical Drawing
See TECHNICAL DRAWING.

Medium
1. A liquid which is added to paint in order to change its character by altering its consistency, drying time or durability. Traditional oil-painting mediums such as copal and megilp are still available, but modern, synthetic mediums are recommended on all counts, particularly with regard to their resistance to yellowing and cracking. Commonly available preparations are listed here. Some are exclusively available from one manufacturer, but for the most part, all artists' colourmen supply a suitable range.

Acrylic mediums	Alkyd mediums
Gel	As for oil paints
Glaze	
Gloss	
Matt	
Retarder	
Texture for impasto	

MEDIUM. *A range of the standard mediums used for oil and acrylic painting.*

Medium for oil paints	Mediums for watercolours
Copal	Art masking fluid
Liquin	Aquapasto
Meglip	Gum arabic
Oleopasto	Gum water
Opal	Ox gall
Win-gel	Watercolour meglip
Winton	

2. The material and/or processes used in the artist's work; oil paints, pencil, clay painting, sculpture, etching etc.

Meglip

A MEDIUM made by mixing MASTIC varnish with linseed oil supersaturated with white lead. Very popular amongst artists of the nineteenth century, its use has since been discouraged because it proved to be a cause of yellowing and cracking.

Memento Mori

A phrase from the Latin, meaning a reminder of death. Usually a symbol or motif whose function is to remind the viewer of the transience of beautiful things and especially of his own life. Commonly a skull, but sometimes a time-piece or a flower. See also VANITAS.

Mesopotamian Art

See BABYLONIAN ART.

Metal Cut

A RELIEF print made by working on a metal engraving plate in the same way, and usually with the same tools, as for a WOODCUT. The artist therefore cuts away the area which is *not* to be printed, rather than incising the lines of the image into the plate. William Blake experimented with this technique in his 'woodcuts on pewter'.

Metal Point

A technique for making a design on a specially prepared surface using a pointed rod of pure soft metal, commonly silver. All metal points, save lead which was the predecessor of the graphite pencil, call for a rough working surface, usually coated with Chinese white. It is virtually impossible to make marks of different strengths or widths in this medium, so the artist relies entirely upon his draughtsmanship.

Metaphysical Art

An Italian movement with few aims or principles, and these rather vague, which enjoyed a brief vogue in the second decade of this century. A reaction to FUTURISM, its principal exponents were Giorgio de Chirico and Carlo Carrà. De Chirico explained that 'a work of art must stand completely outside human limitations; logic and common sense are detrimental to it. Thus it approximates dream and infantile mentality.' The paintings depict a topsy-turvy, frequently eerie world of extraordinary perspectives, incongruous images, and distorted, yet naturalistic figures and objects. They owe much to the dream images identified by the then fashionable psycho-analysts and can be seen, both in terms of style and of content, as predecessors of the school of the absurd.

Métier

The subject-range in which an artist specializes or is considered particularly masterful.

Mezzo Fresco

The fresco technique of the late sixteenth century, as distinct from 'buon fresco'. Because it made use of drier *intonaco*, colours were only slightly absorbed into the plaster.

Mezzo Rilievo

Carved in medium-high or half-relief. Distinctly raised from the surface, but far from free-standing.

Mezzotint

An INTAGLIO or RELIEF printing process developed in the seventeenth century, in which the whole surface of a metal plate is covered with burred dots made with a toothed tool called a ROCKER. The BURRS are scraped away to give half-tones and lights (if the plate were printed before scraping it would result in an almost solid tone). Tone varies according to the depth of the scraping or burnishing. For even darker tones, a DRY-POINT needle may be used to increase the burr. Because of the range of tones available

MINIATURE. Portrait of Mrs Pemberton *by Hans Holbein. This small pendant would probably have been worn by the lady's husband.*

in mezzotint, it was widely used for colour printmaking in the eighteenth and nineteenth centuries, especially in the reproduction of paintings. With the development of photoengraving and photogravure, however, mezzotint became almost obsolete, save as a means of obtaining a thicker texture upon the plate.

M.F.P.S.
Member, Free Painters and Sculptors.

Migration Art
See BARBARIC ART.

Mineral Painting
See WATER–GLASS PAINTING.

Miniature
A very small, finely executed picture, frequently a portrait, painted on ivory, vellum, card or fine skins, such as chicken skin. Miniature paintings can be said to have their origin in mediaeval manuscript illumination. Open letters (B, C, D, G, O, etc.), were filled with tiny pictures in red ink called '*minium*' in Latin, meaning red lead. The term *miniature* is derived from '*minium*' and is unconnected with the Latin '*minor*' or '*minimus*'. By the sixteenth century, the painting of miniatures had become an art form in itself, and miniatures of loved ones, commonly covered by convex glass and framed in gilt, were carried by courtiers. Tempera was the usual medium until the eighteenth century, when transparent watercolours came into favour. Greatest of the English LIMNERS or miniaturists are Nicholas Hilliard, Samuel Cooper in the seventeenth century and Richard Cosway in the eighteenth. Holbein, Fragonard and other court painters also sometimes worked in miniature.

MINIMAL ART. *Equivalent VIII by Carl Andre. One of a group of eight sculptures the artist made from the same number of standard fire bricks arranged in variations, all of which consist of two layers.*

Minimal Art

A broad category for the most extreme forms of ABSTRACTION, first explored by members of the NEW YORK SCHOOL in reaction to developments in ABSTRACT EXPRESSIONISM. The minimal artist is entirely concerned with reducing his work to combinations of geometric shapes, colours and textures (an example would be an all-white, perfectly smooth model of a cube); the results are not intended to represent any object or emotion, either for the artist himself or the spectator. Indeed, much minimal art takes the form of sculpture as it is generally accepted that spectators are less conditioned to analyse sculpture than paintings and other two-dimensional work. The artistic sources of minimal art are found in SUPREMATISM and DE STIJL and the works of Mark Rothko and Ad Reinhardt. Its leading exponents include Ellsworth Kelly, Morris Louis and Frank Stella.

Minoan Art

A term commonly used to refer to the art of Crete, especially that produced between 2,500 B.C. and 1,100 B.C. The term was first used by Sir Arthur Evans following his excavations, begun in 1899, of the palace of Minos, the legendary king of Crete, at Knossos. This excavation revealed splendid wall-paintings and coloured reliefs, as well as large quantities of stone, metal, ivory and clay artefacts.

Early Minoan pottery is characterized by abstract, geometric patterns, while examples from the later phases commonly exhibit stylized, brilliantly-coloured plants, animals and human figures. Many of the conventions of pottery decoration were applied with similar effect to wall-paintings and reliefs. However, rather than stretching across the wall in a continuous narrative, the motifs making up a frieze or relief were most often framed individually. These motifs often portrayed human and animal figures engaged in athletic feats, and resembled Egyptian and Babylonian art in their combination of profile and frontal views.

Various criteria have been established for distinguishing between the major phases of Minoan civilization. Most commonly, the

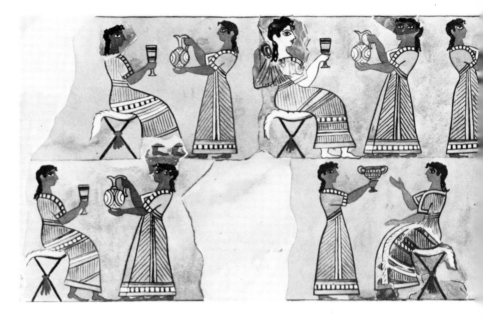

MINOAN. *Ritual scene from the Sanctuary Hall at the Palace of Knossos from about 1500 B.C.*

island's history is divided into Early, Middle and Late phases and is considered in terms of its architecture. Unlike many other ancient cultures, Crete's architecture is less noteworthy for its temples and fortresses than for its luxurious palaces. The first great palaces were built at Knossos, Phaistos and Mallia between 2,000 and 1,700 B.C. These were rebuilt and decorated about 1,500 B.C. in what is known as the Palatial style. All the palaces were destroyed in a series of invasions from the North, beginning in 1,400 B.C., and by about 1,100 B.C. Minoan art had become indistinguishable from that of the mainland.

Misericord

The hinged seat found in church choir stalls. When not being used as a seat, the misericord can be leaned back to serve as a prop or rest while standing. It it usual to find the undersides of these seats carved with grotesque animals and figures from Biblical or folk tales. 'Misericordia' is Latin for 'mercy' and is one of the titles of the Virgin Mary.

Mitre

1. A joint made by fitting two sides together to form a 90° angle; essential in framemaking. 2. The action of making such a joint. 3. A machine or hand tool with a specially angled blade used for cutting lengths of material which are to be joined to make a mitred corner.

Mixed Media or Multi-Media

A painting or other work of art in which more than one medium and/or material is used; for instance, applying cloth and egg shells to a support, using acrylic, watercolour and pen on a single work, or applying tempera to an oil painting.

Mixing Tray

A pan made of easily washable material used for mixing and diluting water-based paints. Most trays have several compartments so that the artist can arrange his colours in a functional PALETTE.

Mobile

A hanging sculpture or other construction composed of various shapes—either man made or natural objects such as shells and bits of wood. Each element in the mobile is suspended by its own wire or string, the

strings being attached to central supports.

Modelling
1. The manipulation and building up of a plastic material such as clay or wax. 2. Posing for an artist. 3. The depiction of light and shade in order to give the illusion of three-dimensional properties to a figure or object in a painting or drawing.

Modelling Clay
1. Any clay which can be modelled or thrown. 2. A non-hardening clay containing various additives, also known as Plasticine. It is useful for making models for casting or for later, larger works. It can be used again and again and can be obtained in a variety of colours.

Modelling Tools
Tools used to shape, smooth and trim clay, plaster and wax. Although available in a

MOBILE. Five White Discs with Colour Tail by *Alexander Calder. The photograph of this hanging structure emphasizes the linking wires* that allow the piece to change the relationship of its parts. Calder is generally credited with exhibiting the first 'mobile' in 1932.

variety of shapes and materials, traditional modelling tools are usually made of box-wood and have two working ends. These are spatulate, pointed, round, square or serrated. Other essential modelling tools have a bent wire at each end for trimming and carving.

Modello

The Italian word for a sketch or MAQUETTE for demonstration to a prospective patron.

Monochrome

Refers to light and dark shades of a single colour, or a picture executed in a single colour. See also GRISAILLE.

Monolith

1. A sculpture made of or cast in one single piece. 2. A stone column frequently erected for commemorative purposes, for example an OBELISK.

Monotype

A single print made from a design which has

MONOTYPE. *Portrait of Whistler by Charles A. Corwin. Monotype prints are made by pressing a sheet of paper on to a smooth, painted surface. In this print, the brushstrokes on the original surface can be seen clearly.*

been painted in a tacky paint or ink on to a metal plate or sheet of glass which is then pressed on to paper. The purpose of transferring the image in this way is to obtain a texture and surface quality quite different from that which can be attained by painting directly on to paper. A further advantage is that additional impressions can be made by re-inforcing the remains of the original design on the plate, though it must be stressed that no two monotypes will be identical. Also a variety of type used in commercial printing.

Montage

A COLLAGE made up entirely of printed and/or photographed images. These may be juxtaposed to make an overall composition or laid one on top of the other to give a new composite image.

Morbidezza

Italian for softness, and hence used to describe the blending of tones, particularly flesh tones, and the 'soft focus' effects which characterize the work of, for example, Correggio or Auguste Renoir.

Mordant

1. The acid in which an etching plate is immersed. The mordant eats away the lines on the plate which are not protected by a RESIST or ETCHING GROUND. 2. A SIZE for the laying of gold leaf by mordant gilding, used predominantly for laying LEAF in oil paintings.

Mosaic

A design or picture made up of small bits of coloured glass, stone, wood, marble or pottery, called tesserae which are set in a MASTIC or GROUT. One of the oldest of all decorative arts, mosaic was used extensively by the Ancient Greeks and Romans. The earliest known examples date back to the fifth century B.C., and were composed of pebbles and shells. They rapidly became more sophisticated, and by 100 B.C. beautiful and intricate mosaics were being executed in Pompeii and in Rome. The opaque glass tesserae commonly used today were introduced from Byzantium (now Constantinople) where mosaic was the principal

MOSAIC. *A Byzantine wall mosaic of about A.D.550 in the Church of San Vitale, Ravenna showing the Emperor Justinian's wife, Theodora, and her attendants.*

pictorial medium. The churches of Constantinople, Venice and Ravenna were resplendent with such mosaics, and were frequently designed around them. The Byzantine influence spread rapidly. During the Renaissance, many prominent masters, amongst them Raphael and Titian executed cartoons for mosaics. The art is still practised by some craftsmen, but is no longer considered practical on a large scale.

Motif

A recurrent theme or pattern in a work of art. The repetition may take place in the same work as, for example, in a decorative border or textile design. It may also be a recurrent subject in a particular artist's work.

Moulding

Lengths of material, usually wood, stone or plaster, used to enclose or decorate doors, windows, cornices, or picture frames. Although modern manufacturing materials and methods have made it possible to expand the range of mouldings now available, most are still variations of traditional

Mouldings

designs. Architectural mouldings are also decorated with traditional patterns such as egg and dart, bead and reel and nailhead. The moulding may be gilt or painted to enhance its effect.

Mount
1. To position a picture, usually a print, watercolour or drawing beneath an aperture cut into a MOUNTBOARD. The purpose of mounting is to draw the eye in from the frame and enhance the effect of the picture. 2. The border made by the mountboard; the distance between a picture and its frame. The artist or his frame will determine the colour and width of such a border; a general rule of thumb is that the depth of the bottom edge should be 20% greater than that of the other three sides. Many mounts have a bevelled edge where they come into contact with the artwork; it is sometimes helpful to decorate and strengthen the mount with thin lines and pale washes. 3. To attach a work of art executed on paper to a stiff (usually cardboard) backing. The traditional method is to paste the two surfaces together or 'lay down' the picture. This is still considered the best practice for a work of any value. For the mounting of mass-produced pieces or works of little value, the modern dry-mounting process may be suitable. This entails bonding the work. A resinous tissue is placed between the two surfaces, is melted by a combination of heat and pressure, and thus fuses them.

Mountboard
A stiff carboard used for mounting pictures (see MOUNT). They may be purchased with the centres already removed so that the artist need only attach his work to the back, though the artist will need to have worked on a standard size of paper. See also MUSEUM BOARD.

Mount Cutter
A hand tool or machine designed to cut the apertures into MOUNTBOARDS.

Munsell System
A method for classifying and measuring colour developed by an American, Albert F. Munsell in 1915. Munsell compiled an atlas of numerous slips of coloured paper arranged by HUE, VALUE, and CHROMA. See also OSTWALD SYSTEM.

Mural
A painting on a wall or ceiling. It can either be painted directly on to the surface, executed on a canvas which is then cemented on to the wall, or executed on panels that will subsequently form the wall to be decorated. Aside from the mechanical problems posed by many walls, there are many purely artistic problems as well. First, the mural designer has to consider the viewpoint from which his work will be seen. Canvases are usually hung at or about eye-level, but a mural is often seen from a variety of angles. There are, therefore, complex problems of perspective to be resolved. The mural must be matt and flat, so that it can be seen from any point and at any time of day without the glare of reflected light. It must be permanent and, last, it must complement its architectural frame. FRESCO is the traditional medium for murals, but is costly and immensely laborious and, although far and away the best method for interiors, is seldom now used. Most interior murals are nowadays executed in OILS, TEMPERA, and POLYMER colours, with far less satisfactory results than fresco affords. Murals on exterior walls are increasingly common in the urban landscape. They too pose their own peculiar problems. There is as yet no surface paint with the durable qualities necessary for an outdoor mural even in dry climates. In the past, therefore, mosaic tesserae, terra cotta tiles and coloured cement have been used traditionally.

Museum Board
An acid-free, pure rag MOUNTBOARD used to protect and preserve works of art on paper. The use of mountboards containing wood pulp is the most common agent of deterioration in such works. The acid in the wood pulp causes paper to discolour and become brittle.

N.A. or N.A.D.

National Academy of Design. The American ACADEMY in New York founded under the title of Society for the Improvement of Drawing in 1825. The academy, which was given its present name in 1828, while still under the direction of its first president, Samuel F. B. Morse, was modelled on the ROYAL ACADEMY in London, and Antique, Life and Painting schools were all operating by 1872. The National Academy of Design was unique among American art associations in restricting its membership exclusively to artists and in enforcing the regular submission of works to exhibitions.

Nabis, Les

One of many such groups of artists of the FIN DE SIÈCLE. Les Nabis dabbled with mysticism and revolted against ACADEMIC conventions. Closely allied to the SYMBOLISTS, Les Nabis derived many of their ideas from Paul Gauguin, particularly with regard to the painting surface and the use of colour. Although they never developed a unified style, these artists—who included Pierre Bonnard, Maurice Denis, Félix Valloton, K.-X. Roussel ('Ker'), Paul Sérusier and Edouard Vuillard—held regular meetings in a bid to express and develop a shared philosophy of painting. They hoped that they might establish a set of rules, the application of which would give their painting a universal quality and enable them to express abstract ideas. This search for universality resulted in an element of abstraction in their work. Other features of the group's paintings were an evident and self-conscious effort to capture the qualities of NAIVE art, a belief that every painting must have some literary content, an interest in the emotional use of colour and linear distortion, and a concern for decorative

LES NABIS. Madame Ranson with a Cat by Maurice Denis. The Nabis painters met at Madame Ranson's house, called 'The Temple', every Saturday afternoon and she was nicknamed by them 'The Light of the Temple'.

presentation. The first Nabis exhibition was held in 1892, although they were not at that time identified by the name which means 'prophets' in Hebrew and was coined by one of their literary associates, the poet Cazalis. After a highly successful exhibition in 1899, the group slowly disbanded.

Naive Art

A term used without much precision to describe the work of modern painters who, despite a lack of conventional expertise or training nonetheless contrive to express something evocative and affecting. Their

NAIVE ART. Tropical Storm with a Tiger *by Henri Rousseau. Rousseau's imaginary jungle was based on tropical plants and animals he saw at the Paris Zoo and Botanical Gardens.*

works belong to no tradition or school and are characterized by bright colours and a complete disregard of such conventions as perspective. The effect may not be realistic, but the intention is immediately clear. Some critics prefer the term 'twentieth-century primitive' for many of the contemporary artists commonly described as naive. The best-known naive artists are probably 'Grandma' Moses and Henri Rousseau.

Narrative Art
Art which illustrates or tells a story. It usually describes self-explanatory events from daily life or those drawn from a text, well-known folk tale or myth. See also GENRE and LITERARY ART.

Naturalism
The realistic representation of figures and objects, without any subjective distortion, stylization or idealization. Classical Greek, Renaissance and Dutch seventeenth-century art are traditionally described as 'naturalistic', since it is sometimes supposed that the art of these periods merely reflects natural beauty. This is, of course, a mis-apprehension. See also REALISM.

Nature Morte
The French term for STILL LIFE.

Navicella
A representation of the Biblical tale of Christ walking on the water and his disciples' loss of faith. The ship in which the disciples are shown is usually understood to symbolize the church.

Nazarenes, The
Initially a derisive name for the *Lukasbrüder* or Order of St Luke, an early nineteenth-century German group of artists and writers. It was the first of many such groups to react against the prevalent spirit of the academies, to revive the spirit of the Middle Ages and to consider art as the tool of religion. Founded by Johann Friedrich Overbeck in 1809, the Nazarenes concentrated on both the motifs and the techniques of early Christian and Renaissance art. They executed many frescoes of a grand or heroic character. Amongst the group's members were Franz Pforr, Peter von Cornelius, Julius Schnorr and Karl Begas. Overbeck and Pforr settled in Rome, where they were joined by Peter von Cornelius, but there the group soon dissolved. Their ideas, however, were to have a considerable influence upon the Pre-Raphaelite movement in England.

N.C.D.A.D.
National Council for Diplomas in Art and Design.

N.D.D.
National Diploma in Design.

N.E.A.C.
The New English Art Club, founded by discontented artists in 1886, and still active today. Its history is one of rebellion against the ROYAL ACADEMY in particular and the ACADEMIC tradition in general. The members favoured the naturalism and spontaneity of PLEIN AIR painting, and included Harold Gilman, Roger Fry, William Rothenstein, John Lavery, Walter Sickert, Philip Wilson Steer, and John Singer Sargent. The breakaway groups from the N.E.A.C. enjoyed unusual success and distinction. These included the CAMDEN TOWN GROUP, headed by Sickert, the GLASGOW SCHOOL, led by Lavery, and the Newlyn Group, who later lived and worked in Cornish fishing villages. Among

other artists associated with the Club were Augustus John, William Orpen, Lucien Pissarro, and Spencer Gore.

Negative Volume or Space

A term used by sculptors and architects to describe those areas of empty space which are delimited and defined by surrounding material, and are thus of importance in the total design.

Neo-Classicism

An international movement of *c.* 1770– *c.* 1830. A reaction to the prevailing BAR- OQUE and ROCOCO styles in favour of the GRAND MANNER of CLASSICISM. Dissatisfac- tion both with the ethical decadence and the aesthetic frivolity of the age led many distinguished artists and writers to follow the lead of the art historian Johann Joachim Winckelmann and the painter Anton Raffael Mengs in seeking to return to both classical ethical values and classical aesthetic rigour. Amongst those who gathered at Mengs's studio in Rome were Benjamin West, the brothers Adam, Angelica Kauff- mann, Joseph-Marie Vien and Henry Hol- land. Vien, in turn, was to teach Jacques- Louis David, in whom the Neo-Classical

movement was to reach its highest ex- pression in painting. In Britain, its influence can be seen in the work of William Blake, Joseph Flaxman and others, but Neo- Classicism was primarily important in its effect upon architecture. The Adam brothers in England, Schinkel in Germany, Ledoux and Chalgrin in France, Powers and Greenough in the U.S.A., were among the architects who re-asserted the grandeur of classicism in many of the most important buildings of their nations.

Neo-Gothic

Principally an architectural term, but often extended to mean any romantic reaction against NEO-CLASSICISM.

Neo-Impressionism

The application of scientific colour theories to the principles of IMPRESSIONISM, practised by Georges Seurat and Paul Signac (see OPTICAL MIXTURE). Neo-Impressionism was

NEO-CLASSICISM. Pauline Bonaparte Borg- hese as Venus *by Antonio Canova. This 1808 portrait of the Emperor Napoleon's sister was a deliberate imitation of a classical subject, pose and style.*

first acknowledged and named at the exhibition of the Société des Artistes Indépendants by Félix Fénéon in 1884. In the next year, Camille Pissarro joined the movement, only to desert it within a very short time. The laborious processes whereby colours were applied in small dots meant that Neo-Impressionist paintings were carefully composed and executed in the studio, a considerable departure from the naturalistic PLEIN AIR painting of the IMPRESSIONISTS. See also POINTILLISM.

Neo-Plasticism
Another name for the movement known as DE STIJL.

Neue Sachlichkeit
A short-lived reaction to EXPRESSIONISM which developed in post-World War I Germany under the direction of Georg Grosz (later a member of DADA) and Otto Dix. The movement, also called New Objectivity, sought to reject Expressionism and ABSTRACTION for a stern, detailed realism, precise to the point of unreality. Neue Sachlichkeit was often concerned with political lampoon or social satire. The only Neue Sachlichkeit exhibition was held at Mannheim in 1925.

Nimbus
See AUREOLE.

New Objectivity
See NEUE SACHLICHKEIT.

New Realism
A term devised by the art critic Pierre Restany c. 1960 to cover a range of art activities which are frequently grouped together as 'European POP ART'. This tends to be an easy definition rather than an accurate one for though, like Pop artists, those associated with New Realism (Yves Klein, Arman and Christo) do take objects and themes from contemporary culture, their creations are predominately non-objective and are frequently intended to be symbolic if obscure).

New York School
A general term for the artists working in New York City from the late 1940s to the late 1960s. Originally, the term was used to refer to the artists who developed ABSTRACT EXPRESSIONISM, but it gradually became a general term for artists working in New York City during this period and it signified the city's emergence as a fertile and vital centre of the contemporary art world and market. The early, and probably the most influential members include Adolph Gottlieb, Hans Hoffman, Willem de Kooning, Jackson Pollock and Mark Rothko. Young artists who gravitated towards these figures included Allan Kaprow and Robert Rauschenberg.

The New York School is associated with extreme forms of contemporary art such as ACTION PAINTING, ASSEMBLAGE, ENVIRONMENTAL ART, HAPPENINGS, HARD-EDGE PAINTING, MINIMAL, OP and POP ART.

Niello
A black metal compound used to fill designs cut into metal sheets. When burnished, the black makes a striking contrast to the surrounding metal. This method of decoration is believed to be the forerunner of LINE ENGRAVING as the artist who wished to see how his niello design was progressing would ink the metal sheet and make a printed impression of the design on paper. The term also refers to the type of jewellery or metalwork produced by this method.

Nocturne
A picture of a night scene; particularly associated with Whistler, whose nocturnes, in Pater's felicitous phrase, 'aspired to the condition of music', and possessed that dream-like quality associated with musical compositions.

Noli Me Tangere
A representation of the Risen Christ drawing away (the phrase is Latin for 'Do not touch me') from Mary Magdalene and instructing her to inform the apostles of His Resurrection. The subject is frequently encountered in Italian Renaissance painting.

Non Finito
A work of art, commonly a sculpture, which is, or appears to be, unfinished.

Non-Objective Art

Art which does not represent any physical object or figure but which is purely concerned with the arrangement of shapes, forms and colours.

Norwich School

A regional school of landscape painters, all of whom lived and worked for much of their lives in the cathedral town of Norwich in Norfolk. The impetus for the school was provided by John Crome, who founded the Norwich Society in 1803. The society held annual exhibitions from 1805–25 and its members included John Bernay Crome, John Thirtle, James Stark, Miles Edmund Cotman, John Joseph Cotman and, above all, John Sell Cotman who was President from 1821–34. There was no distinguishable Norwich school style, but members concentrated on landscape and seascape, predominantly in watercolour, and their work has frequently been compared with that of the seventeenth-century Dutch masters. This similarity, no doubt, owes as much to the nature of the surrounding area of marshes and lowlands which constituted the principal subject of their paintings, as to any conscious imitation.

NORWICH SCHOOL. (*Above*) *Detail from* The Yarmouth Water Frolic *by John Crome. A painting of a ceremonial procession of shipping at Yarmouth.*

NON-FINITO. (*Left*) Captive *by Michelangelo Buonarroti. Many writers have suggested that Michelangelo left some of his sculptures of captives unfinished in order to emphasize the idea of imprisonment, but this is almost certainly inaccurate.*

Nouveau Realisme
See NEW REALISM.

N.P.S.
National Portrait Society.

N.R.D.
National Registered Designer.

N.S.
National Society.

N.S.A.
New Society of Artists; National Society of Artists.

N.S.A.E.
National Society for Art Education.

Nude
The unclothed human body; a representation of the unclothed human body in painting sculpture or photography. RENAISSANCE humanism or 'perfectibilism' maintained that man, and, thus, the human form was God's highest creation and the nearest approximation to his own perfect form. The nude was therefore considered by many to be the highest form of art. The artist does not use the word 'nude' in the same sense as 'naked', for as Kenneth Clark has pointed out in his classic book, *The Nude*, 'naked' implies vulnerability or shame, while the 'nude' is confident and proud.

Obelisk
A single four-sided block of stone (or monolith) carved into a tapering shape which has for its apex a pyramid. The design was originally Egyptian, but has long been popular throughout the world in monumental work.

Objective Naturalism
The application of paint across a picture surface in such a manner that the eye fills in detail where there is none. It depends on close observation of light effects and is a component of IMPRESSIONIST painting.

Objets d'Art
A term borrowed from French for miscellaneous, small objects such as ceramic figurines, snuff boxes, or porcelain vases whose function is subordinate to their decorative value.

Objet Trouvé
See FOUND OBJECT.

Ochre
The clay used to make the painter's colours yellow ochre and red ochre. The clay colour ranges from pale yellow to reddish brown and is the result of iron in the earth in various stages of oxidation.

Odalisque
An Eastern female slave, especially in the harem of the Sultan of Turkey. As elegant, partially clothed or nude figures in oriental settings, they have provided subjects for such diverse painters as J. A. D. Ingres and Henri Matisse.

Oeuvre
A term borrowed from French which refers to the entire work of an artist.

OBJETS D'ART. *These ceramic figurines belong to a series called* Peasants and Such *and were manufactured in Berlin in 1775.*

Oiling Out

When areas of a painting lose their brilliance, it is possible to revive them temporarily by rubbing a small amount of a drying oil, such as linseed oil, over the canvas. This will restore highlights for a time. Sometimes an artist will oil out an area before applying fresh pigment. For a while, it was common practice to oil out an entire painting instead of varnishing, which produces a higher gloss. Since it has now been shown that the practice causes serious darkening and yellowing of the light areas of paint it has been discontinued.

Oil Paint

A paint made by grinding pigment in OIL, (usually linseed oil); nowadays additives such as a THINNER and a SICCATIVE are usually included. Oil was used in paints for many centuries before it became the standard base for artist's paints. EGG TEMPERA was well suited to the demands of the fifteenth-century painters, and oil was used largely for functional rather than artistic purposes. The end of the century however, and the early years of the sixteenth century saw an increased demand for paints which would readily blend and would flow smoothly onto the surface, allowing for sweeping strokes. Gradually, therefore, we see oils and resins being mixed into tempera paints. Piero della Francesca and Filippo Lippi used an intermediate oil and tempera medium, and Jan van Eyck, still earlier in the fifteenth century, was applying oil and varnish glazes to tempera underpainting. By 1540, Venetian masters were using oils throughout the painting, but Velazquez was probably the first great master exclusively to use oil-based paints on canvas.

Being a slow-drying medium, oil paint allows for correction, the colours do not change noticeably after drying and it is possible to obtain both opaque and transparent effects and matt and gloss finishes. Methods of application are also many and flexible. The usual tools for working in oils are BRUSHES or a PALETTE-KNIFE. The support is usually CANVAS or board. Modern manufacturing methods now afford the artist a wide range of colours (105 are listed in one catalogue), and modern MEDIUMS for use

OMEGA WORKSHOPS. Bathers in a Landscape *by Vanessa Bell. A screen made and painted at the Omega Workshop just before the First World War.*

with oil paints have overcome many of the problems of drying time, yellowing and shrinkage which tormented artists in the past.

Oils

Artists use oil with their prepared OIL PAINT for a variety of reasons: to achieve a good working consistency, to reduce brushmarks and to accelerate drying. This last quality causes the oils which are mixed with paints, rather than those used in VARNISHES and MEDIUMS to be known as drying oils. Both

naturally and chemically refined oils are available from the artists' colourmen, whose literature describes the processes and characteristics of each type of oil they prepare. These consist of: Cold Pressed Linseed Oil; Drying Linseed Oil; Drying Poppy Oil; Light Drying Oil, Poppy Oil; Purified Linseed Oil; Refined Linseed Oil; Strong Drying Oil; Stand (Linseed) Oil; Sun-bleached Linseed Oil and Sun-thickened Linseed Oil.

Old Master

Popular term for any of the great artists of the Renaissance and for any of their works. Because the term is derived from the masters of guilds, it is not strictly applicable to painters of the nineteenth-century.

Oleograph

Chromolithographic print made on a textured surface in imitation of an oil painting.

Omega Workshops

An enterprise founded by Roger Fry in 1913. Fry, Duncan Grant and Vanessa Bell, believed that the sensibility of modern art should be translated into readily comprehensible terms through the production of decorative art. Accordingly, they paid many artists including Percy Wyndham Lewis, Henri Gaudier-Brzeska and Edward Wadsworth to experiment with designs for furniture, textiles and utilitarian products. None of the works was signed, but only stamped with the Omega motif. Unlike William Morris's arts and crafts company, the artists were never involved in production.

One-Image-Art

A branch of abstract art in which the artist concentrates on a single theme in a picture or series of works: perhaps a repetitive design or the exploration of a single colour. Also called systematic painting, one-image art is an off-shoot of ABSTRACT-IMAGE PAINTING and almost identical to SERIAL ART.

One-Point Perspective

See PARALLEL PERSPECTIVE.

Op Art

A style of modern painting, popular in the 1960s, which is not concerned with pictorial representation but uses colour, shape and pattern in such technical and controlled ways that the impact on the retina gives a sensation of movement. The majority of op or optical paintings rely principally on combinations of black and white. When colours are used, they generally appear in combinations of COMPLEMENTARIES, because their reciprocal enhancement of INTENSITY works in a similar way to that of black and white. Victor Vasarély, Bridget Riley and Richard Anuszkiewicz are among the leading exponents of this style.

Open Form

A sculptural term for masses which seem less solid because they project into the space around them. See also CLOSED FORM.

Optical Mixture

The application of paint in small areas of separate, pure, colours across the picture surface. When viewed from a distance, the eye welds the small areas to make bigger areas of SECONDARY COLOURS. The NEO-IMPRESSIONIST painters, Seurat and Signac, devised the system after careful study of optics and colour theory. Paintings executed in this manner are usually known as POINTILLIST works, although Seurat prefered the name DIVISIONISM.

Orange

A SECONDARY COLOUR produced by mixing red and yellow. Those commonly available from the artists' colourmen include: Cadmium Orange; Italian Pink; Mars Orange; Winsor Fast Orange and Winsor Orange. See also YELLOW.

OP ART. Supernovae *by Victor Vasarély. The artist has deliberately organized the elements in this painting to confuse the retina of the eye.*

Organic

A descriptive term which, when applied to a work of art, usually means that the artist has succeeded in making a unified, co-ordinated whole, the parts of which are fundamentally dependent on one another and take into account the materials from which they are made as well as the environment in which the work is intended to be displayed. The origin of the term can be traced back to Plato, who proposed that a successful work (describing an oration) would be 'constructed like a living creature' whose parts 'suit each other and the whole work'.

Original Print

One for which the artist alone is responsible for making the image on the plate from which the print is to be taken. The artist does not always carry out the actual printing process. When he does not, he will determine the size of a run and will give his approval of a TRIAL PROOF before the run can start. Most original prints are signed and the plates are defaced after the edition is complete. See also LIMITED EDITION and BON À TIRER.

Orphism

The French poet Apollinaire devised this term to describe the style of painting of his friend Robert Delaunay and other CUBISTS, including Frantisek (Franz) Kupka, Jacques Villon, Marcel Duchamp and Francis Picabia, which was first exhibited in the SALON DES INDÉPENDANTS, Paris, in 1913. Orphism was an attempt to produce an entirely non-figurative art, and was largely based on ideas about the retinal impact of spectral colours in accordance with the theories of Eugène Chevreul. Delaunay, in fact, preferred the name *Simultaneisme*, for his Orphist works were largely based on Chevreul's Law of SIMULTANEOUS CONTRAST, and he described the disks of colour he and Kupka were painting at the time as '*disques simultanés*' ('simultaneous disks'). In its attempt to push theories of modern art to new limits, Orphism paralleled developments taking place elsewhere, in particular DER BLAUE REITER in Germany, RAYONISM and SUPREMATISM in Russia and SYNCHRONISM in the United States.

Orpiment

An ancient, arsenic-based yellow pigment used widely in Oriental art.

Orthogonal

A term of LINEAR PERSPECTIVE which describes a line at right angles, or apparently at right angles, to the PICTURE PLANE, and which extends to the VANISHING POINT.

Ostwald System

A method for classifying and measuring colour developed by the German scientist Wilhelm Ostwald in 1931. Like the MUNSELL SYSTEM, it relies on the organization of sample chips of colour, starting with one solid and showing twenty-four 'foundation hues' which are the result of making increasingly light or dark tints through the addition of white and black.

Ottonian Art

German art of the tenth and early eleventh centuries, which drew largely on CAROLINGIAN, EARLY CHRISTIAN and BYZANTINE styles. Sculpture, mural painting, mosaics and manuscript illumination were the principal art forms.

Outline

A sketch or drawing which shows only the contour lines and has no shading, though the thickness of lines may, in the work of a skilled draughtsman, create subtle illusions of form.

Overpainting

The layers of colour applied to a painting after the preliminary layer has dried. This enables an artist to add details and texture which could not be precisely painted in the underpainting, or DEAD COLOUR whose concern is form and design. The distinction is only to be found in traditional painting as opposed to ALLA PRIMA.

Ox-gall

Once used to reduce the surface tension of watercolours in order to prevent the paint from beading and to ensure an even flow across the paper. Synthetic preparations now fulfill the function of ox-gall, which was made from the gall bladders of cattle.

P

P., pinx., pinxit, pictor

Different forms of the Latin for 'he has painted it' ('*pinxit*') or 'painter ('*pictor*') which sometimes appear on prints, indicating that the artist whose name precedes them painted the original work. Occasionally, such notation is found on an original painting.

Paint

Colouring matter made of PIGMENT dispersed in a BINDER, and to which other components may be added to obtain a desired consistency. Any additive, however, including the liquid binder, must be used in correct proportions and with regard to its own and the pigment's chemical characteristics, or the paint will not adhere to the support properly and may eventually darken, shrink and even flake away.

Before the artists' colourmen began to sell paints in tubes, learning how to mix paints properly was an essential part of an artist's training. Even the basic grinding of the pigment requires skill as the particle size must be fine and regular, and a small number of pigments can actually be damaged by incorrect grinding. Knowing the correct binder-to-pigment proportions (which can vary from less then 10% to as much as 140%), and whether or not a pigment requires the addition of a SICCATIVE or inert pigment before it is suitable for use, is also essential.

Today most artists rely on the artists' colourmen to ensure that purity, tinting strength, dispersion and proportions are correct. Any additional information required (permanence, chemical composition, etc.) is generally provided in the manufacturer's catalogue, which should be studied with care as the artist must ensure that his paint is properly applied and will

PAINTERLY. *Detail from the* Portrait of Pieter Jacobz Olycan *by Frans Hals. Note how the detail of the hair and the ruff is achieved by the application of broad areas of paint rather than by precisely painted lines.*

not deteriorate; especially if he intends to sell his work.

Painterly

A general term for excellence in handling paint, it is more used of work in which colour and tone rather than line create the forms. To say a work is 'painterly' implies that the artist has observed and responded to the world as if it were comprised of areas of colour and shadow which merge into each other, rather than by sharply defined linear images. This distinction was first made by the Swiss art historian Heinrich Wölflinn, and his original German term, 'malerisch', is sometimes preferred as more precise. See also RUBÉNISME.

Painting knives

Painting knife

A thin, flexible metal blade, usually at the

end of a metal wand and with a wooden handle, used for mixing but most often for applying paint. Frequently mistaken for a PALETTE KNIFE, a painting knife is generally triangular with a pointed end which it is easier for the artist to control. Perversely, painting in this manner is called 'palette knife painting', and is distinguished by an IMPASTO effect quite different to that achieved with any brush.

Different types of palette

Palette

1. The surface on which an artist sets out and mixes the colours he intends to use on a particular painting. Traditionally, palettes are oval or rectangular boards made of lightweight hardwood, such as mahogany and have a thumb hole for the artist to hold them by. Some artists prefer palettes made of metal, plastic, glass or porcelain. 2. The range of colours an artist intends to use in a particular painting. By choice, or as an exercise, he may decide to use a limited or restricted palette, meaning a small range of colours. Some artists become associated with a particular range of colours which are

generally referred to as their palettes. 3. The way in which an artist organizes his colours.

Palette knives

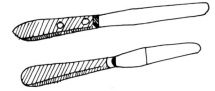

Palette Knife

A flexible blade longer and less delicate than a PAINTING KNIFE, used for mixing colours, scraping paint off the canvas or other support, and sometimes for applying paints.

Palmette

A decorative ornament based on the fan-like arrangement of segments which make up a palm leaf or frond. It is most commonly found in EGYPTIAN, CLASSICAL and BYZANTINE architecture.

Panel

Any firm support such as wood, board, or metal used as a painting surface. Until the fifteenth century, when artists began to use CANVAS, most paintings were executed on panels made from an assortment of materials. Wooden panels, in particular, require careful preparation to ensure that the wood does not absorb the oil from the paint (see ABSORBENT GROUND), and to prevent this the wood must be suitably aged and SIZED. Many artists prefer to paint on panels because they provide a stronger, more rigid and smoother painting surface.

Panorama

1. A vast painting of a landscape or other scene on a roll of canvas hung around the walls of a room to create the impression of an unbroken view. 2. Such a painting wound on two cylinders and unrolled in front of a spectator in the form of a narrative.

Pantograph

A device for copying, enlarging or reducing drawings. The pantograph has four hinged sections with a tracing point at one end and a

Pantograph

pencil at the other. Having adjusted the hinges, which control the scale on which the copy is made, the artist simply traces the drawing with the tracing point, and the pencil at the other end is manipulated by the arms and hinges, making an exact copy of the required size.

Paper

The support usually used for drawing, printmaking and watercolour painting. It is made of cellulose fibres, beaten to a pulp and dried across a fine, wire-mesh screen. The source of fibre for paper is usually wood chips, plants, rags or recycled waste paper. Each source of pulp provides its own characteristic colour and texture which may appeal to the artist for a particular purpose. The best paper is made of pure linen rag. The process of papermaking is believed to have originated in China *c.* A.D. 100 and was introduced to Europe in the thirteenth century. Local vegetable matter was employed wherever paper was made, providing variations in appearance and quality. The use of linen rag as a source of pulp, however, was a European invention.

No matter what material is used for pulp, the basic process is the same whether paper is made in individual sheets by hand, or on a machine reel. Handmade papers are still made by dipping individual screens, or moulds, into a vat of pulp. When removed the screens are rocked back and forth to spread the pulp evenly across the mesh and

to remove excess water. The pulp is then allowed to dry. Thickness is determined by using a deckle, which is essentially a screenless frame that rests above the mould and shows how much pulp has amassed on the screen. When the deckle is removed, a slightly ragged edge is formed and this is one of the characteristics of handmade paper, though the deckle edge is also simulated on machine-made papers. Though a small number of companies specialize in producing relatively large quantities of handmade papers, using standardised formulae and procedures, each sheet is nevertheless unique, and the slight variations in thickness, texture and colour are often made use of in the finished work by the artist.

Machine-made papers, on the other hand, are generally (though not always) made of wood pulp, and the mechanized process means that each sheet is indistinguishable from the next. Providing the materials used are good, there is no difference in quality between hand and machine-made papers. It is important, however, that only the best quality materials be used for artist's papers as acidity and impurities (particularly associated with wood content) will accelerate ageing and deterioration of paper, and therefore work executed on it.

Different techniques and media require different textures and qualities of paper, pastel, for example, is most effective on a rough, often toned paper, while pen and ink is best suited to a very smooth surface. Smooth surfaces can be obtained by adding China clay to the pulp or to the surface of the paper (known as coating), and by calendering, i.e. running the paper through metal cylinders which compress and polish its surface. The smoothest papers are known as 'Hot Pressed' or 'HP'; medium-smooth papers are called 'NOT' or 'Cold Pressed', and those papers with a textured surface, produced naturally or as the result of treating with felts, are termed 'Rough'.

Most artist's papers have been SIZED to reduce absorbency and are tested for consistency of weight, width, acidity, strength and evenness of surface. Most are also subjected to ageing tests. Listed below are some of the most commonly available types of paper and their principal characteristics.

Arches: similar to Ingres; suitable for pastel work.

Art paper: coated with China clay and calendered to give a hard, shiny surface.

Bristol Board: a very smooth drawing surface made by mounting a good HP paper on PASTEBOARD; suitable for pen and ink and other ILLUSTRATION work.

Canson: similar to Ingres.

Cartridge: a smooth paper with a low degree of absorbency; suitable for drawing in pencil, crayon and for some pen and ink work.

Fabriano: similar to Ingres.

Glasspaper: very textured; suitable for pastel and other soft drawing media.

Illustration board: a high-quality PASTE-BOARD; suitable for illustration work and preparing ARTWORK.

Ingres: very textured paper available in a variety of colours; particularly suited to pastel work.

Ivory board: similar to illustration board.

Oil sketching paper: impregnated with chemicals and given an embossed surface to make it capable of receiving oil paints.

Rice: fragile, absorbent papers; suitable for watercolour and ink painting.

Tracing: transparent paper used for copying.

Paper Sizes:
British (untrimmed)

Crown:	15×10	ins
Double Crown:	20×30	ins
Quad Crown:	30×40	ins
Demy:	$17\frac{1}{2} \times 22\frac{1}{2}$	ins
Small Demy:	$15\frac{1}{2} \times 20$	ins
Double Demy:	$22\frac{1}{2} \times 35$	ins
Quad Demy:	35×45	ins
Foolscap:	$13\frac{1}{2} \times 17$	ins
Small Foolscap:	$13\frac{1}{4} \times 16\frac{1}{2}$	ins
Double Foolscap:	17×27	ins
Quad Foolscap:	27×34	ins.
Imperial:	22×30	ins
Medium:	18×23	ins
Double Medium:	23×36	ins
Post:	$15\frac{1}{4} \times 19$	ins
Large Post:'	$16\frac{1}{2} \times 21$	ins
Double Large Post:	21×33	ins
Royal:	20×25	ins
Double Royal:	25×40	ins

Metric ISO A series (trimmed)

A10:	26×37 mm
A9:	37×52 mm
A8:	52×74 mm
A7:	74×105 mm
A6:	105×148 mm
A5:	148×210 mm
A4:	210×297 mm
A3:	297×420 mm
A2:	420×594 mm
A1:	594×841 mm
A0:	841×1189 mm
RA2:	430×610 mm
RA1:	610×860 mm
RA0:	860×1220 mm

Papiers Collés

Compositions made entirely of pieces of paper cut out and stuck to a SUPPORT. Similar to COLLAGES, they may include bits of newspaper, wrapping paper, wall-paper, or any other paper the artist finds of interest. Matisse, who in his later years was a master of papiers collés, explained their attraction thus; 'The cut-out paper allows me to draw in colour. It is a simplification. Instead of drawing an outline and filling in the colour—in which case one modifies the other—I am drawing directly in colour.'

Papier Mâché

Shredded paper made into a pulp by soaking in a starch-based BINDER, such as flour, and moulded to form fairly durable, lightweight objects which can be painted and varnished when dry. Its most common uses are for decorative items; like boxes, ornaments and even small pieces of furniture.

Parchment

A smooth, lightly toned painting, drawing or writing surface made by scraping, drying and stretching animal skins, sometimes imitated in paper. See also VELLUM.

Parergon

A minor passage, such as a still-life or section of landscape, in a composition. Usually carefully painted, parergons may provide essential information for a NARRATIVE work or simply the opportunity for an artist to elaborate or enrich the context and atmos-

phere of his painting, as in the detailed still-lifes that appear in Vermeer's scenes of interiors.

Paris, School of

1. A general heading for the many different movements and tendencies in modern art that took place in Paris during the first half of the twentieth century. Artists of many nationalities flocked to the city during the period 1900–40 and contributed signifi-cantly to the climate of creative and intellectual ferment. The most important movements associated with the School of Paris were CUBISM, FAUVISM, LES NABIS and SURREALISM. Also called Ècole de Paris. 2. A school of ILLUMINATED MANUSCRIPT artists active in the city during the thirteenth century.

Parquet

A disused restoration technique in which thin wooden slats were attached to the back of a wooden PANEL which had warped or otherwise been disfigured. The intention was to straighten or strengthen the panel, but as a method of repairing damage it has fallen into disfavour because the process itself was found to be harmful. As a preventive measure incorporated in the

PAPIERS COLLÉS. The Snail *by Henri Matisse. This picture was completed in 1953, the year before Matisse's death. The artist worked from his sick bed, cutting out paper shapes and directing assistants who placed them on the picture surface according to his instructions.*

preparation of a wooden panel, however, the practice has some merit.

Passage

1. A small but distinctive section in a painting, drawing or other work of art. 2. A zone of transition in a work of art between one tonal section and another, often containing elements of both.

Paste

1. A stiff, starch-based adhesive. 2. The act of bonding materials using this adhesive.

Pasteboard

A stiff SUPPORT made by pasting together layers of paper, usually ending with a layer of cartridge or other relatively smooth paper which provides a suitable surface for drawing.

Pastel

A stick, similar to a CHALK or CRAYON, comprised of powdered PIGMENT, a gum BINDER and, when required, an INERT PIGMENT to control the strengths of different tints. Pastels come in three degrees of hardness, the most brilliant and akin to

PASTEL. *As pastels are difficult to blend, they are supplied in a great variety of tints. The largest box shown here contains 144 sticks.*

paints being provided by the softest grade. Works in pastels are called paintings because colour is applied by mass, and not by line as in drawing. A textured surface is required for any degree of adhesion, and even when applied to a markedly rough surface, a pastel painting needs to be covered by a FIXATIVE or framed under glass.

Pastels do not lend themselves to blending, although this can be achieved to a limited extent by gently rubbing side-by-side strokes of colour on the surface. This problem is overcome in two ways. First, manufacturers provide a large range of TINTS—as many as eight for every colour— so the artist has great freedom in his original selection, reducing the need for blending. Secondly, by laying numerous strokes of colour alongside each other, the artist forces the eye to see them as a blended colour (see OPTICAL MIXTURE), and extremely varied, subtle effects can be achieved in this way.

The medium known as oil pastel relies on an oil binder rather than gum, and it can be used as a paint by thinning with turpentine and applying it in washes with a brush. Oil pastels may be blended by rubbing on the surface and are less easily damaged than traditional pastels. The word 'pastel' may be used to refer to work executed in the medium and the technique, as well as the stick itself.

Pastiche

A work in which a number of the mannerisms of one artist are borrowed by another, who then recombines them in a work which appears to be an original by the first artist. The word encompasses both imitations and FORGERIES. Compare ECLECTIC.

Pastose

An adjective used to describe thickly applied paint. Compare IMPASTO.

Pâte sur pâte

A method of decorating CERAMIC objects with layers of SLIP, so that the resulting design stands out in low RELIEF.

Patina

Strictly, the green 'rust' which appears on

bronze and other metals containing copper after exposure to air or if the metal has been buried for some time. This is a result of the oxidation of the copper (compare AERUGO). Such a coating is considered to enhance the appearance of the metal, and may be deliberately produced by exposing it to acids. The term has been extended to include the mellowing of any surface through age, and may be applied to paintings, stone statues or even furniture.

Patron

A person who supports the arts by purchasing works of art. While the term carries connotations of generosity and selflessness, the history of patronage rarely includes figures who genuinely supported art for either its own or the artist's sake. Instead, history teems with private patrons who commissioned or purchased works that proclaimed their wealth and enhanced their personal reputations. By the seventeenth century, the French art world was dealing in art for its financial possibilities: promoting a national standard and reputation for design, and realizing the investment potential of works of art. This attitude soon became widespread, and continues to this day. Only during the RENAISSANCE perhaps, is it possible to discern an element of true patronage in the arts, and this coincided with efforts, led by Leonardo da Vinci, to have the artist recognized as the equal of others who pursued humanist studies. From that period derives the idea of artistic geniuses entitled to the unique support and honour of the wealthy.

Patroon Painters

A group of New York-based artists working in the first half of the eighteenth century and specializing in portraits of merchants and other wealthy members of their society. These largely untrained artists (most of whom remain unidentified) were influenced by popular English and Dutch portrait styles, but were unable to instill a sense of depth to their work which is essentially NAIVE in character. As the colonies expanded, professional artists among the new immigrants had, by 1750, superseded the Patroon Painters.

Pattern

1. An overall, decorative design, usually involving the repetition of one or more MOTIFS. 2. A mould, model or template.

Pedestal

The base supporting a statue or decorative column.

Pen

A tool used for writing or drawing in ink. The earliest forms of pen, those made from reeds or quills, are still in use today, though most artists, draughtsmen and calligraphers normally employ one of the following styles of manufactured pens:

Ballpoint: a small ball in the tip of the pen shaft controls the flow of ink from a built-in supply. Clogging and skipping, especially in inexpensive models, make ballpoint pens unpredictable and therefore little used for precise work.

Dip pen: a solid handle into which a nib of the desired width and shape can be inserted. So called because the nib is dipped into an external ink supply rather than fed from an internal source.

Drawing pen: a hollow tube-shaped needle or 'stylo' replaces the traditional flat nib in what is otherwise a precisely designed and manufactured reservoir pen. The needle point ensures even line width.

Felt or fibre-tip markers: not a traditional pen, but a fabric wick which is fed from an internal supply of spirit-based (and therefore, unless otherwise stated, FUGITIVE) colour. The marker's smooth passage across a surface and consistent flow, together with the extensive ranges of colour available, make it popular with commercial designers.

Fountain pen: a nib is inserted into the base of a hollow shaft which is filled by placing the nib in an external ink supply and squeezing the built-in suction point. Once full, the ink flows steadily to the nib on demand. Nibs can be changed as desired.

Reservoir pen: as in the fountain pen, a replaceable nib receives a constant supply of ink from a hollow shaft in the handle, or penholder, but the shaft is filled by removing the top and pouring the correct amount from the main supply or by inserting a

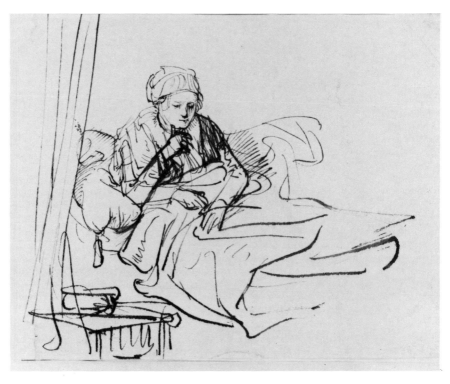

PEN. Saskia in Bed *by Rembrandt van Rijn. A drawing made with a reed pen.*

cartridge of ink into the barrel.

Ruling pen: a draughtsman's tool which holds ink between two pointed prongs, which can be adjusted to any required width by a small slide screw or other mechanism, making it possible for one tool to draw a variety of lines of consistent width.

Pensiero

An infrequently used word meaning a preliminary drawing or SKETCH.

Pentimento

An alteration made while a painting was in progress and which subsequently shows through on the surface of the completed work. The reason for the emergence of *pentimenti* is that oil paint tends to become more transparent with age.

Perceptual Abstraction

An alternative name for OP ART.

Performance Art

A type of HAPPENING, popular in the 1970s, in which the audience is invited to witness or participate in an artistic event, generally supervised by the organizing artist but in which improvisation plays a large part. Performance art considers the human body to be its MEDIUM, and seeks to explore themes and emotions through live, unique performances. One branch of performance art, body art, analyzes and displays the body as a functioning organism; such performances may include sexual and other normally private acts.

Living Sculpture, in which people pose in exhibitions as if they were statues, also falls under this category. Although the actual performance is considered the artistic experience and is regarded as unique, because the elements which made it can never be repeated exactly, performances are often filmed, taped or photographed, and these documents are then used in a subsequent performance or exhibition.

Permanent Colour

A colour containing a pigment which for all practical purposes does not deteriorate or fade under normal lighting and atmospheric conditions. Most artists' colourmen provide detailed information about the degree of permanence of all paint and ink colours.

A simple perspective diagram showing vanishing points (vp), the horizon line (h) and the centre of vision (cv).

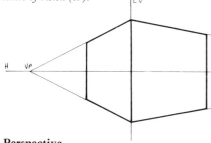

Perspective

A linear system by which an illusion of depth is achieved on a two-dimensional surface (or on a shallow three-dimensional surface such as a relief carving) and by which the space depicted is organized from one point of view. An effect of distance can also be conveyed by the use of AERIAL PERSPECTIVE, but as a system the term perspective refers to the use of line alone. For practical purposes, perspective is divided into two branches: freehand and measured drawing. Measured perspective drawing is used by engineers, architects and designers to represent objects to scale and is a branch of TECHNICAL ILLUSTRATION, combining geometry and draughtsmanship. Freehand perspective drawing is used by

artists to convey depth and solidity and may be distorted or disregarded according to the artist's desire for accurate representation.

One of the principal functions of perspective is to fix the point of view of the artist and therefore the spectator. This is achieved by placing a horizontal line across the picture surface and a vertical line down it. These are called the 'horizon line' and the 'centre of vision' respectively and they establish the position from which the artist views the scene. Both are purely imaginary lines, and may extend beyond the edge of the picture for the purpose of construction. Having established the position of the spectator, the artist proceeds on the basis that the parallel lines appear to converge as they recede, and that they will eventually meet at what is called a 'vanishing point' on the 'horizon line'. The artist then uses converging lines to make objects diminish in size the further they are from the spectator. This explanation only describes the basic principle of perspective, which becomes increasingly complex with the addition of a second or third vanishing point and systems of proportion. There are, however, numerous books and manuals

PERSPECTIVE. *Building of a Palace by Piero di Cosimo. An exaggerated example of perspective, with a single, centrally positioned vanishing point.*

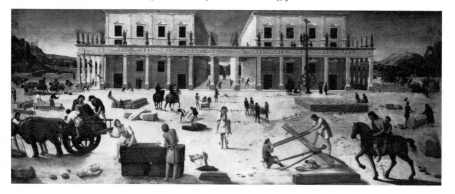

entirely devoted to the subject.

Owing to its importance as a means of convincingly representing the natural world, perspective has been one of the chief areas of study and a criterion of excellence in Western art for many centuries. It was first discussed in the fifth century B.C. by the painter Agatharchus of Athens in his description of a stage setting. Its principles were later described in some detail by the famous mathematician Euclid, and they are found applied most successfully in the ancient world in the illusionistic wall painting at Pompeii. It was not until the Renaissance, however, that the rules of perspective were properly established. Filippo Brunelleschi, Leon Battista Alberti and Paolo Uccello among others evolved a system based on a single, centrally positioned vanishing point that was capable of producing a reasonably accurate representation of physical reality. These rules have since been developed and expanded by mathematicians and optical theorists.

Pétard

A largely obsolete term for a flamboyant or even outrageous work which an artist may include in an exhibition to attract attention to himself and, indirectly, his other work.

Petite Nature

A picture in which the figures are shown slightly less than life-size, but which give the impression of being full-size.

Photogravure

A commercial, INTAGLIO printing process also known as GRAVURE.

Photomontage

A MONTAGE entirely made up of cut out photographs.

Photo-realism

Originally photo-realism only involved the artist in a transferral process: he took a photographic image and translated it, usually enlarging it in the process, into a painting. While requiring great technical skill to match the degree of REALISM achieved by the camera, this process denied the artist any interpretive, creative intervention. The genre has been expanded into what could more accurately be called SUPERREALISM or hyperrealism: still relying for its effect on imitating the highly detailed and sharply defined images of a photograph, but actively presented to the viewer by the artist, rather than the artist serving as a passive intermediary between the photograph and the painting.

Pictograph

A symbol which is clearly recognizable, though highly stylized, because it resembles the object or concept it represents. Many of our road signs (for example those showing men at work) are basic pictographs.

Picture Plane

Sometimes mistakenly used to refer to the physical surface of a picture, the picture plane is a mental concept not a tangible object. It is usually likened to a pane of glass at the foremost edge of the picture, with all the lines of sight passing through it. The principles of PERSPECTIVE are dependent on this concept, as objects within a picture are organized along the spectator's lines of sight which converge on one or more VANISHING POINTS. The idea is probably most easily understood if an analogy is made with a window: the spectator is in a room (i.e. in front of the picture), looking through a glass window (i.e. the picture plane) to a scene outside (i.e. the subject of the picture).

Picture Varnish

The VARNISH applied as a coat to a thoroughly dry painting in order to preserve and protect the paint. It must be easily soluble so that it can be safely removed should the painting require restoration or cleaning.

Pietà

A scene showing the Virgin Mary mourning over the body of the dead Christ, which she holds in her lap. Occasionally other mourners are included, according to which

PIETÀ. *Pietà by Michelangelo Buonarroti. Carved during his period in Rome at the end of the fifteenth century, this statue established Michelangelo's contemporary fame as a sculptor.*

Gospel is used. In Germany, where the pietà grouping is thought to have developed, it is known as a *vesperbild*.

Pigment

The colouring matter in PAINT, derived from natural, such as earths and minerals, or synthetic sources. Before a pigment is used in paint, it must satisfy various requirements: it must not be soluble in water, oil, or other liquids used as VEHICLES (colouring matter which dissolves in its vehicle is

known as a stain or dye); it must be capable of being ground to a uniform particle size for even dispersal in the vehicle; its tinting strength must be sufficient to make it worth using, and it must reach an acceptable degree of permanence. Also of interest to the artist and artists' colourmen is the pigment's opacity, translucency or transparency.

Pisciform
Shaped like a fish.

Pittura Metafisica
The same as METAPHYSICAL ART.

Plane
In PERSPECTIVE, an imaginary two-dimensional surface on which any two points which can be indicated are wholly contained within its surface.

Planography
A printing process such as LITHOGRAPHY in which the reproduction is not made from an incised or raised image as in INTAGLIO or RELIEF processes, but from an image formed on a flat surface.

Plaquette
A metal, usually bronze or lead, replica of a small work of art, frequently one originally fashioned in gold. It is either made by CASTING or by using a die and striking it as in making a medal or coin. In either case, the image appears in RELIEF. Small and relatively inexpensive, plaquettes were easily dispersed and so served as models for design, which helped spread ideas and popularize patterns. Their size also led to their adoption for secondary purposes such as buttons and ornamental sword handles. Plaquettes were most popular during the Renaissance, and Donatello is associated with particularly fine examples.

Plaster
A dry white powder base made of sand and limestone. When mixed with water, this forms a PLASTIC material which can be spread or modelled, depending on its consistency. When the mixture dries it becomes relatively hard and durable, for this reason it is often used for making MOULDS of works executed in clay or TERRA COTTA.

Plaster Print
A print made from an INTAGLIO plate which has been transformed to a RELIEF plate by making a plaster mould of the original, thereby causing all the originally incised lines to stand out in relief.

Plastic Arts
The arts which involve MOULDING or MODELLING material to give it shape, especially sculpture and ceramics, but sometimes extended to include all the visual arts, including architecture and painting, as distinct from music, drama and literature.

Plasticine
See MODELLING CLAY.

Plasticity
1. The combined characteristics which make it possible to model a material: pliability, elasticity and resilience. 2. The quality in a painting or drawing which provides a three-dimensional appearance.

Plate
The surface, usually of metal, from which a printed IMPRESSION is made.

Plate Mark
The impression made by the edges of an INTAGLIO PLATE on the paper area around the printed design due to the pressing action required to make a good print.

Plein Air
The French for 'open air', this expression may be used to indicate that a work has the spontaneity and freshness characteristic of having been painted out of doors. More usually, it is a term for a painting executed in the open air in front of the subject. This manner of painting emerged in the second half of the nineteenth century, and is especially associated with IMPRESSIONISM.

Pochade
A small oil painting or SKETCH executed out of doors and completed in one sitting,

usually so as to provide a reference for a larger, studio painting. A pochade is sometimes considered a finished work in its own right.

Pochade Box

A small oil painting box designed to hold all the materials a painter will need for working out of doors, while being sufficiently portable to allow him to walk to interesting vantage points.

Pointillism

'*Peinture au point*' (meaning 'painting by dots') was the phrase used by the critic Félix Fénéon to describe *La Grande Jatte* by Georges Seurat in 1886, and it was extended as '*pointillisme*' to describe other works by Seurat, Paul Signac and Camille Pissarro executed according to the principles of OPTICAL MIXTURE. Regular, geometric touches of colour formed the basis of the technique, and enabled the artists (who preferred the term 'divisionism') to extend the visual impact achieved by the Impressionists' combinations of COMPLEMENTARY COLOURS. Inevitably, however, the characteristic spontaneity of IMPRESSIONISM was sacrificed for rigid brush-work. The technique was devised by Seurat and Signac, based on studies of the scientific treatises on colour by Eugène Chevreul, Ogden N. Rood, Hermon von Hemholtz and Charles Blanc. It involved the use of pure spectral colours plus white, which were dominated by the primaries and combinations of complementaries. Dots of unmixed colour, which varied in size depending on the scale of the painting and the distance from which it was meant to be viewed, were applied to the canvas in carefully worked out combinations. Close-to, the effect was coarse, but viewed from a distance, the technique resulted in vibrant patterns of mixed colours—the closest the painter can come to achieving the pure mixed colours of light using pigments. See also COLOUR and NEO-IMPRESSIONISM.

Pointing

The process of making a finished sculpture, by copying a model. The sculptor establishes three strategic points on the model (which has been fashioned to such a high degree of finish that all he wants to do is to

POINTILLISM. Sunday Afternoon on the Island of La Grand Jatte *by Georges Seurat.*

duplicate or enlarge it in a more permanent material) and marks out three corresponding points on his block of stone. Having set these out, he has only to measure the distance between each point and any other point on the original, and transfer this distance, enlarging it if his model has been made to a smaller scale than he wants the finished work, to the block. The process is purely mechanical and need not be carried out by the artist himself. Indeed, several machines have been devised for transferring the dimensions from the original to the block.

Polychromatic Sculpture

Sculpture which has been painted to enhance its appearance or render it more lifelike. This practice was common before the Renaissance, but as most of the surviving antique works which the Renaissance sculptors used as examples had lost their colouring through age and neglect, the sculptors failed to realize this. Instead of decorating their finished sculptures, they concentrated on realizing all the qualities of the stone or other material in which they were working.

Polymer Colours

Synthetic paints similar to ACRYLIC.

POP ART. Whaam! *by Roy Lichtenstein. Lichtenstein's conversion of a typical comic strip into a large painting comprised of two joined canvases was typical of the Pop artists' interest in popular imagery.*

Polyptych

A hinged, painted or relief screen comprising two or more panels. The term is usually reserved for works with more than three sections. See also DIPTYCH and TRIPTYCH.

Pop Art

A movement of British origin, but principally associated with the U.S.A., that emphasized the mass-produced objects and popular images of the consumer society. Its artists drew on a wide range of subject-matter from films and advertising to comic strips and household goods, and worked in numerous media, especially painting, sculpture, collage and photography, though they frequently borrowed techniques from commercial and applied art.

Pop Art emerged in Britain in the mid-1950s, and in its early years was dominated by the work of Eduardo Paolozzi, Richard Hamilton and Peter Blake. The exhibition 'This is Tomorrow' at the Whitechapel Gallery, London in 1956 is generally regarded as the formative point in the movement's development, and partially as a result of its influence Pop sources provided many of the dominant themes in British painting throughout the 1960s. It is strongly linked with the work of the Royal College Group that included Allen Jones, David Hockney, Patrick Caulfield and R. B. Kitaj.

In America, the impetus for popular imagery was provided by the subject-matter, ranging from sculptures of ale cans to collages incorporating Coca Cola bottles and press photographs, in the work of Jasper

Johns and Robert Rauschenberg. In the early 1960s, similar themes, combined with a reaction to the autobiographical and obsessive nature of ABSTRACT EXPRESSIONIST painting, appeared in the work of numerous artists, of whom the most important are Roy Lichtenstein, Andy Warhol, Tom Wesselmann, Claes Oldenburg and James Rosenquist. A notable feature was the use of manufactured objects in a manner reminiscent of Marcel Duchamp's READY MADES and for this reason the term Neo-Dadaists was widely used.

Poppy Oil
See OILS.

Porcelain
The highest grade of ceramic ware. The original HARD PASTE formula was developed in China during the seventh century A.D. It contains clay, feldspar and flint and must be fired at very high temperatures. True porcelain ranges in colour from white to grey, has a translucent appearance and produces a clear tone when struck. See also SOFT PASTE.

Portcrayon

Portcrayon
A simple implement which holds charcoal, chalk or other soft drawing media.

Portfolio
1. A firm but portable storage case and carrier for paper and works of art on paper. The standard portfolio resembles a large book cover which can be fastened on three sides, which are made of flaps which secure the contents and hold them flat. 2. A representative selection of an artist's work.

Portraiture
The art of painting, modelling or carving portraits, that is likenesses, of people or animals. While portrait busts, reliefs and statues were popular in ROMAN ART and some pictorial representations, mainly in

the form of mummy paintings, have survived from Egyptian art, the painted portrait as we know it today is largely an inheritance from the RENAISSANCE. The increasingly secular attitude produced by humanist philosophy naturally focused attention on the living man rather than on the life to come. An early example of this attitude is the incorporation of likenesses of the DONOR, and sometimes his family, in what otherwise would be conventional religious scenes. From this evolved the notion of the formal portrait to preserve the memory of the sitter, who had usually commissioned the work. This presented the artist with a persistent dilemma; whether to create a faithful and, therefore, possibly badly received work, or whether to flatter or idealize his subject. Attitudes to this argument change from age to age, and fashions in portrait painting frequently reveal as much about the era in which they were painted as about the character of the subject and artist. At the height of NEO-CLASSICISM, for example, it became fashionable to portray sitters in allegorical or mythological roles, hence Antonio Canova's portrait of Napoleon's sister, Pauline Bonaparte Borghese, as Venus. Most portrait artists attempt to convey something of the character, even the moral qualities, of their subjects as well as to achieve a superficial likeness. This may be achieved by idealizing or emphasizing particular features, placing the sitter in a particular costume and depicting an expressive pose, or including objects associated with his status or profession.

Poster Colours
The commercial name for the inexpensive, brightly-coloured varieties of GOUACHE often used by children.

Post-Impressionism
A term reluctantly coined by Roger Fry to describe a varied group of painters whose works he included in an exhibition organized at short notice for the Grafton Galleries, London in 1910. The title of the show was 'Manet and the Post-Impressionists' and it included works by Paul Cézanne, Maurice Denis, André Derain, Paul Gauguin, Henri Matisse, Pablo Picasso, Odilon Redon,

Georges Rouault, Georges Seurat, Vincent van Gogh and Maurice de Vlaminck. Not surprisingly, Fry found it hard to describe the different styles in the exhibition with one term, and he meant merely to imply that the artists were linked by their dissatisfaction with, and debt to IMPRESSIONISM.

Today, though it is widely used, the term is still vague. The principal Post-Impressionist painters are considered to be Cézanne, Gauguin and Van Gogh, the period it covers to extend from about 1885 to 1905 and the qualities associated with the term to be an interest in the exploration of form in painting, the use of bright or heightened non-descriptive colours, and an interest in the idea of a picture as a decorative area in its own right rather than as a mirror of nature.

POST–PAINTERLY ABSTRACTION. Echo *by Al Held.*

Post-Painterly Abstraction

A title bestowed by the American art critic Clement Greenberg on the work of artists he selected for inclusion in an exhibition held in 1964 at the Los Angeles County Museum of Art. While working independently and having distinctive styles, these artists, Greenberg felt, were united in their reaction against the PAINTERLY, ABSTRACT EXPRESSIONISM which had dominated the previous decade. Their work explored the two-dimensional nature of the

painting surface, often making use of the material of the support itself, using large, flat areas of PURE colour and HARD-EDGE techniques. Among the artists included in the exhibition were Ellsworth Kelly and Frank Stella.

Potter's Wheel

A round platform, mounted on a shaft, which rotates when set in motion, either by the potter's pushing against a bar or other mechanism (see KICKWHEEL) or by a motor. As the platform spins, the potter raises and shapes the clay he has centred on it, making a vessel or other CERAMIC object.

Pottery

A general term for CERAMIC objects, especially those made of more porous clays, such as EARTHENWARE, STONEWARE and RAKU (PORCELAIN is not usually classed as pottery). Throughout its history, this ancient craft has combined utilitarian and AESTHETIC objectives, often producing beautifully shaped and decorated functional items.

Pounce

The fine powder used for POUNCING, usually ground from charcoal, chalk or pipe clay.

Pouncing

The process of transferring a drawing on to a surface by pricking holes in the outline of the original, spreading a powder (POUNCE) over its surface, and forcing the powder through the holes causing them to stain the surface below. See also CARTOON.

Poussinisme

See RUBÉNISME.

Powder Colour

Another name for POSTER COLOUR.

P.R.A.

President of the Royal Academy.

PRE-RAPHAELITE BROTHERHOOD. Ophelia *by John Everett Millais. The literary subject-matter (from Shakespeare's Hamlet) and the exactly painted plants are typical of works by Pre-Raphaelite artists.*

P.R.B.
The initials of the PRE-RAPHAELITE BROTHER-HOOD.

Precise Realism
Another name for MAGIC REALISM.

Precisionism
An attitude more than a clearly defined movement, held by American painters such as Georgia O'Keeffe and Charles Sheeler during the 1920s. Also known as the Immaculates, these artists concentrated on simplifying and ordering their painting, emphasizing draughtsmanship and the geometric nature of their subject. Their subject-matter was usually industrial, urban or architectural, and was noticeably devoid of any human element. Also called Cubist-Realism.

Predella
Technically, the base or lower tier of an ALTARPIECE, or sometimes a raised shelf behind the altarpiece. Such areas were usually decorated—either with paintings or carvings—and the word is often used to refer to the works of art on the predella rather than the structure itself. Predella decorations normally complement the subject-matter of the main altarpiece; for example, if the subject is a particular saint, then the predella may carry several scenes showing incidents from his life.

Pre-Raphaelite Brotherhood
A small but influential association of Victorian artists formed in 1848 and consisting of John Everett Millais, William Holman Hunt, Dante Gabriel Rossetti, J. Collinson, T. Woolner, W. M. Rossetti, and F. G. Stephens. The group was united by a mutual distaste for contemporary academic painting, which its members regarded as trivial and stereotyped. Influenced by the painter Ford Madox Brown, who imbued them with some of the fervent idealism of the NAZARENES, and by engravings of early Italian painting, they determined to revive the purity of art before Raphael.

For their subject-matter, they drew inspiration from the Bible and great works of literature, particularly Dante, Shakespeare, Chaucer, Arthurian legend, Keats, Shelley and Tennyson. The uplifting moral intention of their work was combined with a meticulous observation of nature and a distinctive technique of which the chief

characteristic was the application of bright colours on to a white, wet GROUND. Typical Pre-Raphaelite works have a vibrant, luminous quality and a massive accumulation of detail that contrasts strongly with the predominantly sombre, conservative works of the period.

The Pre-Raphaelites first came to the public's attention in 1851, when Millais's *Christ in the House of his Parents* was exhibited at the Royal Academy. The secretive initials PRB and Millais's depiction of Christ as an ordinary child led to widespread hostility. John Ruskin, however, championed their cause and partly as a result of his support the reputations of the Brotherhood's leading figures, Millais, Hunt and Rossetti, prospered throughout the 1850s. Although the Brotherhood disbanded in 1853–4, these three artists had a considerable influence on late nineteenth century British painting. This took several forms: lyrical mediaevalism that found its most earnest disciples in Edward Burne-Jones and William Morris; anecdotal SOCIAL REALISM and GENRE painting, and, above all, a unique approach to the painting of landscape that emphasized exact representation and bright sunlight.

Primary Colours

For the purposes of the painter, the primary colours are red, yellow and blue. Theoretically, all other colours can be made from them and they cannot be made from others. In practice, however, pigments are not 'pure colours' and so the artist must use prepared colours from a variety of pigments. See also COLOUR.

Primary Structures

Sculptures made of geometric shapes, sometimes painted in PURE colours. Also known as MINIMAL sculptures.

Primer

The GROUND used for PRIMING a canvas or panel.

Priming

Applying a GROUND to a support which has been SIZED, to give it the characteristics desirable of a good painting surface: brilliance, suitable absorbency and a pleasing texture. Priming contributes to good adhesion. See also ABSORBENT GROUND; ADHERENCE.

Primitivism

The same as NAIVE ART.

Print

The image made by pressing an inked master block, screen or PLATE on to a suitably receptive surface, usually paper. A number of IMPRESSIONS are normally made from the same plate. See also ENGRAVING, ETCHING and SILKSCREEN.

Printmaking

The process of making PRINTS, usually used of ORIGINAL PRINTS, rather than those produced by commercial techniques.

Process White

Brilliant white GOUACHE used in the preparation of ARTWORK for photomechanical reproduction.

Profile Perdu

A painted view of a head, in which the face is turned away from the spectator so that he sees the outline of the cheek and chin, and the nape of the neck, but not the nose and forehead as in a traditional profile.

Proof

A print made before an EDITION is commenced so that the artist or printer can ensure that the plate is printing as it should be, and make any necessary alterations. See also ARTIST'S PROOF, BON À TIRER, STATE and TRIAL PROOF.

Provenance

The history of a work of art, giving details of past ownership and ATTRIBUTIONS, in particular.

P.S.

Pastel Society.

Psychedelic Art

Art influenced by the brilliant, often fluorescent, colours and swirling, distorted images associated with hallucinogenic

drugs, such as LSD. More thoroughly explored in commercial and popular art than in the FINE ARTS.

Psychological Balance

A form of composition in which apparently unequal elements are contrasted in such a way that the eye gives to them equal attention, thereby creating a dynamic relationship. For example, a single figure in one section of a picture may be positioned, posed or lit in such a way as to balance a group successfully.

Pure Colour

Colour used without mixing.

PURISM. Still Life *by Charles Edouard Jeanneret. Jeanneret was better known as the architect, Le Corbusier.*

Purism

Charles Édouard Jeanneret (better known as Le Corbusier) and Amédée Ozenfant were the founders and only significant practitioners of this movement. Feeling that CUBISM had degenerated, they sought to purge it of all illustrative and decorative content. In their manifesto, *After Cubism*, published in 1918, they called upon artists to concentrate on simple, geometric forms and unmixed colours and identified the essence of Purism with the asperity of functionalism of machine design.

Purple

The result of mixing the PRIMARY COLOURS red and blue. Those purple paints commonly available from the artist's colourmen

are: Cobalt Violet; Deep Violet; Mars Violet; Mineral Violet; Permanent Mauve; Permanent Magenta; Permanent Violet; Purple Lake; Purple Madder; Red Violet; Violet Alizarin and Winsor Violet.

PUTTO. Putto striking a Tambourine *by Luca della Robbia.*

Putto

A plump, usually nude child, with or without wings, found in European art from the Renaissance onwards. Also called an *amorino*, a putto that represents an angel may be called a cherub. The plural form of the word is 'putti'.

Putty Rubber

See ERASERS.

P.V.A. Colour

A synthetic paint, basically a grade of ACRYLIC, made of polyvinyl acetate. Often used for painting large surfaces.

Pyroxylin

Synthetic LACQUER based on cellulose rather than RESIN.

Quadratura

A painting on a ceiling or wall which makes use of PERSPECTIVE and FORESHORTENING to create an illusion of additional space. This type of painting is distinguished from TROMPE L'OEIL in that it is generally combined with its architectural surroundings and includes features such as columns, marble work and figures to form an integral part of an interior. Popular in the Italian BAROQUE.

Quadro Riportato

An EASEL PAINTING used in the decoration of a ceiling. Such a painting, therefore, has the conventions of horizontal recession and has no vertical PERSPECTIVE or FORESHORTENING to compensate for the position of the spectator beneath it.

Quattrocento

The fifteenth century, especially in Italian culture.

R.A.

Royal Academy or Royal Academician. See ROYAL ACADEMY

R.A.A.S.

Royal Amateur Art Society.

Rabbit-Skin Glue

A strong, pure adhesive made from the hides of rabbits, used as SIZE, as a BINDER, and in the preparation of GESSO. The glue base is sold in sheet, powder or flake forms which are dissolved by soaking overnight in water. To be used full-strength the water is poured off before the glue is heated; dilute adhesive is obtained by measuring the water before soaking and heating the mixture.

Raw Sienna

See BROWNS.

Raw Umber

See UMBER.

Rayonism

One of a number of styles explored by the Russian artists Mikhail Larionov and Natalia Goncharova between 1911 and 1914 as they developed towards abstraction. Larionov may have been prompted to write the Rayonist Manifesto in 1913 after hearing Filippo Marinetti speak in Moscow. Certainly, Rayonism shared the FUTURIST preoccupation with time, particularly Larionov's work with parallel and intersecting beams of coloured light which were intended to help the work of art escape the temporal limitations of physical matter. The name is also spelled Rayonnism.

R.B.A.

Royal Society of British Artists.

R.B.S.
Royal Society of British Sculptors.

R.C.A.
Royal College of Art.

R.D.S.
Royal Drawing Society.

R.E.
Royal Society of Painter-Etchers and Engravers.

READY-MADE. Bottle-rack *by Marcel Duchamp.*

Ready-made
A particular type of FOUND OBJECT, associated with DADA and SURREALISM and championed by Marcel Duchamp, who exhibited manufactured items as works of art. One of the most famous examples was a urinal exhibited in New York under the title of *Fountain.* Duchamp exhibited his ready-mades as ANTI-ART, and in a tirade against modern movements which he felt abused the notion of the ready-made he wrote: 'When I discovered ready-mades I thought to discourage aesthetics. In Neo-Dada [New Realism] they have taken my

ready-mades and found aesthetic beauty in them. I threw the bottle-rack and the urinal into their faces as a challenge and now they admire them for their aesthetic beauty.'

Realism
Like NATURALISM, Realism is concerned with depicting the world as it appears. In the sense that Naturalism and Realism are equally opposed to the principles of both ABSTRACTION and IDEALIZATION, the terms are interchangeable. However, while Naturalism generally restricts itself to a concern for accurate transcriptions of the natural world, Realism additionally concerns itself with the type of subject-matter depicted, and typically concentrates on mundane or squalid objects or scenes. Gustave Courbet, whose most important works depict scenes of everyday life, was the first major exponent of the Realist tradition. The ideals of the tradition were reapplied, with considerable success, by the artists of the ASHCAN SCHOOL and the EUSTON ROAD GROUP.

Recession
The impression of depth in a work of art obtained through applying the principles of ATMOSPHERIC and LINEAR PERSPECTIVE.

Red
One of the painter's three PRIMARY COLOURS. Red paints available through the artists' colourmen include: Alizarin Crimson; Bright Red; Cadmium Red; Cadmium Red Deep; Cadmium Scarlet; Carmine; Crimson; Crimson Alizarin; Crimson Lake; Flesh Tint; Geranium Lake; Indian Red; Light Red; Mars Red; Permanent Red; Permanent Rose; Rose Carthame; Rose Madder; Rose Doré; Rowney Rose; Scarlet: Scarlet Lake; Scarlet Vermilion; Venetian Red; Vermilion; Vermilion Scarlet; Winsor Fast Red and Winsor Red.

Red-Figure Vase Painting
A more sophisticated form of decoration than BLACK-FIGURE VASE PAINTING, which it superseded during the fifth century B.C. The effect of red figures was achieved by painting black GLAZE around the design, so that figures and objects showed through

in the natural red of the clay. Extra details were sometimes added later, and white backgrounds and additional colours came into use during the late fifth and fourth centuries B.C.

Reducing Glass
See DIMINISHING GLASS.

Reflected Colour
Reflected light that has picked up the colour of an object or surface, such as leaves on a tree or a painted wall, and so distorts the natural colour of another object. The problem of reflected colour is particularly encountered in artists' studios.

Regionalism
See AMERICAN SCENE PAINTING.

Registration
In printmaking, the process of aligning an image so that it prints clearly and squarely and, if more than one layer is applied as in colour printing, so that each layer lies exactly on top of the one below. A print which is out of register is blurred, and in colour printing this can be particularly disturbing as each image will compete with the one below instead of combining with it to make a rational whole.

Relief
An image which projects from a fixed background in carved, modelled or moulded works. The design may stand out in high (*alto*), medium (*mezzo*), low (*bas*) or almost flat (*rilievo schiacciato*) relief. The term is used also to describe printing blocks or plates (such as a woodcut) in which the area not to be printed is cut or bitten away so that the design stands out from the background and is the only portion to receive ink.

Relining
A CONSERVATION process in which a deteriorating or damaged canvas is mounted on a new base. See also TRANSFER.

RELIEF. Portrait of the Marquis de Louvois *by Antoine Coysevox. A particularly flamboyant example of high relief.*

Remarque Proof
In printmaking, a STATE on which the artist has written or drawn notes indicating how he plans to proceed. Those marks made directly on a plate (for instance to test the time acid requires to bite to a certain depth) and which are printed when the state is pulled also comprise a remarque proof. These latter are trimmed or smoothed away before the final printing run is commenced.

Renaissance
A term, meaning 'rebirth', which is traditionally applied to the period in Italian art between approximately 1300 and 1550. In the most general sense, it refers to the revival of interest in the arts and letters of antiquity during this period, following—and reacting against—the supposed barbarism of the Middle Ages.

Controversy surrounds the application of the term itelf. Most scholars agree that it originated in Florence and that its primary impact was on Italian art. Likewise, there is widespread agreement that it began at the end of the thirteenth or beginning of the fourteenth century, and drew to a close about 1527. However, the stylistic connotations of the term are far more difficult to determine. To reach a definition, it is perhaps most instructive to consider the artists who have traditionally been associ-

ated with the movement: Giotto, Sandro Botticelli, Leonardo da Vinci, Raphael, Michelangelo, Titian. These artists, for all their stylistic differences, celebrated—to varying degrees—the pre-eminence of man in the universe. It is important to note, however, that this attitude avoided the dogmatic spirit of eighteenth-century NEO-CLASSICISM, which copied CLASSICAL models. Renaissance theory, instead, encouraged creativity by reviving classical ideals. Consequently, it gave rise to a great number of distinctive styles, which evolved over a relatively long period, but were bound together by common motives.

Giorgio Vasari, in his book *Lives of the Artists* (1550), provided valuable (though disputable) guidelines for categorizing the artists grouped together under the heading 'Renaissance'. His chief criterion concerned the application of technical systems, such as FORESHORTENING and PERSPECTIVE, which Italian artists and architects, in particular Brunelleschi and Alberti, rediscovered in antique art and applied with increasing sophistication in their own work. On this basis, Vasari divided the Renaissance into Early and High Periods, the former characterized by fifteenth-century artists such as Paolo Uccello, Masaccio, Fra Angelico and Sandro Botticelli, the latter by such painters as Leonardo da Vinci, Raphael, Michelangelo and Tititan from about 1500 to 1530.

Renaissance thought left a profound mark on the sculpture as well as the painting of the day. The revival of classical attitudes towards ideal physical beauty in man led to splendid representations of the human figure. Donatello's technically sophisticated sculptures established many of the standards which his contemporaries sought to emulate, and Michelangelo's expressive statues bridged the gap between classical realism, MANNERISM and BAROQUE.

The origins of Renaissance thought are not difficult to determine. Through the development of printing techniques and the acceleration of international trade, an ever increasing number of ideas—both scholarly and practical—were exchanged between the leading mercantile countries of the day. The growing sense of economic and intellectual well-being led inevitably to a more secular approach to the world and this was embodied in the philosophy of humanism which derived from classical philosophy, and emphasized the central importance of man in the universe. At the same time, the patrons, collectors and artists of the Renaissance began to hark back, with growing enthusiasm, to the art of the ancient Romans. Inevitably, their knowledge of antique art was piecemeal, though this worked to their advantage, for it provided them with a superficial knowledge of classical styles without obliging them to observe the strict canons of classical theory.

Interestingly, not only the form but the very status of art underwent a change during the Renaissance. Whereas before—and to a considerable extent during—the Renaissance period, art was seen solely as a vehicle of the Church and its doctrines, through Renaissance theory it came to be considered in certain instances as an end in itself.

Rendering
An architect's drawn or painted (usually in watercolour) impression of how his work will appear when constructed and landscaped.

Replica
A COPY of a work of art which is exact in every detail and is frequently carried out by, or under the supervision of, the original artist.

Repoussage
A method of smoothing out a metal printmaking plate which has been dented during alteration or repair, by laying it flat, face down, and hammering lightly from behind.

Repoussé
The technique of making RELIEF decorations on metal by working from the back. The metal is usually suspended so that the artist can use tools to punch up the design from below while he observes the surface.

Repoussoir
A figure or object placed in the foreground of a painting, and which functions in the

same way as a COULISSE, i.e. by directing the eye into the picture to the point the artist wishes to be the centre of attention.

Representational Art

Art which presents its subject in an immediately recognizable manner, though it may not be entirely realistic. Often used interchangeably with FIGURATIVE, it does not imply such a deliberate intention to depict a subject in the way the eye sees it.

Reproduction

A COPY of a work of art, often in another medium, such as printing. Several reproductions are usually made at a time, whereas original copies and REPLICAS are made singularly. Modern technology, especially photomechanical processes, has led to great accuracy in the reproduction of colour. Yet it is impossible for any photograph to convey the unique and subtle variations of texture, tone and hue that combine to make a work of art.

Reredos

Normally a carved and decorated screen, though sometimes a painting, behind an altar. Reredos reached their most extravagant and ornamental forms in Spanish art from the fifteenth century onwards. See also ALTARPIECE.

Resin

A constituent of VARNISH available in either natural (i.e. obtained from trees or plants) or synthetic form which is not water-soluble but can be dissolved in such liquids as oil, alcohol and turpentine. Natural resins may be soft if taken from living plants or hard if fossilized. They include the copal, damar and mastic resins used in varnishes). The synthetic resins most suitable for use by the artist are acrylic and alkyd resins.

Resist

A substance which, when applied to a surface, prevents a liquid from acting on it. Artists may use rubber cement or masking tape for this purpose when applying WASHES or using an AIRBRUSH. Similarly, the BATIK process relies on a wax resist to stop dye from taking in specific areas of the design,

and ETCHING relies on the use of an acid-resisting GROUND and STOPPING OUT MEDIUM to control the action of the acid.

Restoration

See CONSERVATION.

Retable

An ALTARPIECE consisting of one or more fixed (i.e. not hinged as in a POLYPTYCH), framed panels in mediaeval art. Duccio's *Maestà* painted for Siena Cathedral in 1311, for example, is properly called a retable. The term also refers to a raised ledge for ornaments at the back of an altar.

Retardant

A MEDIUM which is added to paint to slow the rate of drying. Oil of cloves is the most common additive for oil paints, and proprietary synthetic mediums are available for use with ACRYLIC and ALKYD paints. Also called a retarder.

Retardataire

An adjective used to describe art which seems to lack knowledge of current trends and developments.

Retinal Painting

An alternative name for OP ART.

Retouching

Improving the appearance of a painting, either by repairing areas which have been damaged during a move or while in storage, or by applying retouching VARNISH to passages which have become dull.

Retreating Colour

See ADVANCING COLOUR and COLD COLOURS.

Retroussage

The process of reducing the amount of ink held in the lines of an INTAGLIO plate by wiping the entire plate with a soft, absorbent cloth. The effect is to make the lines print with less definition and so to soften the overall effect.

R.G.I.F.A.

Royal Glasgow Institute of Fine Art.

R.H.A.
Royal Hibernian Academy.

R.I.
Royal Institute of Painters in Watercolour.

R.I.A.
Royal Irish Academy.

R.I.B.A.
Royal Institute of British Architects.

Rilievo Schiacciato
An extremely low form of RELIEF practised chiefly in the fifteenth century, notably by Donatello. Also called *relievo stiacciato*.

R.M.S.
Royal Society of Marine Painters.

Rocaille
A decorative motif, first used architecturally, based on rocks and shells but elaborated to form ARABESQUES incorporating scrolls, swirls, curves, volutes—any possible linear extension of the original form. See ROCOCO.

Rocker

Rocker
A tool, consisting of a slightly serrated, curved blade at its front edge, which is used to roughen the surface of the plate for a MEZZOTINT.

Rococo
A style which developed in France from the use of ROCAILLE motifs in the court of Louis XIV, Rococo reached its peak during the reign of Louis XV, notably in the years 1730–45. Reacting against the heavy, more plastic quality of BAROQUE art, which had previously been the dominant mode, it was characterized by a combination of light (chandeliers and mirrors were popular objects) and elegant lines to produce ornate and airy decoration. The basic *rocaille* motif was explored, elaborated and combined with elements from oriental art in a way

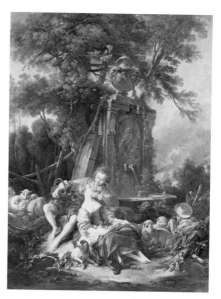

ROCOCO. An Autumn Pastorale *by François Boucher.*

that may strike the modern eye as excessively florid.

The style spread rapidly to Austria, Spain, Russia, Northern Italy and Germany, where it reached a peak in unbridled architectural fantasies. In painting, France and Italy (especially Venice) produced the most important artists, including Jean-Antoine Watteau, François Boucher, Pietro Longhi, Francesco Guardi and Giovanni Battista Tiepolo. In England, the style was largely confined to the APPLIED ARTS, of which the finest examples are the furniture of Thomas Chippendale and ceramics known as Chelseaware. The artist William Hogarth is sometimes suggested as an example of an English rococo painter, on account of his heightened palette and use of light, but the work of Thomas Gainsborough is perhaps more typical of the style.

R.O.I.
Royal Institute of Oil Painters.

Roman Art
Roman civilization is inseparable from politics, and the cosmopolitan nature of its art reflects the size of an empire which, at its

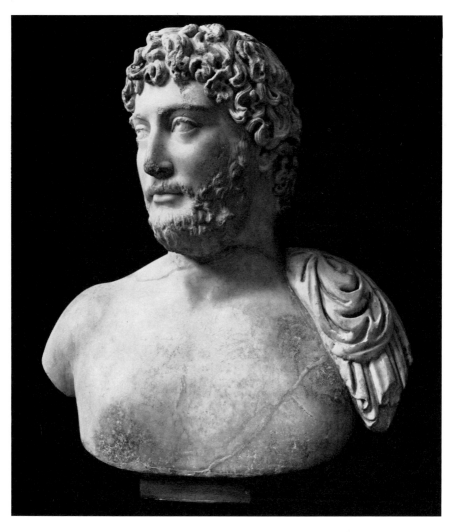

height, stretched from Britain to Syria. The art that developed during the nine centuries that encompass the rise and fall of both the Republic and the Empire from 509 B.C. to A.D. 410 includes a wealth of architecture, sculpture, painting, pottery, mosaics, metal work, ivory carving and many other examples of decorative art. In a brief account, however, the developments of a period covering nine centuries can best be understood by examining general trends in two principal areas, those of sculpture and painting.

The original impetus for Roman art was

ROMAN ART. *Top: A marble bust of the Emperor Hadrian (A.D.117–138). Note the holes drilled in the eyes to form pupils.*

provided by Greek culture, and though most of the works of the HELLENIC sculptors and painters have been destroyed, an indication of their character has been preserved in a mass of Roman copies. Roman art, however, was by no means a pastiche of Greek art, for as the Empire expanded there was a constant demand for sculptures, monuments and paintings to decorate newly established cities and estates. The Greek

influence was modified and Roman art began to emphasize realism and narrative, though never to the exclusion of Hellenic themes.

The principal development in Roman sculpture lies in the emphasis on portraiture, and this falls into two categories: BUSTS, which concentrated on highly realistic portrayal, and which usually represented family ancestors; and monumental statues, generally of emperors or important officials, which retained the Hellenic concept of an ideal type. However, perhaps Rome's most original contribution to the development of sculpture was in the form of RELIEF carvings. These decorated triumphal arches, columns and monuments, and tended to be narrative accounts of actual events, though again the Hellenic influence persisted and a number of reliefs showed scenes from Greek mythology. These two strands, increasing realism, obtained by such means as drilling holes in the eyes for pupils and imitating natural posture and idealization, persisted until the final years of the Empire, when Christian, Egyptian and Barbarian influences began to swamp a tradition in sculpture that had evolved steadily since the Archaic Period (see GREEK ART) more than a thousand years before.

Few examples of Roman painting survive. The best preserved were found in the area submerged under ash after the eruption of Vesuvius, the most famous of which are at Pompeii. These wall-paintings show a movement away from the flat, colourful depictions characteristic of what is known as the Incrustation style (175–80 B.C.) towards ILLUSIONISM, which was fully achieved in the Intricate style (A.D. 50–70). After the Intricate phase, wall-painting was supplemented with panel-paintings, and, though realism continued to be emphasized over the succeeding three centuries, by A.D. 400, Roman painting, like its sculpture, had virtually abandoned realism for a mannered, expressionistic style which eventually gave way to the spiritual concerns of Christian art.

The subject-matter for Roman paintings includes landscape, mythology, GENRE, and scenes from street life. Portrait painting does not appear to have been a principal interest,

surviving examples from mummy cases are flat and make little attempt at the mask-like realism which developed in portrait sculpture. Landscape painting was widely practised by Roman artists, both as background for works which feature figures and as an art form in its own right, though in contrast to the general tendencies of Roman art, it tended not to be naturalistic, but was loosely drawn and atmospheric.

Romanesque Art

The dominant style of art in Christian Europe during the eleventh and twelfth centuries, is developed in the Île de France in the early eleventh century and from there spread across most of Europe. By the second half of the twelfth century it began to be superseded by the GOTHIC style, though in Germany, Spain and parts of Italy it survived until well into the thirteenth century.

The Romanesque style was principally architectural, developing in a time of relative stability, when both royal and papal authority were being restored and the church was rapidly expanding, thus necessitating the building of new, larger churches, monasteries and cathedrals. The characteristics of Romanesque architecture are massive, thick walls, small windows, and rounded vaults and arches, the general impression being one of solidity. The expansion of the monasteries—especially those of the most active Romanesque patrons, the Cluniac order—the crusades, and pilgrimages to the holy shrines in search of sacred relics all contributed to the spread of Romanesque art, from its origins in France, across Europe and into the Holy Land. This is the first time that a coherent, cross-cultural artistic style can be identified in Europe, though Romanesque works were more subject to local tastes and traditions than the subsequent, decidedly international Gothic style. Wherever the Romanesque style took hold, artists were provided, for the first time in more than a century, with the opportunity for reviving the art of stone carving, which was to be fully developed in Gothic art and architecture. Using as their models remains of CLASSICAL buildings and monuments and elements from OTTONIAN, CAROLINGIAN and BYZANTINE art, these

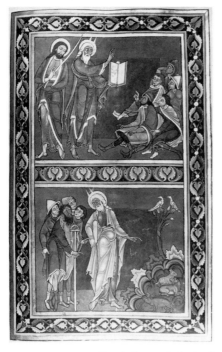

ROMANESQUE ART. *Frontispiece to the book of Deuteronomy in the* Bury Bible *by Master Hugo of the Abbey of Bury.*

carvings generally took the form of reliefs on columns and figures on the external arches over the entrances to the buildings. The disparate influences on Romanesque artists resulted in carving and painting which had a figurative rather than purely ornamental basis; but the style was mannered, and though dominated by Biblical scenes and references, incorporated many fantastic elements—beasts comprised of parts from assorted animals, including man—and all Romanesque art was subservient to architectural needs. Statues were perceived primarily as structural decorations, and while columns and arches may have been ornamented, they never pretended to be other than what they were: no attempt was made to alter the basic shape or to disguise the purpose of the object. Nevertheless, Romanesque buildings were thoroughly decorated: much of the carving was polychromatic, and the large wall spaces

were covered in wall paintings, MOSAICS and tapestries. The painting of MINIATURES and other general features of the well-established Romanesque art of manuscript ILLUMINATION were incorporated in other Romanesque art forms. Wall paintings, for example, were often broken down into panels and treated as if they were enlarged pages from a manuscript. The same applies to mosaics; and tapestries, such as the famous Bayeux tapestry, were narrative and used motifs and styles of expression characteristic of the illuminator: figures were flat and simply depicted though contained within decorative borders. Romanesque artists also worked in precious metals, ENAMELS, and STAINED GLASS, and made some free-standing wooden, ivory and metal carvings, art forms which were to be greatly developed during the coming Gothic period.

Romanists

After the full impact of the Italian Renaissance had been felt throughout Europe, a stay in Italy came to be considered almost indispensable for a young artist; a belief that endured for centuries. Italianizers is the general name for artists who came under the influence of Italian art and artists during a visit to the country. The Romanists were the first Italianizers, visiting Rome in the early sixteenth century and disseminating the artistic knowledge they gained on their return home. The term is particularly applied to Flemish artists, foremost among whom were Jan Gossaert (also called Mabuse) and Bartholomeus Spranger.

Romanticism

A broad movement, though more accurately an attitude, in arts and letters which developed in the late eighteenth century in reaction to the pronounced rationalism of the Enlightenment. It is often considered an inevitable manifestation of the revolutionary spirit of the age. The chief characteristics were its emphasis on emotion, the expression of an individual and 'spontaneous overflow of powerful feeling' (Wordsworth) and its concentration on the imaginative powers of the artist.

Ironically, though the Romantic artist's approach was often markedly innovative,

his subject-matter was frequently national-istic or moralistic. This was especially true in England and Germany, where Roman-ticism received its first impetus and was most widely accepted. An interest in medi-aeval literature among the Romantic artists of these countries eventually led to a preference for contemporary literary themes among Romanticists of many nationalities. Consequently, Romantic painting came to reflect many of the preoccupations of the period's writers, particularly their concentration on the individual and his relationship to the natural world.

Landscape painting inevitably became a favoured vehicle for the expression of these ideas, and numerous sub-categories rapidly evolved to help express man's complex reaction to nature. Among these were the picturesque, which derived from seventeenth-century Dutch painting and was concerned with rusticity, variety and contrast, and the SUBLIME, which concerned itself with grandeur and its companion emotion, terror.

Romantic artists were interested not only in contemporary literature, but also in contemporary events. In the politically troubled but technologically progressive world around them, they often perceived eminently suitable themes for their art. In France, Eugène Delacroix and Théodore Géricault were the chief exponents of this tendency, and in England J. M. W. Turner led many of his fellow artists to an appreci-ation of nature as a force indivisible from the course of human events.

Romanticism, as an artistic style, left little mark on the sculpture of the day. Chiefly, this was due to the fact that the medium does not lend itself to the free-handed, spontaneous interpretation favoured by many Romantic artists. Nonetheless, throughout the Romantic period a great number of commemorative statues were erected to national heroes, an inevitable result of the era's strong nationalistic tend-encies.

Romanticism declined in popularity in the middle of the nineteenth century, but many of its ideals were revived in such FIN DE SIÈCLE groups as the SYMBOLISTS, who sought to escape the bounds of scientific rationality by exploring the forces they believed to exist beyond the limits of the human intellect.

Rome, School of

A term used to describe a broad range of artists who worked in, and drew inspiration from, Rome. The eclectic nature of the School is obvious in the fact that it spans four centuries and includes such diverse artists as Sandro Botticelli, Michelangelo, Raphael, and Giovanni Battista Piranesi. Nonetheless, these artists shared a source of inspiration: the city of Rome itself, which gave rise to large numbers of LANDSCAPES, TOPOGRAPHICAL paintings and drawings, GENRE paintings and ILLUSIONIST works, and which provided material for the diametri-cally opposed NEOCLASSICAL and ROMANTIC styles.

Even before the barbarian invasions in A.D. 410, Rome had relinquished its role as the capital of the art world to Con-stantinople (compare BYZANTINE ART), and it was not until the fifteenth century, with the maturity of the RENAISSANCE, that it was once more to be regarded as pre-eminent. In the intervening centuries, Roman art and architecture had suffered badly; little was preserved in its entirety, and Renaissance artists and scholars were required to recon-struct the splendours of the Roman Empire using literary descriptions, fragments of sculpture and the ruins of buildings and monuments. The degree of success with which they accomplished this task is evident in the fact that, during the next four centuries, it became traditional for artists from all over Europe to complete their training and gather artistic inspiration through a visit to Rome. See also ROMANISTS.

Rose-Croix Movement

An artistic movement of the late 1880s and 1890s typical of many FIN DE SIÈCLE associ-ations in its nostalgic attitudes and tendency to dabble with the occult and mysticism. The Rose-Croix artists based themselves on the ancient (1484) Rosicrucian order foun-ded by the Christian Rosenkreuz and devoted to the occult. They attempted to

reconcile the teachings of the Catholic church with their mystical beliefs, and favoured allegory and myth to REALISM. Prominent artists included Odilon Redon and Émile Bernard, both typical of the group in their close contacts with SYMBOLISM.

Roughcast

1. The layer of rough plaster, usually composed of sand and lime, which is applied to a bare wall before the ARRICCIO in FRESCO painting. 2. The basic shape or outline for a sculpture.

Roulette

Roulette

A tool consisting of a small, toothed wheel at the end of a handle, used in INTAGLIO ENGRAVING. The wheel makes a series of perfectly even dots on the metal plate, and it was widely used to make halftones in the days that engraving was a popular method of illustration. A roulette can also be used to transfer designs, see CARTOON.

Royal Academy

A formal body of British artists founded in 1768 and grounded in the ideals of earlier Continental models. From its inception, the leading principle of the Academy has been the setting and maintaining of artistic standards for professional artists, students and members of the public, and the fostering of an exclusively British school of art. Although it has enjoyed Royal patronage throughout its history, it has remained a private, rather than state-controlled, enterprise.

The personal prestige and intelligence of the first President, Sir Joshua Reynolds, helped establish the extremely high standards of the Academy, and his keen interest in teaching led to the formation of the Royal Academy Schools, which have provided classical training for a select group of young artists ever since. As a result of the Royal patronage it has enjoyed and the high ideals upon which it was founded, member-

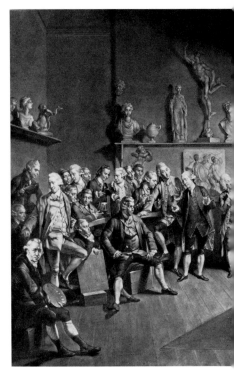

ROYAL ACADEMY. Academicians of the Royal Academy in the Life Drawing Room *after Johann Zoffany. The first President of the Royal Academy, Joshua Reynolds, is holding an ear trumpet and standing to the left of centre, Zoffany himself is sitting in the foreground on the left holding a palette. The two female members of the Royal Academy, Angelica Kauffman and Mary Moser, were not allowed to be in the same room as the naked male models and so their portraits were included on the wall on the right.*

ship in the Royal Academy has traditionally carried with it a certain degree of social status.

At any given time, the Academy is composed of forty full members and thirty Associates, representing the disciplines of painting, drawing, printmaking, sculpture and architecture. By tradition, every newly-elected member has presented the Academy with an example of his work (called a Diploma work), a practice which has led to the formation of an important, if

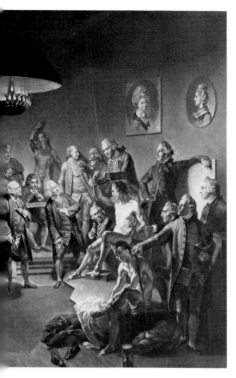

extremely eclectic, collection. Although the Academy's reputation for conservatism has tended to alienate the AVANT-GARDE, the open character of its exhibitions, especially the annual Summer Exhibition, has encouraged creativity and ensured a regular flow of talented artists.

R.P.
Royal Society of Portrait Painters.

R.S.A.
Royal Scottish Academy; Royal Society of Arts.

R.S.M.A.
Royal Society of Marine Artists.

R.S.P.P.
Royal Society of Portrait Painters. Cf. *R.P.*

R.S.W.
Royal Scottish Water-colour Society; Royal Scottish Society of Painters in Water-colour.

Rubbers
See ERASERS.

R.U.A.
Royal Ulster Academy of Painting, Sculpture and Architecture.

Rubénisme
During the late seventeenth and early eighteenth centuries, the French Academy of Painting was divided by a fierce argument over whether colour or line was of the greatest importance in painting. Those who favoured the supremacy of colour took the name Rubénistes (sometimes spelled Rubénsistes), after the great colourist Peter Paul Rubens, and those who favoured line became Poussinistes, after Nicolas Poussin.

Rupestrian
Refers to paintings and drawings executed on rock walls, particularly those associated with CAVE ART.

R.W.A. or R.W.E.A.
Royal West of England Academy.

R.W.S.
Royal Society of Painters in Water-colours.

S.A.A
Society of Aviation Artists.

S.A.B.A.
Scottish Artists' Benevolent Association.

Sacra Conversazione
Representations on a single canvas or panel of the Virgin and Child attended by saints and organized in a single, unified group. This type of composition developed in Italian art in the fifteenth century, and is distinct from the earlier depictions of single figures on separate panels. If the work was commissioned as a votive offering, the DONOR and sometimes his family were included in the figures grouped around the Virgin and Child.

S.A.E
Society of American Etchers.

S.A.G.A.
Society of American Graphic Artists.

S.A.I.
Scottish Arts Institute; or Society of Architectural Illustrators.

Salon
1. A regular, social gathering of artists, writers, poets, musicians, philosophers or other intellectuals in a private house. 2. The annual exhibition of the French Royal Academy of Painting and Sculpture, held in the Salon d'Apollon in the Louvre and notoriously conservative, especially in the second half of the nineteenth century. 3. A number of different independent group exhibitions in France. See also SALON DES INDÉPENDANTS and SALON DES REFUSÉS.

Salon des Indépendants
The annual exhibition of the Societé des Artistes Indépendants, which was composed of a group of progressive artists dissatisfied with the official SALON. The society was founded in 1884 by Georges Seurat, Paul Signac and Odilon Redon amongst others, and although artists were charged for works they displayed in the annual exhibition there was no selection committee.

Salon des Refusés
By 1863, the hostility of the official French Academy to the work of many contemporary artists was so open and the number of rejections to that year's Salon was so high, that Napoleon III instructed that a special exhibition be held in order to enable the public to see the work of the 'refused' artists. Paul Cézanne, I. H. J. T. Fantin-Latour, Édouard Manet, Camille Pisssarro and James Abbot McNeil Whistler were among the artists who exhibited at the Salon des Refusés, but the public merely confirmed the Academy's disapproval and the exercise was not repeated.

Salt-glaze
A thin, colourless ceramic glaze often used on STONEWARE, made by adding common salt to the heat source of a KILN towards the end of the firing process. The salt vaporises to make the glaze, which having no colour of its own, protects and gives a sheen to the object while allowing the natural colour of the clay to show through.

S.A.M.
National Society of Art Masters.

Sanguine
1. A natural chalk, dull-red in colour. See also CONTÉ. 2. A drawing executed in this MEDIUM. 3. A reddish-brown colour.

S.A.P.
Society of Artist Printmakers.

Sarcophagus
A stone, or occasionally a terra cotta coffin, frequently decorated with sculptured relief or paintings. Sarcophagi are the source of some of our most detailed knowledge of

SARCOPHAGUS. *A sarcophagus from the Church of San Vitale, Ravenna showing a relief sculpture of* The Adoration of the Magi.

ancient art, particularly HELLENISTIC, ROMAN and EARLY CHRISTIAN sculpture.

Saturation
The degree of INTENSITY of a COLOUR. See also CHROMA.

Sc., Sculp., Sculpsit, Sculpebat
Abbreviations and different forms of the Latin meaning 'he cut it' or 'he carved it' and found on prints in place of INC., INCID., INCIDIT, INCISOR. Also occasionally used by sculptors to indicate an original carving rather than a cast.

Scaling
The deterioration of a painting in which the paint is chipped or flakes away from the SUPPORT. This may be caused by poor preparation of the support, by rolling or creasing a canvas or by damp storage atmosphere.

Schema
A drawing reduced to a basic diagram, for example a head reduced to an egg-shape.

Schildersbent
An informal organization of Dutch and Flemish painters working in Rome, founded in 1623 and banned by the Pope in 1720 because of the scandalous lifestyle of its members. Also called Bentname and Bentvueghels. One of its early leaders was Pieter van Laer (see BAMBOCCIATA).

School
A term used to identify a group of artists whose work shows general similarities, usually as a result of training (e.g. School of Duccio), attitude (Romantic School) or geographical proximity (e.g. School of Paris). The term is used with varying degrees of precision.

Scorper
An ENGRAVING tool with a wide, rounded end used for making thick lines and removing large areas of the block or plate. It is particularly associated with wood engraving and is also known as a scauper or scooper.

Scraperboard
A drawing surface which is covered with a smooth, glossy layer of GESSO and covered

with ink. When the ink has dried, the artist uses a sharp tool to make his design by scraping away the top layer of ink. The result is a very precise drawing which resembles a WHITE LINE ENGRAVING and can be used as ARTWORK. It is possible to buy prepared scraperboards which have a variety of top colours and contrasting undercoats, but the traditional combination remains black ink on a white base. Known as a scratchboard in the U.S.A.

Sculpture
A three-dimensional work of art made by carving, modelling or making a construction or arrangement of material, such as an ASSEMBLAGE or MOBILE. See also LIVING SCULPTURE.

Scumbling
An oil-painting technique in which the painter applies a thin, broken layer of opaque paint over an existing colour (see DRAGGING). Because the bottom layer is allowed to show through, the two colours complement one another, creating a complex, tonal effect.

S.D-C.
Society of Designer Craftsmen and Craft Centre (formerly the Arts and Crafts Exhibition Society).

S.E.A.
Society for Education in Art.

Seascape
A painting or drawing of which the central subject is the sea, or the relationship between the sea and sky, but often, with boats, birds or figures. When nautical features are prominent, the picture will normally fall into the category of MARINE PAINTING.

Secco
See FRESCO.

Secession
See SEZESSION.

Secondary Colour
Any colour produced by mixing two PRIMARY COLOURS. If equal amounts of each primary are used, the results will be orange (red plus yellow), green (yellow plus blue) and violet (red plus blue). See also COLOUR.

Section d'Or
1. The French for GOLDEN SECTION. 2. An exhibition and a periodical of the same name organized by Jacques Villon, and other artists involved with ORPHISM, in Paris in 1912. The exhibition was held at the Galerie la Boétie, and was dominated by the work of Robert Delaunay.

Seicento
The seventeenth century, especially in Italian culture.

S.E.I.F.A.S.
South Eastern and International Federation of Art Societies.

Sepia
A brown pigment made from the inky fluid secreted by such creatures as the octopus and cuttlefish and principally used to colour ink and watercolour. Although apparent in classical Roman art, it fell from use until the end of the eighteenth century, when it replaced BISTRE as the medium for monochrome wash drawings. In recent years, it has again fallen from favour as the pigment tends to fade in strong sunlight.

Serial Art
As with ONE-IMAGE ART, the serial artist limits himself to a single, recurring image in a work or series of works. Serial art, however, is more often associated with POP than with MINIMAL ART, since its motifs are generally figurative, for example Andy Warhol's Coca Cola bottles and Jasper Johns' American flags. In additon the variations of the image are most frequently expressed by changes in colour and medium rather than by alterations in sequence or spatial relationships. Also called Serial Imagery.

Serigraphy
The general term for the art of SILKSCREEN printing, often restricted to its use as a creative rather than a commercial technique.

Settecento
The eighteenth century, especially in Italian culture.

Sezession
Different groups of Austrian and German artists broke away from the official art establishments in the 1890s to organize their own publications and exhibitions. These were called '*sezessions*', or 'secessions' in English, and were devoted to the exploration of current developments in art; they are especially associated with ART NOUVEAU. The most important were those in Berlin, led by Max Liebermann, Munich, led by Franz von Stuck and Wilhelm Trubner, and Vienna, led by Gustav Klimt. The group known as the Neue Sezession was formed by artists who broke away from the Berlin Sezession.

Sfregazzi
The technique in oil painting of depicting shadows in flesh tones by spreading a thin glaze over the appropriate area with the fingers.

SFUMATO. *The famous smile of the* Mona Lisa *by Leonardo da Vinci.*

Sfumato
The use of gentle gradations of TONE to create form in oil painting. The term derives from the Italian word '*fumo*' meaning 'smoke' and the distinctive characteristic of *sfumato* is the blending of tones as if seen through smoke. Leonardo da Vinci was one of the first artists to practise this technique, of which the clearest and possibly the most famous example is the smile of the Mona Lisa.

S.G.A.
Society of Graphic Art.

S.G.P.
Society of Graver Printers.

Sgraffito
Also known as Graffito. 1. A method of decorating STUCCO by scratching a design into a layer of wet plaster to reveal the different colour of the dry plaster beneath. It is found in this form on the exterior walls of many Renaissance palaces. 2. The term also refers to any type of scratching, whether on gold LEAF on a painting or on coloured glass, to make a design.

Shade
1. The degree a colour is modified by the addition of a TINT or of black, or its degree of INTENSITY. A shade of red, for example, may be darker, lighter, deeper, redder, yellower or more blue. 2. The dark area of a figure, object or scene as a result of the obstruction of a light-source. 3. As a verb, the term refers to the action of darkening sections of a drawing or painting, normally in order to convey the shape of a figure or object. In drawing, this is achieved by a number of methods, such as HATCHING and CROSSHATCHING; in painting by the addition of a darker tint or black, as above.

Shape
The external appearance of an object, as opposed to its structure. The term is often used synonymously with FORM, though strictly speaking, it is merely one of the characteristics of form.

Shaped canvas
A canvas stretched over a frame of any unconventional shape, i.e. not a square, rectangle or circle, and frequently organized so that the picture is a three-dimensional object. The artists Barnett Newman and Ellsworth Kelly are particularly associated with first developing the use of shaped canvases in the 1950s.

Sharp-Focus Realism
An alternative, occasionally used, name for MAGIC REALISM.

S.I.A.D.
Society of Industrial Artists and Designers.

SHAPED CANVAS. (*Left*) Blue Rose *by Jeremy Moon. The outline of the canvas accents the diagonal divisions of the striped sections.*

SILHOUETTE. *An illustration by Arthur Rackman from* The King of the Golden River *by John Ruskin.*

Siccative
An additive which accelerates the drying of paint or varnish.

Significant Form
A term used by the critic Clive Bell in his book *Art* (1914) to describe the characteristic which he believed distinguished beauty in a work of art from beauty in the natural world. He defined it as the artist's special juxtaposition of line and colour that appeals to the aesthetic emotion of the spectator, and emphasized that subject-matter was irrelevant. The concept enjoyed considerable popularity for a while, but it has been widely discredited, partly because it fails to account for the spiritual quality in art.

Silhouette
1. A monochrome rendering, solid except for the outline, which is mounted or executed against a contrasting background. Traditionally, the silhouette is a black paper cut-out of the profile of a face, and takes its name from the French Minister of Finance, Étienne de Silhouette, during the reign of Louis XV, who used to make such cut-outs as a hobby. 2. The appearance of a figure or object against a strong light so that the shape is defined by the outline.

Silkscreen
A method of making prints, widely used by commercial designers and creative artists. The process is as follows. A fine mesh screen, usually of silk, is stretched taut on a frame with a sheet of paper or another suitable surface placed directly beneath it. A design is either cut into a stencil which is on top of the screen or is painted directly on to the screen with a varnish or other liquid RESIST. Ink or paint is then wiped across the surface of the screen using a tool called a

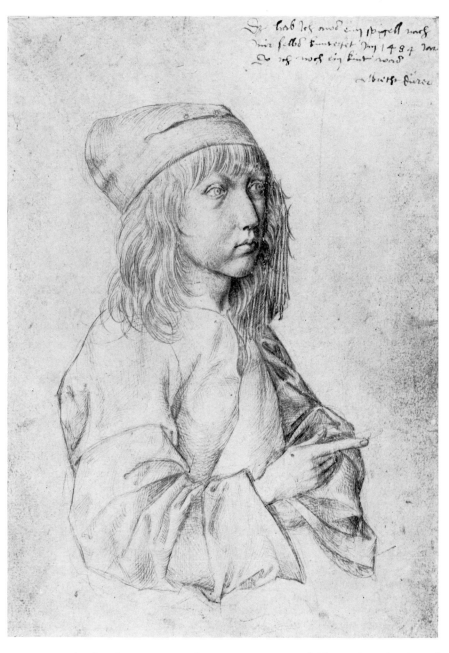

SQUEEGEE, so that it only penetrates to the surface below where the screen is not covered by the stencil or resist. By making more than one screen for the same design,

SILVER POINT. Self-portrait at the Age of Thirteen *by Albrecht Dürer. The delicate tones of this remarkably precocious drawing are typical of the medium.*

and by using different colours, it is possible to build up subtle and complex prints.

The silkscreen technique was developed shortly after the start of the twentieth century and has been widely used for commercial textile printing. Its potential as a creative art was developed in the U.S.A. in the late 1930s under the Federal Art Project.

Silver Point
METAL POINT in which the drawing rod is made of silver.

Simultaneisme
The name Robert Delaunay preferred for the movement which became known as ORPHISM.

Simultaneity
See FUTURISM.

Simultaneous Contrast
The way two colours act upon each other, in particular the mutually intensifying nature of COMPLEMENTARY COLOURS and the effect caused by placing a strong colour next to a neutral grey, in which case the grey appears to be tinged with the colour's complementary. The phenomenon was named and described by the French chemist, Eugène Chevreul in 1839.

Simultaneous Representation
A picture which shows multiple views of the same person or object, either super-imposed or combined. This method of exploring a subject tends to be associated with CUBISM, but it has in fact been used by artists of many ages and cultures, perhaps the most obvious examples occurring in EGYPTIAN ART. The choice and juxtaposition of different elements can lead to a far more complete representation of the subject and of the artist's reaction to it, than a conventional portrayal.

Sinking In
Dull areas on an oil painting which are the result of the absorption of some of the oil by the GROUND. This is a common occurrence, usually alleviated by the application of RETOUCHING VARNISH. See also ABSORBENT GROUND.

Sinopia
1. An obsolete Latin name for the red ochre pigment made from red iron oxide. 2. The underdrawing for a FRESCO, so named because the pigment was commonly used for this purpose during the Renaissance. In this context, the plural of the term is 'sinopie'.

Size
1. A pure glue or gelatinous adhesive. 2. The application of a weak solution of this substance to a painting SUPPORT before it is PRIMED in order to seal the pores. This reduces the surface's absorbency, which invariably causes deterioration, and so protects the fibres from direct contact with the oil paints.

SKETCH. Reclining Nude *by Fernand Léger. The attractive spontaneity of a sketch such as this is often lost in a more finished work.*

Sketch
A preliminary drawing, painting or model normally accomplished at one time and used as the basis for the general composition of a finished work of art. It may also be carried out to note the essential features of a

scene, or to explore a specific aspect of the subject, such as its underlying structure or colour. The artist often carries out a sketch so as to crystallize his initial conception of his subject and so excludes detail (unlike a STUDY). Such works frequently possess an economy and spontaneity that makes them appealing in their own right. See also BOZZETTO and MAQUETTE.

Slip

1. A liquid clay, available in different colours, used by potters to decorate ceramics and to attach handles and other auxiliary features before firing. In the first instance it is applied with a brush, in the second it is squeezed through a nozzle. 2. A narrow, flat MOULD-ING which may be used to separate the picture frame from the picture. The slip is usually made of wood, is bevelled on the inner edge, and may be painted, gilded, waxed or cover-ed in a coarse-woven linen, hessian or other similar cloth of a natural colour.

S.M.

Society of Miniaturists.

Smock

The traditional, loose-fitting working gar-ment of the artist.

S.M.P.

Society of Mural Painters.

Social Realism

A number of different painters and sculptors have concentrated on political and soci-ological subject-matter, emphasizing the grim conditions of the poor and deprived. Social realism is used of those works which intentionally draw attention to the con-dition of such classes, and often contain a political message. Nineteenth-century works such as Honoré Daumier's *The Heavy Load* and Gustave Courbet's *The Stonebreakers* have often been quoted as examples of this *genre*, although the term is of recent origin and has been more precisely used to describe the works of Italian artist Renato Guttoso and his followers, and such groups as the KITCHEN SINK REALISTS, and the Ashcan School (see EIGHT, THE).

Socialist Realism

The official art of the Soviet Union, the aims of which were established by the Communist Party in 1934, when ABSTRACT ART was banned. The apparent intention of most Soviet art since that date has been to glorify the State and the dignity of the worker. As a result it has often seemed nearer to propaganda than art.

Soft-Ground Etching

An ETCHING process, often used in com-bination with other techniques such as AQUATINT, which is characterized by the soft lines and textured backgrounds of its prints. In the original soft-ground method, which was invented in France in the eighteenth century, a copper plate is covered with a GROUND containing beeswax and grease and is, as a result, permanently soft. A piece of paper is then laid over the ground and the design drawn on the paper with a pencil. The pencil lines press the paper against the ground, so that when it is peeled away, the ground adheres to the paper in these areas, thus exposing the metal of the plate. Moreover, the texture of the paper makes an impression on the ground which appears on the finished print. This effect can be varied by pressing different fabrics, papers and other materials into the ground.

Soft Paste

A mixture of clay and ground glass, orig-inally used in Europe to imitate the HARD PASTE or true PORCELAIN that was imported from China, fired at comparatively low temperatures.

Soft Sculpture

Sculptures or other constructions made from substances such as cloth, plastic, fur, feathers or sand rather than the more durable materials traditionally used for sculpture. The American artist Claes Old-enburg, in particular, has made a number of soft objects, including a typewriter and a drainpipe.

Sopra Porte

Paintings, frequently of landscapes, used to decorate the spaces over doorways.

SOFT SCULPTURE. Soft Drainpipe—Blue (Cool) Version *by Claes Oldenburg. By re-making a familiar object in an inappropriate material and to an unfamiliar size, the artist forces the viewer to look at the work and its subject afresh.*

Sotto In Sù

An Italian phrase meaning 'from below upwards' and used to describe the fore-shortening of figures in a ceiling painting, so that they appear to recede upwards and convey the illusion of additional space above the spectator. Paintings using this technique were executed in both oil paint and fresco. One of the earliest successful examples is Andrea Mantegna's *Camera degli sposi* at Mantua, but later artists such as Correggio in the seventeenth and Giovanni Battista Tiepolo in the eighteenth century, created spectacular illusions working in this manner.

South S.A.

Southern Society of Artists.

Soviet Realism

The same as SOCIALIST REALISM.

S.P.

Société International de Philogie, Sciences et Beaux Arts.

S.P.A.D.E.M.

Société de la Propriété Artistique et des Dessins et Modéles. A French society associated with and fulfilling a similar function to A.D.A.G.P., and particularly concerned with copyright.

Spasimo, Lo

An Italian word meaning 'swooning' and used to refer to representations of the Virgin Mary fainting at the sight of Christ carrying the Cross to Calvary or nailed to it. According to the Apochrypha, the Virgin was accompanied by Mary Magdalene, Salome and Martha who are often shown supporting her as she faints.

Spatter

A random pattern of small drops or flecks of water-based paint or ink.

S.P.D.A.

Society of Present-Day Artists.

Spectrum Palette

A palette which is restricted to the colours of the spectrum, i.e. red, orange, yellow, green, blue, indigo and violet, together with white. The most significant aspect of such a palette is the absence of black, which was abandoned by the Impressionists who depicted shadows by means of com-plementary colours and not by the use of chiaroscuro. See also IMPRESSIONISM and COLOUR.

SOTTO IN SÙ. *Detail from* The Glorification of the Urban VIII's Reign *by Pietro de Cortona on the ceiling of the Gran Salone of the Palazzo Barberini, Rome. The exaggerated foreshortening is most obvious in the feet and elbows of the angel sitting on the cloud in the left-hand corner. The artist has employed a number of illusionist devices to blend the painted, sculpted and architectural features of the ceiling.*

Spolvero
The tracing or copy of a CARTOON which was pricked for POUNCING so that the original drawing was not damaged.

Sprezzatura
1. The rough, spontaneous quality which characterizes a SKETCH. 2. An alternative name for a SKETCH.

S.P.S.
Society of Portrait Sculptors.

S.P.S.A.S.
Swiss Society of Painters, Sculptors and Architects.

Squaring Up
A method of transferring a preliminary drawing to the final picture surface, which is usually larger. Both surfaces are divided into an equal number of proportionally equal squares and the lines in each square on the drawing are transferred to the equivalent square on the picture surface. Because each unit deals with a limited number of lines within fixed confines, the process is essentially mechanical and therefore easily accomplished.

Squeegee
A rubber blade mounted on a handle and used to spread ink across the stretched screen in the SILKSCREEN process.

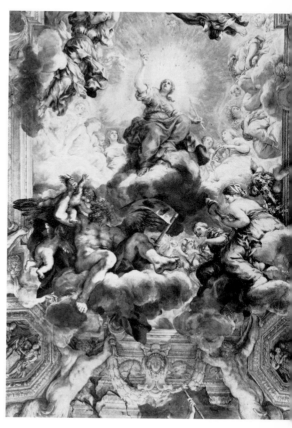

SQUARING UP. *Study for* Ennui *by Walter Sickert. The grid drawn over this study would have been used for transferring the composition to a canvas.*

S.S.A
Society of Scottish Artists.

S.S.I
Society of Scribes and Illuminators.

S.S.N.
Sociétaire de la Société Nationale des Beaux Arts.

S.S.S.A.
Society of Sussex Sporting Artists.

S.S.W.A.
Scottish Society of Women Artists.

Stabile
A type of cut-out abstract sculpture devised and named by Alexander Calder, inventor of the MOBILE. Unlike the mobile, however, the stabile is stationary.

Staffage
Auxiliary figures or animals incorporated in a drawing or painting of a landscape, town or building to provide incidental interest, scale or to emphasize perspective. While necessary to the overall design, these elements were generally considered of minor importance and it was not unusual for the artist to ask an apprentice or other member of his studio to paint them into the composition.

Stained Glass
Sections of coloured glass which traditionally are joined together with strips of leading, though some artists have experimented with setting the glass in concrete or fibre glass. The technique was developed by BYZANTINE artists and has remained virtually unchanged over the centuries. The basic process involves the artist in drawing a CARTOON in which he considers not only the design he wants to make, but also the effect of the lead piping which surrounds each piece of glass, and how he wants to use his colours. If these factors are not considered in advance, the work may be dominated by the leading or the use of colour may be too fragmented to create the desired impression, for being comprised of individual facets of varying size, shape and colour, the tech-

STAINED GLASS. *Finishing touches are given to a scale design for a stained glass window.*

nique does not allow blending. Once satisfied with his overall design, the artist cuts the glass to match the shapes on his cartoon, using either a diamond glass cutter or heated cutting implement. Each section of glass is then considered for detail. In true stained glass, the sections are coloured by fusing metal oxides to the surface and to these sections, a certain amount of painted detail may be applied in order to emphasize drapery or facial features. In addition, pigment may be scratched away to allow light to show through as a highlight. This was the technique employed by the stained glass artists involved in making the enormous windows for GOTHIC cathedrals. The fusing of pigments to the glass (or sometimes actually mixing them with the sand before it was made into glass) resulted in brilliant colours; usually reds, yellows, blues, greens, violets, browns and pinks. It was later discovered that two layers of glass could be superimposed to give a more subtle range of colours. True stained glass, typical of Early Gothic art, gave way to two variations. The first was grisaille glass, which was essentially monochromatic, relying predominantly on

combinations of yellow and white glass. The other was glass which was entirely painted rather than composed of fragments of coloured glass. Both tendencies moved towards realism in depiction; this is particularly true of the painted glass (practised to the exclusion of stained glass by the sixteenth century) which obviated the necessity for large numbers of small facets and simply applied the oil painter's conception and technique to a glass surface, thus losing the unique luminous quality characteristic of true stained glass. After the domination of stained glass by painted glass, the art form fell from popularity, but was eventually successfully revived by artists associated with the ARTS AND CRAFTS MOVEMENT. It was freely adapted by ART NOUVEAU artists and designers (notably Louis Tiffany, maker of the famous Tiffany lamps), and has been practised by such eminent twentieth-century artists as Marc Chagall and Georges Rouault.

Stand Oil
See OILS.

State
In printmaking it is often difficult to see how a PLATE is developing in the course of preparing it for printing. An artist, therefore, will probably take individual IMPRESSIONS from it at different stages so that he can see how it is progressing. Each time he takes an impression, the condition of the plate is described as a 'state' and, by extension, the term also refers to the impression itself. The impressions are referred to, and often marked, according to their order of execution, for example: first state, second state, third state, fourth state, fifth and final state (i.e. the plate is completed and the final edition may be printed).

Statue
A carved or modelled representation, generally of a person or animal.

S.T.D.
Society of Typographical Designers.

Steel Engraving or **Etching**
1. A PRINT made from an engraved or etched

copper PLATE which has been faced with steel by a process called electroplating. The softness of copper assists the artist while he is drawing on a plate, but it is rapidly worn down during printing, with the result that the lines become increasingly faint and imprecise. 2. The process by which such prints are made.

Stencil
1. A re-usable pattern made by cutting a design into a thin but rigid surface and using it as a MASK. When paint or ink is spread or sprayed across the stencil, the image only appears on the exposed sections. 2. To make an image by using such a pattern.

Stereochromy
See WATER-GLASS PAINTING.

Stile Liberty
See ART NOUVEAU.

Still Life
A representation, normally a painting or drawing, of inanimate objects. The subject-matter may include any item which has been removed from its natural context and arranged by or for the artist, though the *genre* is usually associated with such subjects as flowers, fruits, dead animals and birds, domestic utensils and musical instruments.

Still lifes have appeared as elements in later compositions from the time of classical Greek art, and are found in a number of secular paintings of the Renaissance. The representations of inanimate objects as the exclusive subject-matter of a painting, however, only emerged as a separate *genre* in Dutch seventeenth-century art, when objects were frequently chosen for their symbolic value. For long considered one of the lowest forms of art, the still life has become increasingly popular since the eighteenth century as a means of exploring form for its own sake and for demonstrating artistic virtuosity.

Stipple Engraving
A virtually obsolete engraving technique, popular in England in the eighteenth and nineteenth centuries, which recreated the qualities of tone and texture found in chalk

and crayon drawings. This was accomplished by building up a design from a series of dots or short, jabbing strokes. Also a print made by this method.

Stippling
The use of small, carefully applied dots and strokes to make a definite tonal area. POP artists frequently employ this technique, which they have adapted from cartoon illustrations printed as HALF-TONES.

Stoneware
Pottery fired at a high enough temperature to vitrify the clay so that it is close-grained, almost non-porous and, as a result, extremely durable. A GLAZE may be added to decorate the surface but is not essential. See also EARTHENWARE.

Stopping-out Medium
A liquid RESIST used in ETCHING.

Straight-edge
Any straight, preferably heavy, strip or bar which can be used as a guide for drawing, scoring or cutting straight lines.

Street Art
Works of art or events which occur in public places. They may be in the form of murals on buildings, paintings on billboards usually reserved for commercial advertisements, or HAPPENINGS. It is usual for street art to have some moral or political message.

Stretcher
The wooden frame over which canvas is stretched to make a suitable painting SUPPORT.

Stucco
A slow-drying, durable plaster made from lime, ground marble and glue (and sometimes strengthened by the addition of animal hair) and used for decorating walls and ceilings. It can be coloured, moulded and modelled and is suitable for a variety of decorative techniques. It is known to have been used by the ancient Egyptians and during the HELLENISTIC period, but is most commonly associated with decorative art and architecture since the RENAISSANCE.

Studio of . . .
Describes a work which was not executed by the artist whose style it resembles, but by one of his students or an artist paid to work in his studio. This description does not entirely disassociate the work from the master, who may have indicated the basic composition and would probably have supervised the execution of the work.

Study
A preliminary drawing or MODEL done to a high degree of FINISH for use in a subsequent work. Like a SKETCH, a study may deal with the overall composition or concentrate on a specific detail.

Stump
See TORTILLON.

Style
The complex of characteristics which identifies works of art with a particular artist, school, movement, period or geographical region. In painting, for example, these features include such elements as brushwork, use of tone and colour, and choice of different motifs, and they reflect the artist's training and background as well as his own personality.

Style Criticism
The assignment of works of art to a particular artist, school, movement, period or geographical region on the basis of the manner of its execution. The study of style is an important aspect of ATTRIBUTION.

Style of . . .
In the same style as the work of a particular artist, but not by him.

Stylization
Literally, the representation of natural objects according to the conventions of a particular artistic style. In this sense, however, all works of art are stylized, and the term tends to be applied to works that follow the rigid conventions of a particular school, age, or type as in MANNERISM, BYZANTINE ART and HIERATIC ART.

SUBLIME. The Great Day of His Wrath *by John Martin. This powerful vision of the end of the world contains the element of the terror that is an essential part of the sublime.*

Sublime

A value in AESTHETICS that is distinct from beauty and related instead to the emotions of grandeur and terror. The concept has a long history, deriving from Longinus's theory of classical rhetoric where it was equated with excellence, a sense in which it is sometimes used today. It was first defined as a separate category, however, by the English philosopher Edmund Burke in his *Philosophical Enquiry into the Origin of our Ideas of the Sublime and Beautiful* (1757), who introduced the idea of terror as its dominant feature. Later it was refined by the German philosopher Immanuel Kant in his *Critique of Judgement* (1790) who argued that the mind is attracted to the great nobility of 'volcanoes in all their violence, hurricanes with their devastation, the lofty waterfall' because they diminish man, though Kant added that for such sights to be sublime and not merely terrifying, the spectator must be in a position of safety.

Successive Contrast

The name given by the chemist Eugène Chevreul to the phenomenon generally known as ACCIDENTAL COLOUR.

Suite

A group of painting related by a common theme or narrative.

Sunday Painter

An amateur artist who may paint seriously and continually when other employment permits, often with little or no formal training. Some Sunday painters have achieved remarkable success, none more so than Henri Rousseau, a French customs officer who took up painting as a hobby, and whose NAIVE style attracted the admiration of artists from Paul Signac to Pablo Picasso.

Superimpose

To lay one image or piece of material over another.

Superrealism

1. An alternative name for PHOTO-REALISM.
2. An obsolete name for SURREALISM, invented by the critic and poet Herbert Read in the late 1930s.

SUITE. Marriage à la Mode *by William Hogarth. The six paintings that make up this suite are individually titled: 1.* The Marriage Contract *2.* Shortly after the Marriage *3.* The Visit to the Quack Doctor *4.* The Countess's Morning Levée *5.* The Killing of the Earl *6.* The Suicide of the Countess. *The suite is a parody on the morals and customs of 'high life'. Even as her marriage contract is being drawn up in the first scene, the young lady is arranging an assignation with the lawyer, Silvertongue. He later becomes her lover, kills her husband and causes her suicide when, in the final painting, she learns that he has been hanged for murder.*

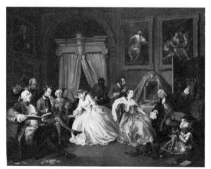

SUPREMATISM. (*Opposite*) Dynamic Suprematism *by Kasimir Malevich. An experiment with overlapping elements arranged to give a sense of depth and motion to the geometric form in the composition.*

Support

The surface on which a painting is made, usually CANVAS, PANEL, PAPER or board, and, in the case of oil painting, first covered with a GROUND.

Suprematism

'To the Suprematist, the visual phenomena of the objective world are, in themselves, meaningless; the significant thing is feeling, as such, quite apart from the environment in which it is called forth,' wrote Kasimir Malevich, the originator of Suprematism in his book *The Non-Objective World*. Malevich had experimented with RAYONISM and CUBISM before taking the reduction of form to it logical conclusion: simple geometric form existing without reference to any object in the real world. The first Suprematist work was a static pencil drawing of a grey square centred on a sheet of white paper, called *Basic Suprematist Element* (1913). By 1918, when Malevich produced his famous *Suprematist Composition: White on White*, he had ceased to be content with static, two-dimensional painting and was experimenting with spatial relationships which resulted in compositions which not only expressed three dimensions, but were dynamic: creating a sensation of motion. While Malevich was the first and most important Suprematist, his fellow Russians, El Lissitzky and Wassily Kandinsky, also contributed to the development of the movement.

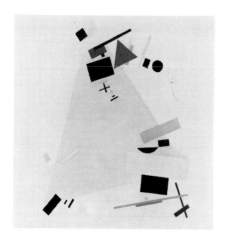

Surrealism

Originally an offshoot of DADA, Surrealism emerged in Paris in the early 1920s as a literary movement devoted to exploring the unconscious part of the mind. The leading figures were the poets Breton, Reverdy, Aragon and Eluard, with Breton as the guiding force who organized the movement and officially inaugurated it with the publication of the first *Manifesto of Surrealism* in 1924. In this pamphlet he defined Surrealism as '. . . pure psychic automatism by which it is intended to express, either verbally or in writing, the true function of thought. Thought dictated in the absence of all control exerted by reason, and outside all aesthetic or moral preoccupations.' Surrealism then, was never a style in literature or art. It was a way of thinking that its exponents, borrowing heavily from the theories of Sigmund Freud, hoped would sweep the modern world and liberate thought from the constraints of logic to reveal a different, 'super' reality. Surrealist art, therefore, should be regarded as but one aspect of a movement that had impossibly wide and optimistic ambitions; to the extent that it even formed a quarrelsome alliance with the Communist Party in the mid-1920s.

The Surrealists saw forerunners in many artists of the past, including Hieronymus Bosch, Francisco Goya, Odilon Redon and, in their own day, Giorgio de Chirico who was warmly welcomed into the movement. The Surrealist artists themselves faced a dilemma. The complicated techniques involved in traditional painting and sculpture required a degree of conscious craftsmanship that discouraged the spontaneous emergence of unconscious images. For this reason, the most genuinely Surrealist works tend to be the FROTTAGES, COLLAGES, AUTOMATIC DRAWINGS and FOUND OBJECTS which could be swiftly accomplished or interpreted and so represent the unadorned results of unconscious mental processes. André Masson, Max Ernst and Jean Arp are the artists who most faithfully followed the spirit of Surrealism in this way. In contrast are the highly finished and detailed pictures of such artists as Salvador Dali and René Magritte who consciously illustrated

SURREALISM. Metamorphosis of Narcissus *by Salvador Dali. As if in a dream the schematic figure of Narcissus gazing at his reflection becomes a stone hand holding a hatching egg.*

fantastic, imagined landscapes and dream worlds in which natural laws were distorted. Other important Surrealist artists include Joan Miró, Man Ray and Yves Tanguy.

S.W.A.
Society of Women Artists.

S.W.A.S.
Society of Women Artists of Scotland.

S.W.E.
Society of Wood-Engravers.

S.W.L.A.
Society of Wildlife Artists.

Symbolism
Principally a movement in late nineteenth-century French poetry, whose leading figures were Baudelaire, Mallarmé, Rimbaud and Verlaine, and with which a

religion, typically presented in the form of enigmatic images and allegorical scenes that evoke abstract ideas and emotions in the spectator who is drawn into a vague, fantastic world. It was this quality, particularly the phantoms and grotesque figures of Redon and Ensor, that so attracted the SURREALISTS who saw the Symbolists as direct forerunners in their exploration of the unconscious mind.

Synchronism

The name given to the American version of ORPHISM, formulated by the painters Stanton Macdonald-Wright and Morgan Russell in Paris in 1913, and influential in the United States until about 1918.

Synthetic Cubism

See CUBISM.

Synthétism

An alternative name for CLOISSONISME, preferred by Paul Gauguin.

Systematic Painting

The same as ONE-IMAGE painting.

number of artists were associated. Pierre Puvis de Chavannes, Odilon Redon, Gustave Moreau and James Ensor were the most important of these painters and, though they never formed a cohesive group, they were united by a common interest in the mystical and spiritual nature of art. In this they contrast strongly with, and to some extent were a reaction against, IMPRESSIONISM and REALISM, which were preoccupied with depicting the natural, observable world.

The subject-matter of Symbolist painting was largely drawn from mythology and

Table Easel
See EASEL.

Tachisme
The literal meaning of '*tachisme*' in French is 'blot' or 'stain', and while it is usual to consider the tachiste artists as European ACTION PAINTERS, because of the similarity of the finished works, a closer study of the semantic differences in the groups' names indicates a difference in philosophy. Action or GESTURAL painters are principally interested in the manner of the application of the medium and in its overall, final appearance, while the tachistes emphasize the significance and expressive power of each area or blot of paint. Prominent practitioners of tachisme which, like action painting, reached its peak during the 1960s, are Francis Arnal, Jean Fautrier, Georges Mathieu, Hans Hartung and Pierre Soulages.

Tactile Values
A phrase introduced by the art historian Bernard Berenson in his *Florentine Painters of the Renaissance* (1896) to distinguish paintings which create a three-dimensional illusion from those which remain two-dimensional. He claimed that three-dimensional works stimulate the sense of touch and regarded this as a distinctive feature of Florentine Renaissance painting.

Tatlinism
A little-used name for CONSTRUCTIVISM deriving from the name of the movement's founder, the Russian painter Vladimir Tatlin.

TACHISME. Untitled *by J. P. Riopelle.*

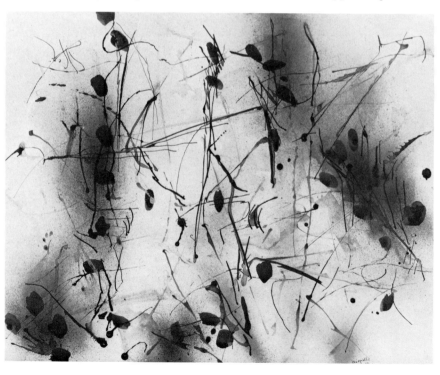

T.C.T.A.
Teaching Certificate for Teachers of Art.

Technical Illustration
A field of ILLUSTRATION, dominated by professional DRAUGHTSMEN who produce scale representations of objects for construction or manufacture, particularly in architectural and engineering projects. The distinction between technical illustration, which is also known as mechanical drawing because it makes use of geometrical instruments, and COMMERCIAL ART is becoming increasingly vague.

Technique
1. The individual characteristics of any MEDIUM, as in oil or watercolour painting, pencil drawing, stone carving, metalwork and pottery. A painter, for example, must understand the composition of the variety of paint he is using, the characteristics of his SUPPORT and GROUND, and the uses of different types of brushes among many other considerations if he is to achieve the exact effects that he desires. 2. A particular method of manipulating or applying a medium, for example DRAGGING in oil painting.

Temper
1. To prepare paint, plaster, concrete or clay for use by mixing with water or another medium. 2. To treat metal, by repeatedly heating and cooling, so that it develops uniform hardness and becomes less brittle.

Tempera
A paint made of powdered pigments mixed with a BINDER, usually egg yolk or gum, so as to make an EMULSION for which water is the VEHICLE. Tempera is a durable medium with several distinct characteristics: it dries rapidly; the colours are difficult to blend so modelling is achieved by means of HATCH-ING; the colours are considerably lighter dry than wet; when completely dry the paint is extremely durable and almost water-resistant; the dry paint also has a matt surface which is not varnished, but may be lightly polished with a soft cloth. The traditional SUPPORT for tempera is a well-primed panel, though canvas and paper are also used.

The origins of tempera painting are unknown, but it was probably used by the ancient Greeks, and the Romans and Egyptians were certainly familiar with it in one form or another. Egg Tempera, i.e. tempera with an egg yolk binder, was the most important medium for panel-painting in Europe from the twelfth to the fifteenth century, and particularly fine examples of its use are to be found in the works of the Italian artists Fra Angelico and Sandro Botticelli and the Flemish artists Rogier Van der Weyden and Jan Van Eyck. In the fifteenth century, tempera was superseded by oil painting, and the medium was neglected until the present century when its use has experienced a limited revival.

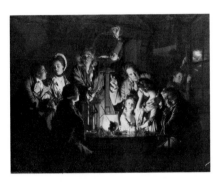

TENEBRISM. Experiment with the Air-pump *by Joseph Wright of Derby. In this picture, the artist has carefully explored the effects of the bright artificial light on the faces of the figures round the table.*

Tenebrism
A manner of painting typified by deep shadows, and a pronounced contrast between dark and light areas and often with a single source of light. The term is most frequently used to describe the works of the seventeenth-century Italian painter Caravaggio, and his followers, particularly Spanish and Neapolitan artists such as Francisco Zurburàn and José de Ribera.

Terra cotta
1. The Italian words 'terra cotta' literally mean 'baked earth', and the term could be

applied to any unglazed clay object which has had an initial firing. However, its use tends to be restricted to the clays which range in colour from red to black, the most common being reddish-brown. Terra cotta has been used as the material for countless objects since the Neolithic age, particularly simple pots, figurines, architectural decoration and roofing tiles.

Tertiary Colours

The result of mixing two SECONDARY COLOURS. Any tertiary contains, of course, an element of all three PRIMARIES. Tertiaries range from browns to greys to blacks. See also COLOUR.

Tesserae

The small pieces, normally cubes, of coloured glass, stone, metal, ceramic or other material which are used to make a MOSAIC. Individually they are known as tessera.

Texture

The nature of the surface of a work of art, particularly the way its appearance stimulates the spectator's sense of touch. The texture is an integral part of any work, from the expressive and ragged appearance of a PALETTE-KNIFE painting to the smoothness of a PORCELAIN vase.

Thinners

The quick-drying liquids, usually turpentine or white spirit (although there are some proprietary thinners for modern media) used to dilute paint and varnishes.

Throwing

The technique of raising and shaping clay on a POTTER'S WHEEL.

Thumbnail Sketch

A small, usually rapid drawing which captures the distinctive features of a figure, object or scene.

Tint

The variation of a colour that results from mixing it with a small quantity of another colour, black or white. Tints are also made, especially in graphic art, by diluting the amount of PIGMENT in the paint or ink.

TONDO. (*Top*) The Madonna and Child with the Infant St. John *by Michelangelo Buonarroti. This unfinished relief sculpture shows the young St. John the Baptist holding out a goldfinch, which is a symbol of the Crucifixion, to the Christ Child.*

THROWING. (*Bottom*) *The potter's fingers shape the lip on a bowl as it spins on his kickwheel.*

Tondo
A circular painting or relief sculpture.

Tone
The range of light and dark of any colour, and black and white. The tone of an object is governed by the amount of light it absorbs and reflects, so the artist who wants to depict the fall of light, varies the tone of different areas of his painting so that he shows how the different objects in it react to light. The term can also be used in the many senses of the word SHADE. See also COLOUR.

Toned Ground
A GROUND to which a transparent coloured GLAZE or VEIL has been applied to add a particular tone.

Tooth
The texture, i.e. the degree of roughness or smoothness of a painting surface. It is a quality most apparent on watercolour paper and canvas, and always contributes to adherence and appearance.

Topographical Art
Painting and drawing concerned with the depiction of specific places, such as landscapes, country houses, towns and ancient monuments. There is no clear distinction between a landscape painting and a topographical view, except that the topographical artist's primary intention is to provide an accurate portrait of a particular place, whereas a landscape artist uses his subject as the basis of his painting and may alter it as he pleases. See also VEDUTA.

Toreutics
The art of making RELIEF designs on metal by chasing. See also REPOUSSÉ.

Tortillon
A simple tool, used for blending pastel, charcoal and other soft media, made of a stick of rolled or compressed paper with a pointed end. Also known as a stump.

Transfer
1. The process of moving an image from one surface to another. This is most simply carried out by placing a soft pencil drawing face down on a sheet of clean white paper and rubbing the back of the image. There are however, numerous methods of moving images, from SQUARING UP, and the use of specially prepared papers such as carbon paper and graphite paper, to technical processes involved in commercial printing. 2. In CONSERVATION, a transfer is the process of lifting pigment from a deteriorating SUPPORT and placing it on a new one, though frequently it is the picture surface that remains fixed and the support that is moved.

Translucid Painting
The same GOLDEN PAINTING.

Trecento
The fourteenth century, especially in Italian culture.

Trefoil
A decorative motif comprised of three leaves or lobes on a single stem.

Trial Proof
The IMPRESSION taken at a STATE during printmaking. Although artists may sell such proofs (which are marked T.P.) they are not considered part of an edition and are not numbered. Compare ARTIST'S PROOF.

Triptych
A hinged, painted or relief screen made of three panels, the central one generally being sufficiently larger than the two sides to permit their being folded in on it for storage. The triptych was most frequently used as an ALTARPIECE.

Trompe L'Oeil
A painting, or a detail in a painting, that deceives the spectator into thinking that the objects in it are real and not merely represented. For such an optical illusion to work with complete success, it is necessary for the objects in the picture to be near to the PICTURE PLANE (i.e. close to the spectator) as in a noticeboard or objects hanging on a wall. Although this type of painting requires considerable skill and is popularly admired, it is, in fact, no more than a technical trick and tends to lack artistic profundity. Some painters, such as the

(*Above*) Still Life—Violin and Music *by William Michael Harnett. A successful illusionistic work by a nineteenth-century American painter. Note how he has painted in his printed announcement card between the panels at the bottom right.*

SURREALISTS, have successfully incorporated trompe l'oeil in their work, and numerous stories are associated with this form of painting throughout the ages. The classical Greek painter Zeuxis, for example, was said to have painted grapes so realistically that the birds tried to eat them, and Rembrandt's students painted coins on the floor of his studio for the pleasure of watching him bend down to pick them up.

Trucage
The creation of a FAKE.

Truquer
The person who executes a TRUCAGE; a forger.

Turpentine
A rapidly drying liquid, distilled from pine resin and used as a THINNER. See also WHITE SPIRIT.

U.A.
United Society of Artists.

Ukiyo-e
A form of popular Japanese art produced from the sixteenth century onwards and almost exclusively comprised of colour woodblock prints, famous for their flat, decorative areas of bright colour and bold designs. The word '*ukiyo-e*' means 'floating

world' and probably refers to the rapidly changing fashions for different subject-matter, which ranged from scenes of every-day life to landscapes, animals, birds, flowers, scenes from plays and portraits of courtesans. The most famous Japanese

UKIYO-E. (*Below*) Self-Portrait: 'Les Miser-ables' *by Paul Gauguin. This picture dedicated to the artist's friend Vincent van Gogh, displays the influence of* ukiyo-e *prints in its flat areas of colour and decorative floral motif.*

(*Right*) 'She looks as if she wants to go for a walk' *by Taiso Yoshitoshi. A nineteenth-century Japanese woodblock print typical of the thousands imported into Europe in the second half of the nineteenth century.*

artists in this form were Hokusai, Hiroshige and Utamaro.

The importance of Ukiyo-e prints to Western art lies in their huge influence on European painting from the mid-nineteenth to the early twentieth century. They were especially admired by the French IMPRESSIONISTS, the POST-IMPRESSIONISTS, LES NABIS and a variety of ART NOUVEAU artists.

Umber
Dark brown earth pigment, divided into two categories: Raw Umber which is a dark yellowish brown and Burnt Umber, which is a dark reddish brown.

Umbrian School
Artists of the fifteenth and first half of the sixteenth century, working in Central Italy. The school is defined on geographical rather than stylistic grounds and is centred on the town of Perugia. Its most important artists are Piero della Francesca, Luca Signorelli, Petro Vannucci Perugino and Raphael.

Underglaze
In ceramics, colour which is applied to the clay surface before the transparent GLAZE.

Underpainting
The same as LAY-IN.

Unit One
A group of eleven British artists, including Barbara Hepworth, Henry Moore, Edward Burra, Paul Nash, Ben Nicholson and Edward Wadsworth, who banded together in 1933 to promote the spirit of contemporary art. They held an exhibition in the same year and in 1934 published a book called *Unit One*.

Utrecht School
Early seventeenth-century Dutch painters, the most important of whom were Dirck van Baburen, Gerrit van Honthorst and Hendrick Terbrugghen who visited Rome shortly after Caravaggio's death and were profoundly influenced by his work and that of his followers. On returning to Utrecht, they spread a Caravaggistic interest in realism and pronounced CHIAROSCURO throughout their artistic circle, influencing such distinguished figures as Frans Hals and Rembrandt.

Value
The term that describes the degree of lightness or darkness of a COLOUR against a scale which ranges from pure white, through grey to pure black. The darker and lighter colours are referred to as of lower and higher value. For the artist, judgement of the value of a colour always involves an element of compromise, for the pigments on a palette can only approximate to the limitless range of colour in nature.

Vanishing Point
In PERSPECTIVE, the point at which parallel lines meet on the HORIZON LINE. The lines of a railway track, for example, seem to come close together as they recede into the distance. The point at which they converge is the vanishing point. A painting or drawing may make use of several different vanishing points, especially as a means of working out proportions and angles of vision.

Vanitas
A type of STILL-LIFE in which some or all of the objects portrayed are symbols representing the theological doctrine that man's time on earth and his material possessions are temporary. Such pictures are particularly intended to remind the spectator that the after life is more important than life on earth. Objects frequently found in vanitas paintings are skulls, clocks, sundials, hour glasses, flowers, money and symbols of earthly power such as crowns. See also MEMENTO MORI.

Variant
A copy of a painting or other work of art which varies slightly from the original.

VANITAS. Still Life with Boy-Angel blowing Bubbles *by Gerard Dou. The different symbols in the painting are intended to remind the spectator of the transitory nature of human existence. The skull represents death, the hourglass is time, the feathers and the lute refer to frivolous pleasures and the bubbles suggest the fragility of life.*

Varnish

A protective covering made of natural or synthetic resin dissolved in turpentine or oil. A good varnish protects the paint surface from damp and atmospheric pollution and will not alter the pigments. It should also be easy to remove for cleaning and restoration. Today there are a number of synthetic varnishes on the market which fulfil all of these specifications. Moreover, they do not darken, are easy to apply and are less brittle than their natural counterparts. Nevertheless, some artists prefer to buy or make their own varnishes from amber, copal, damar or mastic RESINS and the resulting varnishes take their names from these resins. All varnishes should be applied under warm, dry conditions to warm, clean surfaces to avoid the development of BLOOM. The painting to which picture varnish is applied must be thoroughly dry, and for an oil painting this can be as long as twelve months. If the artist wants to see how a painting will look when varnished, needs to submit it to an exhibition or wants to revive passages which have become dull, RETOUCHING VARNISH

VARNISHES. *A range of varnishes for use with every medium.*

may be used and a permanent varnish applied over it at a later date. Varnishes are available in gloss or matt finishes, and a combination of the two provides a semigloss surface. A less glaring sheen can be obtained by using a wax varnish and polishing it with a soft brush or silk cloth. All of these protective layers give a uniform surface to a painting which subtly alters its appearance.

Varnishing Day

A day after an exhibition has been hung, but before it is officially opened to the public, when the artists are allowed to touch-up or re-varnish their works. This may be to repair damage caused during the hanging of the exhibition or to remedy effects of lighting on the existing surface. More and more frequently, the Varnishing Day is also a preview day for patrons and press.

Veduta

An accurately rendered view of a town or city. These views are particularly associated with eighteenth-century Italy, where artists called *vedutisti* depicted townscapes and ancient monuments for sale to tourists. The most famous artists to work in this *genre* were Canaletto and Giovanni Battista Piranesi. *Vedute* of imaginary scenes, sometimes incorporating famous buildings,

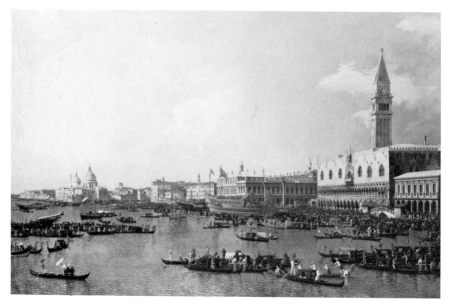

VEDUTA. The Basin of S.Marco on Ascension Day *by Canaletto. This highly detailed and accurate scene shows the view towards the Doge's Palace during the annual ceremony on Ascension Day, when the city is symbolically wedded to the Adriatic.*

were called *vedute ideata*. See also CAPRICCIO.

Vehicle
The liquid substance that binds pigments to make paint or is used to thin them.

Veil
A transparent tinted GLAZE applied to a white painting surface to make a coloured GROUND. This ground will retain most of the reflective qualities of the original white surface. The veil may be applied over any preliminary drawing or UNDERPAINTING as these will show through clearly. See also IMPRIMATURA, VELATURA.

Velatura
Originally a thin GLAZE applied over the entire painting surface with the fingers to make certain that there were no uncovered patches. Today, it simply refers to a VEIL which is put on over any preliminary sketching or underpainting.

Vellum
A high quality PARCHMENT made from the skin of lambs, kids or calves and normally only used for CALLIGRAPHY or manuscript ILLUMINATION.

Venetian School
As the rival port to Constantinople in the Mediterranean, Venice became supreme after the perfidious Fourth Crusade left Venice and attacked and crippled Constantinople in 1204. Become vastly rich in consequence, and in touch with both east and west, Venice, was a police state of tyrranical ferocity. Where other states portrayed their great men, Venice in the Renaissance, put up buildings and adorned them with sculpture and painting to the glory of the Venetian state. A long peace gave their art a sense of almost Victorian ease and comfort, grace and relaxed power and thus has always appeared 'more modern' than other Italian art.

Venetian artists achieved a unique understanding of painting and perhaps the open, luminous lighting of the Venetian summers assisted this. Sacred figures were painted as real people, and art in Venice had a wider popularity than the scholarly and sometimes abstruse neo-Platonic allegories of

Florentine art had for the populace of Florence. Among their great painters were Gentile da Fabriano of Florence, and Pisanello of Verona, Antonello da Messina who imported the technique of oil painting, and the two families: the Bellini and the Vivarini. The VEDUTA painting of Canaletto with its luminous atmosphere, led, in the next generation, to the soft and shimmering touch in landscape of Francesco Guardi, hinting at the later painting of light in French Impressionism.

Verdigris
See AERUGO.

Verism
The attempt in a work of art to depict external appearances as accurately and exactly as possible, without any interpretation or idealization. PHOTO-REALISM is the most extreme form of verism.

Vermilion
See RED.

Vernissage
The French word meaning VARNISHING DAY.

Vesperbild
See PIETÀ.

Video Art
A work of art made to be viewed on a television screen. The special qualities of colour and brightness possible in this medium are exploited, as well as the opportunities it provides for two-dimensional, controlled KINETIC experiment.

Vignette
1. A painting, drawing or photograph which is not contained within a border and whose edges fade into the background. 2. An ornamental design or illustration at the beginning or end of chapters in a book.

Vingt, Les
An influential avant-garde group of twenty Belgian artists, the most important of whom were James Ensor and Henry Van

der Velde. They appeared in Brussels in 1884 and during the next decade held a series of exhibitions that provided a forum for such distinguished artists as Vincent van Gogh, Paul Gauguin, Henri de Toulouse-Lautrec, Édouard Manet, Georges Seurat and Paul Cézanne. The exhibitions and their own painting, especially the work of Van der Velde, helped to spread the precepts of NEO- and POST-IMPRESSIONISM.

Viridian
See GREEN.

Visual
In commercial art, a drawing (completed to varying degrees of finish) which shows how an artist expects an idea to appear when printed.

Volto Santo
Specifically, the large wooden cross found in Lucca Cathedral which shows the fully robed body of Christ and is believed to be an actual, miraculous, portrait. The term has taken on a more general meaning to encompass copies of the Lucca cross and any portrait of Christ believed to be an ACHEIROPOIETOS.

Vorticism
'It is not a good thing, at the present day, to paint a picture in the manner of Tiepolo or of Velazquez or of Manet, but in some new or different manner, more appropriate to the beliefs and conditions obtaining in the twentieth century.' So wrote Percy Wyndham Lewis, founder and principal member of the short-lived but highly influential Vorticist movement. Wyndham Lewis, who is perhaps better known as a writer and the Editor of the Vorticist manifestoes which he published in the journal *BLAST*, was influential but not popular as a painter (Sickert is reputed to have told him: 'I give you this cigar because I so greatly admire your writings. If I liked your paintings, it would have been bigger.') His first Vorticist painting was completed in 1912 and the first and only exhibition of Vorticist work was held in 1915. Shortly afterwards, the group disbanded and its members, together with those of the CAMDEN TOWN GROUP, merged

VORTICISM. (*Above*) Composition *by Percy Wyndham Lewis. An aggressive, angular watercolour by the leading Vorticist painter.*

to form the LONDON GROUP. Vorticism borrowed from both CUBISM and FUTURISM (though it claimed to be a reaction to them) and is noted for its preoccupation with the forms of the machine age. Apart from Wyndham Lewis, other artists associated with Vorticism were Edward Wadsworth, William Roberts, David Bomberg, Jacob Epstein and Henri Gaudier-Brzeska. The name of the group was invented by the poet Ezra Pound.

Wanderers, The
A group of thirteen Russian artists who rebelled against the Imperial Academy of Arts in 1870, and attempted to make art

available to a broader social spectrum. Under the leadership of Nicolas Kramskoi, they formed the Society of Travelling Art Exhibitions, which displayed members' work in the provinces. The Wanderers introduced a form of SOCIAL REALISM to Russia, and the work of such artists as Vasili Vasilievitch Vereshchagin, Ilya Efimovich

WATERCOLOUR. Study of a Gurnard *by Joseph Mallord William Turner. This study is made up of transparent watercolour washes with the highlights added later in opaque body colour.*

Repin and Vassily Polenov clearly demonstrates their efforts to make art appealing to the masses by exposing the plight and extolling the virtues of the common man.

Warm Colours
Those colours in the range from red to yellow which give the impression of advancing when applied to a painting surface. See also ADVANCING COLOUR and COLD COLOURS.

Wash
Diluted watercolour or ink which is spread

evenly over the surface of the paper, usually by applying horizontal strokes with a fully charged brush. Special effects can be gained by applying one wash over another that is still wet, or by using washes in combination with pen drawing.

Watercolour

Broadly, any painting MEDIUM soluble in water, such as TEMPERA or GOUACHE. The term, however, properly refers to the technique of painting with transparent WASHES of colour that was developed in England during the eighteenth and nineteenth centuries. In this method, the medium is made of pigments ground with a water soluble BINDER, usually gum arabic, and is available in cakes, pans or tubes. In pure or 'true' watercolour painting, the paper shines through the washes of paint to provide a luminous effect, and the colours are made lighter by thinning, not by the addition of white pigment. Similarly, lights and highlights are provided by leaving the paper bare, or by scraping or rubbing to remove paint.

Painting with transparent watercolour emerged in England in the second half of the eighteenth century principally as a TOPOGRAPHICAL ART. It rapidly matured into a fully-fledged school of landscape painting, among whose principal exponents were Thomas Girtin and J. M. W. Turner, which endured and developed throughout the nineteenth century. As a technique, however, its use was largely confined to the U.K.

Water-glass Painting

A method of mural painting which experienced a brief vogue during the nineteenth century. Water-based paints were applied to a layer of plaster and sealed with a silicate mixture. Because some pigments reacted with the silicate, however, the murals tended to disintegrate rapidly, and the method is rarely used today. Also known as mineral painting and stereochromy.

Water Tension Breaker

A substance added to water or to water-based paints in order to reduce surface tension. This prevents the paint from beading on the paper or other picture surface and ensures even staining without reducing colour strength. See also OX GALL.

Wax Painting

See ENCAUSTIC PAINTING.

Wax Resist

The use of a waxy drawing medium, for instance a crayon, for making a design over which a coloured wash is spread. The wash will be absorbed only where the surface is not coated with wax. A variety of effects can be obtained by scratching away the wax in different areas and applying additional washes. See RESIST.

W.C.C.

World Crafts Council.

W.C.S.I.

Watercolour Society of Ireland.

W.E.R.P.

Wood Engravers and Relief Printers.

Wet on wet

The application of fresh paint over an area on which the paint is still wet.

Wetting Agent

The same as WATER TENSION BREAKER.

White

Theoretically, the combination of all three PRIMARY COLOURS in equal proportions, but in practice it is impossible to mix white paint from coloured pigments. The artist must, therefore, use paint made of naturally white pigments; those commonly available from the artists' colourmen include: Chinese White; Cremnitz White; Flake White; Permanent White; Silver White; Titanium White; White and Zinc White. See also BLACK and COLOUR.

White-line Engraving

An engraved print on which the image is formed by the areas of the block or plate that do not print ink, rather than those that do. In short, in a white-line engraving the image shows white on a black ground, rather than black on a white ground.

WHITE-LINE ENGRAVING. Pasiphaé Embracing an Olive Tree *by Henri Matisse. In this illustration for* Pasiphaé *by Henri de Montherlant, Matisse used the power of white-line engraving to balance the text which appeared opposite. He treated each double page of text and illustration as though it was a single subject surrounded by a white border.*

White Spirit

A THINNER used with oil paints and varnishes in place of TURPENTINE.

Whiting

Chalk which is purified, ground with water and dried to form an INERT PIGMENT.

W.I.A.C.
Women's International Art Club.

W.I.A.S.
Women's International Art Society.

Wiener Werkstätte
A Viennese association of craftsmen and designers formed in 1903. Under the leadership of Josef Hoffman and Moser, the group combined the philosophy of William Morris's ARTS AND CRAFTS MOVEMENT and the tastes and trappings of ART NOUVEAU.

Win-Gel
See MEDIUM.

Woodblock Print
The same as WOODCUT.

smoothly planed wood and the areas not to be printed are cut away. The raised areas are subsequently inked and a sheet of paper pressed on to the block, either by hand or in a printing press. Coloured prints are obtained by carving different blocks for each colour required.

Woodcuts were widely used throughout Europe in the fifteenth and sixteenth centuries, particularly for book illustrations, though they achieved their most sophisticated form in the works of Albrecht Dürer, Hans Holbein and Lucas Cranach. With the development of metal engraving techniques, the woodcut fell from favour until it was revived towards the end of the nineteenth century by artists such as Paul Gauguin and Edvard Munch.

Woodcut
An ancient printmaking technique for which a block of wood is carved with knives and gouges to make a RELIEF print, which is itself called a woodcut. The block is cut from the side, rather than the end of a plank, so that the grain runs lengthways along its surface. The design is then drawn on the

WOOD ENGRAVING. The Chillingham Bull by *Thomas Bewick. Bewick considered this work, which he executed in 1789, to be his masterpiece.*

Wood Engraving

A printmaking technique, similar to WOOD-CUT, but using particularly hard wood, usually box, that is cut from the end of the plank. The surface of the wood is highly polished and the design is cut with a BURIN, normally so as to produce a WHITE-LINE ENGRAVING.

The technique was first developed, though not invented, in the eighteenth century by Thomas Bewick, who was originally trained as a metal engraver. Because wood engraving involves cutting into, not across the grain of finely textured wood, it can be used to achieve the subtle effects possible on metal plates. In addition, until the twentieth century, metal plates could not be printed in the same process as type, whereas wood blocks could. As a result, by the mid-nineteenth century Bewick's technique had become the most widely used means of printing newspaper and book illustrations, though it was superseded by photomechanical reproduction in the 1880s.

World of Art Group

A group of Russian painters, poets and dancers formed in St Petersburg in 1890 in direct opposition to THE WANDERERS. The group espoused the doctrine of 'art for art's sake' in the same way as the AESTHETIC MOVEMENT, and in painting, experimented with IMPRESSIONISM. The group had particularly strong links with the world of ballet, and included Serge Diaghilev (who edited its magazine) and Leon Bakst among its members.

X Group

A group of painters organized by Percy Wyndham Lewis in 1920 at the prompting of some of the original VORTICISTS. The other members were Edward Wadsworth, Charles Ginner, William Roberts and Frank Dobson, but they disbanded after only one exhibition.

Xylography

1. A rarely used term for woodblock printing, whether with a WOODCUT or WOOD ENGRAVING. 2. The mechanical reproduction of wood grain for decorative purposes.

Yellow

One of the painter's three PRIMARY COL-OURS. Yellow paints commonly available from the artists' colourmen are: Aureolin; Brilliant Yellow; Buttercup; Cadmium Yellow; Canary; Chrome Lemon; Chrome Yellow; Gamboge; Golden Yellow; Indian Yellow; Lemon Yellow; Marigold; Mars Yellow; Middle Yellow; Mimosa; Naples Yellow; Permanent Yellow; Primrose; Winsor Lemon; Winsor Yellow and Zinc Yellow. See also COLOUR.

Yellowing

The discolouration of oil paintings. This occurs naturally in the ageing of some types of paint or varnish or as the result of excessive use of linseed oil. Its most common cause, however, is accumulated dirt on the varnished surface, and this can often be easily remedied by replacing the varnish.

Zoomorphic

A word used to describe the forms of works of art and ornaments based on animal shapes, particularly those associated with BARBARIC and Mediaeval art. Together with their decorative function, these forms are often intentionally symbolic.

FURTHER READING

AESTHETICS

ALEXANDER, SAMUEL. *Beauty and Other Forms of Value*. London, MacMillan, 1933.

BAUDOUIN, CHARLES. *Psychoanalysis and Aesthetics*. London, Allen and Unwin, 1924.

BELL, CLIVE. *Art*. London, Chatto and Windus, 1916.

COLLINGWOOD, ROBIN GEORGE. *The Principles of Art*. Oxford, Clarendon Press, 1938.

COLLINGWOOD, ROBIN GEORGE. *Speculum Mentis, or The Map of Knowledge*. Oxford, Clarendon Press, 1924.

FRY, ROGER. *Vision and Design*. London, Chatto and Windus, 1923.

SEDDON, RICHARD. *The Artist's Vision*. (*Studio Magazine*. December 1948 to March 1949.)

TOLSTOY, LEO. *What is Art?* London, Oxford University Press, 1969.

ART HISTORY

General

Encyclopedia of World Art. 15 vols. London, McGraw-Hill, 1965.

GOMBRICH, ERNST H. *The Story of Art*. London, Phaidon, 1950.

Larousse Encyclopedia of Art. London, Paul Hamlyn, 1957–61.

Primitive and Prehistoric

FRASER, DOUGLAS. *Primitive Art*. London, Thames and Hudson, 1962.

PERICOT-GARCIA, LUIS, GALLOWAY, JOHN and LOMMEL, ANDREAS. *Prehistoric and Primitive Art*. London, Thames and Hudson, 1969.

WINGERT, PAUL S. *Primitive Art: Its Traditions and Styles*. New York, Oxford University Press, 1962.

Classical

BEAZLEY, SIR JOHN DAVIDSON and ASHMOLE, BERNARD. *Greek Sculpture and Painting*. London, Cambridge University Press, 1932.

BOARDMAN, JOHN. *Greek Art*. London, Thames and Hudson, 1964.

BRILLIANT, RICHARD. *Arts of the Ancient Greeks*. London, McGraw-Hill, 1973.

HENITZE, HELGA VON. *Roman Art*. London, Weidenfeld and Nicolson, 1972.

RICHTER, GISELA M.A. *A Handbook of Greek Art*. London, Phaidon, 1967.

Mediaeval

BECKWITH, JOHN. *Early Christian and Byzantine Art*. Harmondsworth, Penguin Books, 1970.

BECKWITH, JOHN. *Early Medieval Art*. London, Thames and Hudson, 1964.

DODWELL, C. R. *Painting in Europe 800–1200*. Harmondsworth, Penguin Books, 1971.

GRABAR, ANDRÉ and NORDENFALK, CARL. *Early Medieval Painting*. Geneva, Skira, 1957.

MARTINDALE, ANDREW. *Gothic Art*. London, Thames and Hudson, 1967.

POPE-HENNESSY, JOHN. *Italian Gothic Sculpture*. London, Phaidon, 1971–72.

SWARZENSKI, HANNS. *Monuments of Romanesque Art*. London, Faber and Faber, 1967.

Renaissance to Mannerism

BENESCH, OTTO. *The Art of the Renaissance in Northern Europe*. London, Phaidon, 1965.

BERENSON, BERNARD. *Italian Painters of the Renaissance*. London, Phaidon, 1952.

BERENSON, BERNARD. *Venetian Painters of the Renaissance*. New York, Putnam, 1905.

BLUNT, ANTHONY. *Artistic Theory in Italy: 1450–1600*. Oxford, Clarendon Press, 1940.

BURCKHARDT, JACOB. *The Civilization of the Renaissance in Italy*. London, Harper and Row, 1975.

LEVEY, MICHAEL. *Early Renaissance*. Harmondsworth, Penguin Books, 1967.

LEVEY, MICHAEL. *High Renaissance*. Harmondsworth, Penguin Books, 1975.

MURRAY, LINDA. *The High Renaissance and Mannerism*. London, Thames and Hudson, 1967.

MURRAY, PETER and LINDA. *The Art of the Renaissance*. London, Thames and Hudson, 1963.

SHEARMAN, JOHN. *Mannerism*. Harmondsworth, Penguin Books, 1967.

VASARI, GIORGIO. *Lives of the Painters*. Betty Burroughs, ed. London, Allen and Unwin, 1960.

Baroque to Rococo

BAZIN, GERMAIN. *Baroque to Rococo*. London, Thames and Hudson, 1964.

HUBALA, ERICH. *Baroque and Rococo Art*. London, Weidenfeld and Nicolson, 1976.

KITSON, MICHAEL. *The Age of Baroque*. London, Hamlyn, 1966.

WITTKOWER, RUDOLF. *Art and Architecture in Italy: 1600–1750*. Harmondsworth, Penguin Books, 1973.

Neoclassicism to Romanticism

BRION, MARCEL. *Art of the Romantic Era*. London, Thames and Hudson, 1966.

HONOUR, HUGH. *Neoclassicism*. Harmondsworth, Penguin Books, 1968.

Modern (Nineteenth century to Present day)

ARNASON, H. H. *A History of Modern Art*. London, Thames and Hudson, 1969.

BOWNESS, ALAN. *Modern European Art*. London, Thames and Hudson, 1972.

Larousse Encyclopedia of Modern Art from 1800 to the Present Day. London, Hamlyn, 1965.

LUCIE-SMITH, EDWARD. *Movements in Art Since 1945*. London, Thames and Hudson, 1969.

PEVSNER, NIKOLOUS. *Pioneers of Modern Design*. Harmondsworth, Penguin Books, 1960.

READ, HERBERT. *Art Now*. London, Faber and Faber, 1960.

ROSENBLUM, ROBERT. *Cubism and Twentieth-Century Art*. London, Thames and Hudson, 1960.

SCHMUTZLER, ROBERT. *Art Nouveau*. London, Thames and Hudson, 1964.

ART PSYCHOLOGY AND PERCEPTION

ARNHEIM, RUDOLF. *Art and Visual Perception*. London, Faber and Faber, 1956.

EHRENZWEIG, ANTON. *Psychoanalysis of Artistic Vision and Hearing*. London, Sheldon Press, 1975.

GOETHE, J. W. VON. *Theory of Colours.* London, Cass, 1967.

GOMBRICH, ERNST, H. *Art and Illusion.* London, Phaidon, 1977.

GREGORY, RICHARD. *Eye and Brain.* London, Weidenfeld and Nicolson, 1972.

JUNG, CARL. *The Integration of Personality.* London, Kegan Paul, 1941.

PETERMAN, BRUNO. *The Gestalt Theory.* London, Kegan Paul, 1932.

SEDDON, RICHARD. *The Two Modes of Perception and Expression Performed by Artists when Painting. (Journal of Aesthetics and Art Criticism* of the American Society for Aesthetics. Vol. VI. No. 1. September, 1947.)

HILER, HILAIRE. *The Painter's Pocketbook.* London, Faber and Faber, 1970.

MAYER, RALPH. *The Artist's Handbook.* London, Faber and Faber, 1973.

BIOGRAPHICAL REFERENCES

BAIGELL, MATTHEW. *Dictionary of American Art.* London, John Murray, 1979.

MURRAY, PETER and LINDA. *Dictionary of Art and Artists.* Harmondsworth, Penguin Books, 1976.

OSBORNE, HAROLD, ed. *The Oxford Companion to Art.* Oxford, Clarendon Press, 1970.

Who's Who in Art. 19th edition. Havant, Art Trade Press, 1980.

MATERIALS AND TECHNIQUES

DOERNER, MAX. *The Materials of the Artist.* London, Granada, 1979.

HAYES, COLIN, ed. *The Complete Guide to Painting and Drawing Techniques and Materials.* Oxford, Phaidon, 1978.

HILER, HILAIRE. *Notes on the Technique of Painting.* London, Faber and Faber, 1969.

ACKNOWLEDGMENTS

The illustrations are reproduced by kind permission of the individuals, institutions and agencies listed below. The numbers following the names refer to the pages on which the different illustrations appear.

Collection of the Whitney Museum of American Art, New York 7 (Gift of Mr and Mrs Samuel Kootz), 8, 13; National Gallery, London, 9, 22, 27, 53, 56, 60, 74, 81, 89, 97, 98, 101, 112, 166, 178; Tate Gallery, London 10, 17, 31, 45, 55, 82, 83, 93, 94, 105, 119, 125, 134, 136, 137, 156 (left), 160, 165, 167, 168–9, 171, 180; Victoria & Albert Museum, London 19, 20, 39, 41, 44 (top), 87, 96, 98, 104, 118, 180–1; Collection, The Museum of Modern Art, New York 21 (Philip Johnson Fund), 26–7, 29, 139 (Van Gogh Purchase Fund), 141 (James Thrall Soby Fund); Mansell Collection 24–5, 26, 30, 34, 43, 50, 65, 67 (bottom), 69, 73, 77, 79, 106–7, 109, 113, 115, (left), 131, 139, 146, 153, 155, 157, 161 (top), 162, 184; Trustees of the Wallace Collection 25, 56–7, 145; Fitzwilliam Museum, Cambridge 32 (top); National Galleries of Scotland 32 (bottom); Merseyside County Art Galleries 37; Detroit Institute of Arts 38 (Gift of Leslie H. Green); Albright-Knox Art Gallery, Buffalo, New York 44 (bottom); Royal Academy of Arts 61 (left), 172 (top), ; Los Angeles County Funds 62; Photograph by Shunk-Kender, reproduced courtesy of the artist 62–3; Photographic copyright (1981) by the Barnes Foundation 67 (top); James Bourlet & Sons 71 (bottom), 75; The Metropolitan Museum of Art, New York 84–5 (Gift in memory of Jonathan Sturges by his children, 1895), 174; Stedelijk Museum, Amsterdam 88–9; Rowney Ltd 102, 126, 177; Iveagh Bequest, Kenwood (Greater London Council) 115 (right); Art Institute of Chicago 133 (Helen Birch Bartlett Collection); Corpus Christi College, Cambridge 148; Ashmolean Museum, Oxford 50–1, 161 (bottom); Harrison Mayer Ltd 172 (bottom).